ARTS ADMINISTRATION:
How to Set Up and Run Successful Nonprofit Arts Organizations

Arts Administration

HOW TO
SET UP AND RUN
SUCCESSFUL NONPROFIT
ARTS
ORGANIZATIONS

TEM HORWITZ

Chicago Review Press

First Edition

The author gratefully acknowledges permission to reprint granted from the following:

Producers on Producing by Stephen Langley;

Financial Practice for Performing Arts Companies — A Manual by Mary Wehle.

ISBN (clothbound edition) 0-914090-47-X

Library of Congress Catalog Card Number 77-93723

Book design and typography by Claire J. Mahoney

Published by
Chicago Review Press, Inc.
215 West Ohio Street
Chicago, Illinois 60610

*To a continuing faith in partnerships and
meetings of all kinds, whatever their duration.*

MAX

Contents

Contents

Contents

Introduction

This book is written for artists and administrators who want to set up arts organizations, reorganize existing ones, or simply think about some of the possibilities open to them. Arts administration itself is going through a period of rapid development, and to some extent the relationship of art and arts organizations to the society is changing. In this book I hope to interpret these changes in a practical way for individuals who are involved in the "business of the arts."

Arts administration is not an easy field. A major preoccupation is the enormous and continual financial woes of most organizations. But economic questions have also been used to mask a host of other difficulties. Simple, effective business procedures have largely been ignored, financial management has been slip-shod, and organizational structures inefficient. In many institutions, relationships between staff and Boards of Directors are ambivalent and unproductive, marketing tends to be sporadic, and promotion is hit or miss.

Expectations and models have to be changed for arts organizations. It is preposterous, for example, to project mounting deficits in the performing arts into the distant future without contemplating some major changes. Imagine any other business

or industry in this country making such a projection. It's unimaginable. Yet, this is exactly what is happening in the performing arts. It is one thing to write reports and to lobby for more support for the arts. It is another thing to take these lobbying efforts as gospel. A model of financial self-sufficiency is economically as well as psychologically more satisfying and sustaining to those working in the arts, even if it is not immediately attainable. Paths are made by walking, not by crying about the fact that the road appears to be blocked.

In addition to the constant financial pressures, arts administrators are frequently in the position of having to work with artists, who are often not the easiest people to deal with, while taking their directives from Boards of Directors which tend to look at arts administrators as semi-competents or failed businesspeople. Administrators are often caught in the middle. To make matters worse, while the administrator assumes responsibility for organizing productions, promoting the work, etc., the public glory goes to the artists, with the administrator's role as often as not taken for granted. The arts administrator is ultimately a facilitator, and to some this is not a very rewarding position to be in. It also distinguishes the position of the arts administrator from the executive or administrator in other fields, to whom the glory, money, and status accrue as a result of the positions that they fill. In this book, rather than glossing over problems and issues of this sort, I have chosen to highlight them, to make would-be administrators aware of some of the difficulties that they will encounter, and to confirm for others in the field that their problems are not unique. All of this in the hope that clarifying the issues will provide the first step towards resolving the problems.

There is a clear bias in this society towards bigness, and clearly there are benefits to be derived from scale. Only a large museum can mount a retrospective of a prolific artist whose work is scattered all over the world; and a large symphony can perform work that a small chamber group cannot. And though I don't challenge the right of these large art-beasts to exist — though I do think that they gobble up too much of public and corporate support of the

arts — it is my belief that the living arts prosper in smaller and more flexible settings. Moreover, these large institutions, which too often serve as models, tend to be organized and to function in ways that possibly were innovative in the nineteenth century, but which have increasingly less to do with the world in which we live. The bias of this book is towards small- to medium-size arts institutions, and above all towards the innovation that can take place in these settings.

This book is divided into three sections. The first six chapters deal with the nitty-gritty of arts administration — grant writing, marketing, financial management, boards of directors, etc. The second section is a detailed examination of the legal questions relating to nonprofit organizations, with specific advice for laymen and lawyers about obtaining and maintaining an IRS tax exemption. This chapter was written by Thomas Leavens, Director of the Lawyers for the Creative Arts. The final section includes interviews and case studies of three arts administrators who have imaginatively put together successful organizations. The final chapter is a detailed history of one arts organization from a number of different perspectives. It is included not only because I was involved with it and know it well, but because it poses some interesting problems and some unusual solutions to common dilemmas in the arts.

The Board of Directors

Q. What do you have to say about the relationships between the artistic directors of a non-profit theatre and the board of directors or trustee?

A. All of my experiences with them have been bad! And not just with me, I might say, but right across the country. The idea that there should be superimposed a group of well-meaning community laymen who act as a bureaucratic structure and take care of the artists, because they're babies and can't really take care of themselves, I think, was imposed on this country in the early days when the Ford Foundation first began to help the theatres. It seemed that that was the way to tie you into some kind of respectability, in the community, and into your region.

Producers on Producing by Stephen Langley.

Interview with Adrian Hall, Trinity Square Repertory Company

Conventional wisdom and custom would have it that the way to organize your board of directors is to include the wealthiest and most prominent people you can find, a smattering of professionals whose services you can use, and representatives from parts of the community with whom you want to be identified. The assumptions that underlie this 'wisdom' are that the arts organizations by their very nature are not respectable, and that they necessarily lack the business acumen and skills required to function successfully in the world. Creating a parent body filled with respectables and savvy professionals is a sure way, then, to cure these deficiencies.

Now without going into a detailed cultural history of the arts, the models for many arts organizations are the cultural giants that were organized in the last half of the nineteenth century and the early part of the twentieth century. These institutions tended to be battle grounds on which the wars of the old and the new money were fought. Part of the declaration of arrival — arriving from some mundane activity like slaughtering cattle, making steel, building railroads — was identifying oneself with those higher and finer things in life — the arts. The process of identification to the most aggressive of this breed meant not necessarily observing or participating in the cultural activities themselves, but controlling the institutions. To be on the board of the opera or the museum was a sign of having arrived.

Eastern institutions tried to identify themselves with European traditions, the Midwest attempted to model itself after the East Coast, and the Far West did the best it could. No matter where one stood, "real" art came from someplace else, and on the whole so did the role models. Maybe it is the new self-assurance that comes from feeling that the United States is the cultural center of the world that makes it possible for us to question some preconceptions about the structure of arts organizations, and to think perhaps of slaughtering some of the sacred cows. The truth of the matter may well be that David Rockefeller, even though he has expressed interest, is not the right person to be on the board of your community puppet theatre.

I am not arguing that it is necessarily wrong to appoint people

to your board who can solicit money for you, or that it is mistaken to try to get a lawyer and an accountant. But these are not your only choices. It may be in your interests to retain as much control over your corporation as you possibly can. You may decide that since very few people can hope to understand your work, you can't deal with a board that is going to need constant educating. Your image of yourself may exclude the possibility of being identified with "establishment" figures. You may want a small board that will be intimate and closely identified with your work, or a large board filled with people who like to party together and to give away their money.

Within the constraints of the law, you must make these choices. It may seem unreasonable that you, who have created your organization with your own sweat and imagination, should have to surrender ultimate authority to a group of people who will become your board of directors. You will do this to satisfy the IRS, to assure them that you are a not-for-profit corporation whose interests extend beyond those of you in the inner circle who stand to profit from success. But you do have options in creating or altering your board, even though, once created, it will have a life of its own.

The remainder of this chapter explores your options in detail, and is intended to give you the information necessary for making choices about the most desirable board of directors for your organization.

The Board of Directors: what it is and what it does — The specifics will vary, but the basic requirements in most states for a board are that is consist of at least three members, that they be at least eighteen years old, and that they meet at regular intervals. The board of directors of a not-for-profit corporation is responsible for the overall management of the organization. It is (legally) responsible for the actions of the corporation, and it must see that the corporation adheres to the guidelines and purposes articulated in the by-laws or articles of incorporation.

The board assumes financial responsibility for the organization, which can be significant if the corporation has debts which

it is unable to pay, or in the event of the dissolution of the corporation. In this case the board is responsible for donating the assets of the dissolving corporation to another not-for-profit corporation.

A conventional board assumes responsibility for raising funds for the organization. In some cases board members donate substantial sums of money themselves, solicit funds from businesses and foundations in the name of the group, or organize fund-raising events in the form of benefits, teas, or more broadly based fund-raising activities. How the board operates in this sphere is in large measure a function of how it has been set up and what responsibilities have been given it by its founders. When you invite someone to join your board, you should make your expectations of his/her financial and fund-raising responsibilities as explicit as you possibly can. Not everyone is a fund-raiser.

In most cases, the board should oversee the general management of the organization, but should not be overly involved in the day-to-day activities. The board might allocate $10,000 for an exhibit, and expect that this budget be adhered to, but not haggle over each invoice or item of expense. As Lao Tzu remarked on administration, "Rule a nation as you would cook a small fish." Know what you want to do, and pay attention to the details, but too much meddling will only reduce the little fish to a hopeless mess.

The relationship of the board to the staff is crucial and complicated. In many arts organizations the founders and principal artistic personnel are not only on the board, but in many cases have created the board. Yet it is this board which has the ultimate responsibility for hiring and firing staff. It is not uncommon for the founder of an organization, the person who may have made the whole thing happen, to be fired by a board of directors. Short of this, the situation can still be difficult. If the organization is in financial trouble — or if the board *feels* that the organization is in financial trouble — it may insist on radically altering business practices or the very activities of the organization. If the organization is in the artistic doldrums it is the board's responsibility to take some action, to give advice, to make program decisions,

to replace the artistic director. Even if things are going well, the board might find itself in the position of having to resolve serious conflicts within the organization. In my own experience, the founders and principal staff members of a very, very successful not-for-profit corporation found themselves at loggerheads with each one deciding that he wanted to control the organization. The question ultimately had to be decided by their board – a board filled with friends and colleagues. After an agonizing struggle that involved all of the parties, the board decided to find a third person to take over the leadership of the organization. A board may have to resolve nasty conflicts of this sort, though ideally it is sufficiently in touch with principal staff to resolve such conflicts before they become unmanageable.

Who should be on the board? – Boards can be organized according to a number of different principles, depending on what you feel your organization most needs. They can be composed of professionals whose services are needed by the organization, by community representatives, or by close friends and supporters. There is also the possibility of the empty board, which allows the staff to operate the corporation as it sees fit.

If you need a variety of professional services which you feel you can't afford to pay for, you can try to attract a sample of professionals whose services you need. If these services are not donated, you can perhaps get them discounted. You might think of a lawyer, an accountant, a graphic designer, a printer, a marketing executive, an architect, or the owner of a supply house which stocks goods that you use regularly. This mercenary approach has its disadvantages. Asking someone to be on your board who has special skills does not guarantee that he will be willing or able to donate them to you. Your lawyer may know nothing about copyrights, your corporate executive may not have a feel for the workings of a small arts organization, your advertising director may be skilled in merchandizing toothpaste but may not know what to do with you. And also, donated services are sometimes felt to be charity, with you, the recipient, expected to be grateful for whatever crumbs are thrown your way.

Or you may choose board members because of their access to money. You may want to ask people to be on your board who have extensive business connections with corporations that give money to the arts; with people associated with foundations from whom you want to solicit funds; from socially prominent people who have private wealth; from people prestigious in their own field whose membership on your board will make you look all that much more respectable; or from individuals who have their own money and who would be interested in giving some of it to you.

Groups for whom it is important to have a broad impact on communities can look for board members who will act as spokesmen in their communities for your group. You can think of these communities as ethnic groups, occupational groups, or geographic groups, but you should be specific in identifying what groups you are trying to approach, and be sure that you choose an effective representative from that community.

It is difficult to get everything, so try to pinpoint your greatest needs and select people who can satisfy those needs. And remember, for every service provided to you by your board, your staff loses self-sufficiency. The administrative director of your organization should certainly be as competent in his or her field as any of the board members, if there is to be any balance or mutual respect. Ideally, board members should possess skills which supplement the skills and expertise of the staff. A board which feels it is actually running an organization will feel that it should have a significant voice in all of the choices being made in the organization. Perhaps important members of a theatre board will want to see *The King and I* rather than the newest Harold Pinter play that the staff wants. All of which is to say that everything has its price, and people *do* expect something in return for the work and money which they invest in an activity. whether it be status, friendship, identification with the art, a sense of service, or even the fulfillment of a company requirement. And the more work and time the board puts into your organization, the more work and time you are likely to have to invest in relationships with the board members.

The Board of Directors

Where do board members come from? — The logical place to start your search is with friends and acquaintances who already have some sense of what you are doing and are sympathetic with it. It is difficult to approach someone cold to be on your board, so even friends of friends are a better place to start. Draw up a list of everyone whom you intend to approach to see how the group as a whole fits together, and how many of your needs are met by the group. If you are looking for an active member, make sure that he/she has enough time and interest to do what you want him/her to do. It is essential that every potential board member be approached in person to be on the board, and that the expectations that you have about this person — how much time will be required and what his/her specific responsibilities will be — are explored as fully as possible. It is desirable to put this in writing either prior to or after the interview. Acquiring new board members should not be a casual process.

The process of selecting new board members will largely be determined by the by-laws of your organization. Potential board members should have the approval of the existing board, and all of the principal artistic and administrative personnel.

Length of Service — It is important to have an institutionalized way of insuring the vitality of the board. Board members should be involved long enough to come to fully understand the organization and to do what they can to facilitate its growth and development, but not so long that they become fixtures. In most cases the deadwood will leave of its own accord, but if you need an active board and get stuck with a board which is there out of habit, you are in trouble. In this case you will wish that you had set terms for board members. On the other hand you don't want to have to get rid of your strongest supporters just because their term is up. It is a difficult problem which can be partially solved by having fixed terms, but allowing for re-election under special circumstances. In any event, it is desirable to have appointments staggered so that you are getting a limited group of new members each time the board changes. If terms are three years, you would want to stagger elections so that you replace one third of

the board each year. Three year terms are a reasonable length of service.

Size of the board — The optimum size of your board is a function of how much work there is to be done, how often you plan to have the board meet, and how much staff time there is to service the board. For a small organization a board of three to five may be more than adequate, particularly if you want to have intimate, centralized decision making. For a larger organization, particularly one in which the majority of the work will be done in committees, fifteen to thirty members might be more reasonable. The larger the group, though, the more time is required to create a group feeling, both in terms of time spent at each session and length of service. With a large group there will be more opinions to listen to, more advice, and less cohesiveness. On the other hand there is a larger pool of resources to draw from. The choice is a complicated one, but the main factors should be the needs of the organization and the amount of time that the administrators are willing to spend in working with the board of directors.

Frequency of meetings — A non-working board can meet once a year at dinner and turn over the operation of the corporation to the staff. A working board must meet frequently enough to discuss all the major issues of immediate significance, and to have enough time left to reflect on the larger questions such as the future of the organization. Too often meetings will be taken up with the day-to-day problems, leaving no time for the less immediate, but no less crucial questions with which the board should deal. Also, too much time between board meetings can result in a loss of interest among the board members, while meeting too frequently can make serving on the board a burden. An average board should meet five to eight times a year. With more informal contact, this frequency of meeting can be reduced.

Auxiliary boards — If you have chosen not to divest yourselves of the control of the corporation and have a board stocked either with figureheads or with yourselves, you can still get many of the

same benefits from setting up auxiliary boards. These can be the Friends of the XXXXX, who can raise money for you and provide the same support that an active board can.

In Conclusion — In *The Effective Board* Cyril Houle lists the requirements for an effective board. This list provides useful categories for thinking about the composition, structure, and activities of a working board.

1. The members of the board should be effective individually in their board work.

2. Board members should have complementary talents.

3. Board members should be representative of the interests served by the organization.

4. The board should be large enough to get all of the work done, but small enough to be intimate.

5. There should be clear organizational patterns and good communication between the board and the staff.

6. It is essential to have good working relationships among the board, the staff, and the organization's executives.

7. The board should have a total sense of the organization's objectives.

8. The board should know to what degree these objectives are being realized by the organization.

9. Board members should be comfortable with one another.

10. Each member should feel involved with the work of the board and the progress of the organization.

11. The board should have specific goals in terms of its work.

12. The board should make policy decisions only after talking to all concerned parties. The board should not operate in a vacuum.

13. The board should have good relations with its community.

14. Board members should derive a sense of achievement from their board work.

The National Council on the Arts, in conjunction with the Taft Corporation, reviewed the organization of 173 groups that had applied for Challenge Grants from the NEA. The study revealed a number of points which I will summarize here. First, there is a great deal of tension among the artists, the administration, and the board of directors of most arts organizations. Boards tend to think that arts administrators are hacks; administrators feel that boards are a "necessary evil"; artists think that board members are insensitive boors. Second, communications among these three groups are poor. Third, there is rarely an organized effort to inform board members about their duties, responsibilities, and even about the actual functioning of the organization. Fourth, board meetings tend to be poorly organized and unproductive. Fifth, there is usually considerable frustration between the board and the administration. The board frequently operates in a vacuum or is controlled by the selective presentation of facts by the administration. Administrators on the other hand often feel that there is no sustained involvement on the part of the board, and consequently no consistent policy making.

It is best to be aware of these common problems before you set up your board, and in fact desirable that you resolve these questions as best you can before you set up your corporation so that your choices can be made explicit, and incorporated into your by-laws. There is a great deal of latitude within the constraints of the law. Be cautious and deliberate, but don't be afraid to make unconventional choices if they fit the realities of your group and its activities.

Grants and Grant Writing

Corporate, Foundation and Government Support of the Arts

For most arts organizations, grants represent an essential part of every budget. Yet, as the Taft Corporation discovered in their study of 173 of the best-put-together nonprofit arts organizations, most "do not often conduct systematic, ongoing prospect research to identify and define potential new sources of support." Arts organizations have a tendency to rely on the same small group of friends for the majority of their funding. And most small arts organizations don't even know where to start. In this chapter I want to present a simple research system for identifying funding sources, advice on approaching these sources, and general information on writing grant proposals. I have chosen to deal with three types of funding sources: foundations, corporations, and the government.

FOUNDATIONS

At present there are over 26,000 foundations in this country.

These foundations fall into a number of general categories. There are *family foundations* which are set up by wealthy individuals to support, in most cases, a limited number of activities of interest to the founders. Many of these foundations do not have permanent offices or full-time staff members. Decisions are made by members of the family, the family counsel, or a small group of family and friends. At the other pole are the large *general foundations* like the Ford Foundation, which support a wide variety of activities, and which tend to give most of their money to large, well-established arts organizations. *Community trusts* tend to be more like the large foundations, but with a regional focus. They are made up of smaller foundations whose funds and resources are pooled for greater impact and better management. *Corporate foundations* are set up to dispose of the 5% adjusted gross income which corporations are allowed by law to give away. These foundations support a wide variety of activities, but usually concentrate on one or two specific areas of interest.

With 26,000 foundations to choose from, how do you go about selecting the foundations which you want to approach for money? Fortunately, there are extensive resources for answering this question, ranging from alphabetical listings of all of the foundations in the United States to computerized services which can give you information about foundations in virtually whatever form you want. The important thing is that with 26,000 foundations to choose from you have to narrow the field down so that you approach only those foundations from which you stand a reasonable chance of getting some support. All of this is to say that you have to thoroughly research the subject using the references which are available, and find out as much as you can about the foundations which seem like good bets for you and your organization. Then you must determine how much time, energy, and money you are willing to invest in soliciting funds from these sources.

The place to begin your search, if possible, is at The Foundation Center, which is a nonprofit organization whose function it is to amass and to make available as much information as possible on foundations. The national collections are in New York, in Washington, and in Chicago. "The Foundation Center Collec-

tions" are housed in regional libraries around the country, and I have included a list of these collections at the end of this chapter. A visit to one of these centers is an essential part of one's education in this field. The Foundation Center is a model of efficiency.

The best place to begin your search is by looking in the most recent edition of *The Foundation Grants Index*. This is an index of contributions by the major foundations in the country. It is organized in such a way that you can look first at the foundations in your state to see which of them have given money to arts organizations such as your own. This will provide you with a list of some of the most likely sources for you to approach. The next step will be to check in Section III of the *Index*, "Key Words and Phrases," where you can find out what grants have been given in your field nationally in the previous year. You may find a national foundation which appears to be interested in supporting groups just such as yours.

The Foundation Grants Index: Subjects on Microfiche breaks down current foundation grants into approximately forty categories such as the visual arts, music, dance and theatre, the media. Whether or not you get any additional information that you can use immediately, this breakdown provides invaluable information on who is getting grants in your field, what areas of funding seem to be the most attractive at any given time, and which foundations are the most active in your field. These microfiche cards are available at the centers, where they can be read on "readers" and where xerox copies can be made on the combined "reader/printers." Copies of the microfiche cards in any given area can also be purchased.

The next step will be to look in *The Foundation Directory*, which is the comprehensive listing of over 2500 foundations which either have assets of over one million dollars or award grants of more than $500,000 annually. The *Supplements*, issued semi-annually, should not be overlooked because they include information on smaller foundations. In these directories you want to look in the "Index of Fields of Interest" to find out which foundations have a *stated* interest in your field. This is the other side of the

coin from checking to see which foundations actually gave money in your field.

It is desirable that in the course of your research you familiarize yourself with all of the foundations active in your area. You may just know someone on the board, or on the staff, or have a friend who does. These connections may make it much easier to approach them, even though they may not have given money in your field. The best source of information on this will be the state or regional guides to the foundations in your area. A list of these is included in the appendix to this chapter.

Having narrowed the list of 26,000 foundations down to a manageable number, you can begin your research into the foundations that you have selected. The most informative piece of information that you can get about a foundation is their *annual report*. Unfortunately, fewer than 400 foundations actually distribute annual reports. *The Foundation Directory* indicates which foundations do publish one. You can get the annual reports by writing the foundations, or you can procure microfiche copies of them from The Foundation Center.

If your foundation does not publish an annual report, you can get most of the same information from reports that the foundations are required to file with the government. Form *990-PF* and *990-AR* are both submitted to the IRS annually. From these you'll find addresses, phone numbers, a complete list of grants, assets, trustees, managers, etc. These reports are on aperture cards, which once again can be read using a microfiche reader. Copies of these forms are at the Foundation Centers, and are also on sale from the IRS. Prices are $1 for the first card and $.10 for each card thereafter. Write IRS Center, Box 187, Cornwall Heights, Pa. 19020. Ask for the foundation by name, give the address, and specify the returns that you want. Orders take from one to two months to process, so give yourself plenty of time. You will be billed when the order is processed.

All of this may sound very complicated, but in reality it is simple, though detailed, work. Investing one or two days in researching the source material will familiarize you with the whole system and make subsequent visits a snap. Once you get the basic

information relating to funding in your field, it is desirable to keep yourself informed about new funding programs, new foundations, changes in existing foundations. The best source for this information is *The Foundation News*, which is published six times a year by The Council on Foundations. It is available at $20 per year; write Box 783, Old Chelsea Station, New York, New York 10011. The *Foundation Grants Index* is included as a supplement to *The Foundation News*. Another periodical worth subscribing to is *Fund Raising Management*, Hoke Communications, 224 Seventh Avenue, Garden City, New York 11530. $8 per year. Also recommended is *The Grantsmanship Center News*, published ten times a year by The Grantsmanship Center, 7815 South Vermont Avenue, Los Angeles, California 90044, at $10 per year.

Now if you want to be ritzy about it you can subscribe to a new Foundation Center program called *Centerline* which gives you phone access to all of this information, a research service provided by staff members of the center, as well as a computer search service which will give you information on a computer printout organized by zip code, foundation assets, subject areas, etc., etc. All of these individual services are charged, but if you are heavily into foundation support, and flush, this would be the way to go. Perhaps you can apply for a grant to get this service.

CORPORATE FOUNDATIONS AND CORPORATE CONTRIBUTIONS PROGRAMS

Business support for the arts has more than doubled since 1970. Contributions for 1976 were $221 million, and estimates indicate that this figure is going to continue to rise over the next decade. This is to say that business represents a major source of funding for the arts, and in all likelihood, its significance will increase in the years to come.

Corporate giving is different from either individual gifts or foundation funding in a number of important ways. Individuals may have a love of a particular art, or some personal interest in it, and consequently want to sponsor it, and foundations may have a stated function to support the arts. Corporations on the other hand have another principal activity, and their support of public

charities is a minor part of their organizational activity. Foundations ask whether or not the project deserves support; corporations more or less explicitly ask, "What's in it for us?" "How is your art going to benefit my business?" To some companies, like Pall Mall, the arts confer a desirable image. It is important that their product be associated with something more glamorous than tar, nicotine and cancer. The arts, the new woman, tennis, all fit this image. The mesh may not be quite so neat with other companies. There are of course corporate leaders who are Sunday painters, amateur actors, photographers, who will be likely to support these areas of personal interest, but even these personal desires have to be justified to a board of directors and shareholders. In some cases making peace with the work force encourages corporations to subsidize cultural offerings in-shop, or to make tickets available to employees. At times strong feelings about the value of the arts to the community and to the society motivate giving.

Whatever the reasons, your approach to corporations must be if anything more careful than your first gestures to a foundation. It is essential to do your homework, to find out as much about the company's giving patterns as you can. Find out what other arts groups they have funded. Find out who makes the decisions and what outside affiliations they may have. It is of course desirable to begin with companies that are in your own community. A New Mexico corporation is not likely to be interested in giving money to a chamber music group in Michigan. At the same time, a regional office of a large corporation may not be in a position to make any donations without the approval of the home office. For a start, try to select corporations which are based in your area.

The best contacts are going to friends, or friends of friends, who have contacts with the individuals responsible for the corporate donations. If you have no direct contacts try to find out who would be responsible for this. It could be a committee, the board of directors, the director of public relations, or advertising, or community relations. A few corporations, like Dayton Hudson of Minneapolis have created the position of Director of Cultural Affairs.

One of the critical areas in your approach to a corporation is going to be your financial situation and the budget for your project. Foundations who deal regularly with arts organizations will expect most of them to be on shaky financial grounds. Corporations are not going to be so tolerant. Remember, businessmen spend a good deal of time analyzing projects using detailed financial information, and looking at them from the point of view of profit or loss. What you can do is to assemble your financial data as carefully as you can. Try to pick a specific project for funding, one with which the corporation can hopefully identify itself. This will also make it easier to analyze from their point of view. Be sure to distinguish between requests for operating funds and capital funds. Present financial information as clearly as possible, and in generally accepted formats. Try to select projects that look economically feasible on paper. In drawing up the actual budget be as detailed as possible. The Business Committee for the Arts — which should know about this—suggests making the following distinctions, and clearly explaining references to "operating deficits" which are real expenses less earned income, "net deficits" which are total expenses less earned income and contributions, and "carryover deficits" which are deficits from previous years that have not been made up.

The Business Committee for the Arts (BCA), 1700 Broadway, New York, New York 10019 publishes some useful information on approaching corporations, and is a clearing-house for information related to business contributions to the arts.

Be alert to other possible kinds of contributions. A manufacturing firm may be amenable to providing you with seats that they manufacture, or air-conditioners, or paint, rather than giving you a cash contribution. You may be able to induce an airline to give you free transportation for touring. Advertising agencies, accounting firms, marketing firms may be willing to donate services for a specific project. A number of large corporations are willing to donate the services of retired executives for a year. Local merchants can do advertising for you, sell tickets to your performances, or donate goods. Make a list of business connections that you have and see if they provide either goods or ser-

vices that you use on a regular basis. Try to figure out a plan that would benefit both of you.

The following list of types of corporate giving should prove useful as an outline for thinking about the questions with respect to your particular organization.

Donations
 Cash
 Matching gifts
 Securities
 Goods

Subsidies
 Purchase of tickets
 Sponsoring performances
 Commissioning work

Indirect Subsidies
 Advertising
 Advertising in programs
 Donation programs through employees

Loans
 Personnel
 Space
 Exhibits
 Equipment

Participation
 Attendance at performances or classes
 Membership on board of directors
 Management counselling

THE GOVERNMENT

The third major source of funding for the arts is federal, state, and local governments. The logical place for small, newly founded arts groups to look for funding is with their state or local arts council. They will probably be the most receptive to your appeals, though at the same time they will be the source with the

least money to go around, so grants from them will tend to be small.

The National Endownment for the Arts (NEA, Washington, D.C. 20506) will be giving away on the order of $123.5 million dollars in fiscal 1978. It is likely that this figure will continue to increase in coming years, making them a major contributor to all of the arts. The NEA publishes a comprehensive guide to all of its grants, "Guide to Programs." Reading this short publication is a must for every arts administrator in order to get an overall sense of what programs exist for arts organizations and for individual artists. There is a certain amount of creative proposal writing that one can do from reading this booklet: getting ideas for new projects, figuring out ways of funding old projects, combining projects which can get funded in new funding areas. A theatre, for example, might be eligible to get funds to sponsor a video workshop for its actors conducted by a visiting video artist. Performing arts groups can get money to commission a visual artist to design a poster for them.

In addition to this general brochure there are more detailed pamphlets in each field which give you the specifics for each grant category. Even if you aren't going to apply for a grant this year, it is desirable to get a copy of the brochure for your field to see what information you are going to have to assemble over the course of the next year or so, and what you might have to start doing now in order to be eligible for grants at some future date. The grant applications themselves are good to work from in getting an idea of the kinds of information required, or to give you a format if you are going to be writing free-style grants to other funding sources. (See Appendix C, page 66.)

In my experience, the NEA requires a fair amount of detailed paper work with your grant application, and documentation of the project when it is completed. It is not an impossible bureaucracy by any means. Of course the big money goes to the cultural giants and current cultural heroes, but the staff and the panels are remarkably open-minded and knowledgeable about the fields in which they work. They are willing to take chances on new groups and innovative projects.

A useful publication relating to government funding in the arts is *The Cultural Post*, published by the NEA. It has information on NEA programs, new funding sources, new publications in the art world, arts lobbying, etc. It is well put together, informative, and *free*. Write: *The Cultural Post*, Subscriptions, Program Information, Mail Stop 550, National Endowment for the Arts, Washington, D.C. 20506. Write small and you will be able to fit all of that onto one side of an envelope.

In recent years CETA (Comprehensive Employment and Training Act) has become a major source of funding for the arts. Estimates for 1976 place the figure at $40 million. I have included a fairly detailed account of applying for CETA funds in this chapter. If CETA funds are not being made available to the arts in your locale, you can use the same information to lobby to get CETA funds allocated to the arts.

CETA

The purpose of the Comprehensive Employment and Training Act (CETA) of 1973 is to decentralize the design and delivery of employment and training programs to the state and local government levels. CETA, in effect, transfers control over a large portion of federal revenues to state and local jurisdictions and replaces a variety of federal employment and training programs. This permits planning policy and programs based upon local labor markets by CETA program operators.

CETA is a revenue sharing employment and training program where decisions about the kinds of programs, how money is to be spent, who is to be served, what types of delivery systems are needed, etc., are made at the state and local levels. Employment and training programs are becoming an increasingly visible area of public administration. Labor markets differ in needs, in the degree of unemployment, and in the character of local institutions. This warrants local decision making.

HOW TO APPLY FOR CETA FUNDS

Step 1 — *FIND OUT WHO YOUR PRIME SPONSOR IS.*

In order to apply for CETA funds, the first step is to determine the agency and location for the CETA prime sponsor in your area. To do this, call or write the State Manpower Services Council (SMSC) for your state. A list follows starting on page 36.

Step 2 — Once you have this information, call the prime sponsor and *FIND OUT WHO THE PRIME SPONSOR'S CETA PLANNER IS.*

The CETA planner (or manpower planner) is the key person with whom you will need to deal. Every prime sponsor has identified one or more persons as the planner. This person is generally the major source of CETA information for the prime sponsor. In many instances, the planner will have additional responsibilities other than planning. Also, many planners are administrators and/or decisionmakers for the CETA program as well. Thus, it is extremely important to get to know and keep in general contact with this person.

Step 3 — You should then *MAKE AN APPOINTMENT TO TALK WITH THE PLANNER* as soon as possible.

If your prime sponsor is a local one, you will very probably talk directly with the planner. If your prime sponsor is a consortium or balance of state, you may be instructed by the planner to talk with a designated person in your local jurisdiction rather than directly with the planner.

You should then state that the purposes of the requested meeting are: (a) to introduce your agency to the planners, (b) to determine the prime sponsor's funding cycle, (c) to inquire about the present CETA programs being funded, and (d) to discuss future funding possibilities.

Step 4 — The next step is to *TALK WITH THE PLANNER* about the four areas mentioned in Step 3.

a. In introducing your agency to the planner, you should describe its purpose, size, and functions and activities. Prime sponsors are required by the CETA legislation to serve those members of the community who are unemployed, underemployed,

and/or economically disadvantaged. In order to accomplish this, prime sponsors should work with local agencies and groups representing those target groups. Therefore, you should present your agency in those terms to the planners.

b. The first consideration in determining your next action is the prime sponsor's timetable for making Fiscal Year 1977 funding decisions. This will generally be based on two factors: (1) the prime sponsor's fiscal year or program year dates and (2) the date that funding applications are due in to the prime sponsor.

c. The next consideration is the present funding for CETA in your community. The planner can make a list of services and program operators available to you. This information can help you to draw up a realistic proposal and avoid wasted effort. For example, your organization may have considered requesting funds to set up a comprehensive counseling center. You may find out that such a center already exists. In that case you may decide that your proposal should concentrate on providing additionally needed services to the existing center.

d. If you have a specific funding request in mind, now would be the time to discuss it with the planner. You should describe your funding request both in general terms of what you want funded and why, and of funds required, the exact types of service to be provided, the significant segments (taget groups) you will serve, and other pertinent information.

Probably the most important part of this discussion is *why* you want to receive CETA funds. It is critical to establish the need to obtain funding since the prime sponsor must justify the funding requests made to the Department of Labor in terms of meeting communities' employment and training needs. Therefore, if you can demonstrate to the prime sponsor the extent to which you will be serving the unemployed, underemployed, and/or disadvantaged through your funding proposal, you will be that much ahead in the process.

Step 5 — After you have had this preliminary introduction to

CETA and to the CETA planner, you should *BECOME FAMIL-IAR WITH CETA IN YOUR AREA.*

Since CETA is becoming more integrated into the local governmental structure, it generally facilitates your ability to work with CETA if you know how to work with the political system of which CETA is a part.

Step 6 — In order to have specific input, you should *FIND OUT THE CETA FUNDING PROCESS FOR YOUR AREA.*

Once again, the planner would be your key contact for this information. There are many variations of funding methods used by prime sponsors. Some fund programs only once a year, others fund incrementally throughout the year. Some have a contingency fund in the event new proposals are brought to their attention.

Step 7 — After you find out the methods and schedules for funding, you should *DETERMINE THE METHOD FOR SUBMITTING YOUR FUNDING APPLICATION.*

This, of course, depends on the information previously obtained. The most important consideration is to follow the prime sponsor's guidance in this area. However, you should be aware of your other options as well. Generally, there will be four ways to submit proposals: answer an RFP, prepare a presentation to be made at a public hearing, submit an unsolicited proposal — and make a direct presentation to the governing body for your jurisdiction.

Step 8 — After you know which method you will use, you should then *COMPLETE AND SUBMIT YOUR APPLICATION.*

The two most important considerations here are timeliness and thoroughness. Your request should build from the justification for funding based on fulfilling a community need to serve unemployed, underemployed, and/or disadvantaged significant segments and continue from there. Also, the prime sponsor will very probably provide you with instructions on completing funding applications.

Step 9 — The final step, Step 9, is *BE VISIBLE AND ACTIVE ON A YEAR-ROUND BASIS.*

If you are funded, congratulations! If you are not funded, don't give up.

(Information derived from "A Guide to Seeking Funds from CETA", U.S. Department of Labor.)

CETA

STATE MANPOWER SERVICES COUNCIL CONTACTS

REGION I — Boston, Massachusetts

Regional Administrator for ETA
U.S. Department of Labor
Rm. 1703, JFK Building
Boston, Mass. 02203

Connecticut	Labor Department 200 Folly Brook Boulevard Wethersfield, Conn. 06109
Massachusetts	Executive Office of Economic Affairs Hurley Building Government Center Boston, Mass. 02114
New Hampshire	Office of Manpower Affairs P.O. Box 1477 Concord, N.H. 03301
Vermont	Office of Manpower Services 79 River Street Montpelier, Vt. 05602
Rhode Island	Division of Job Development and Training 1 Weybosset Hill Providence, R.I. 02908

Maine

Office of CETA Planning
 and Coordination
8 Crosby Street
Augusta, Maine 04330

REGION II — New York, New York

Regional Administrator for ETA
U.S. Department of Labor
Rm. 3713
1515 Broadway
New York, N.Y. 10036

New York

New York State Department of Labor
State Campus Building No. 12
Rm. 563
Albany, N.Y. 12226

New Jersey

Labor Department
Labor and Industry Building
John Fitch Plaza, Rm. 1007
Trenton, N.J. 08625

Puerto Rico

Right to Employment Administration
Avenida Ramon B. Lopez, Esq. Lealtad
Rio Piedras, Puerto Rico 00923

Virgin Islands

Cooperative Area Manpower
 Planning System
P.O. Box 599
Charlotte Amalie
St. Thomas, Virgin Islands 00801

REGION III — Philadelphia, Pennsylvania

Regional Administrator for ETA
U.S. Department of Labor
P.O. Box 8796
Philadelphia, Pa. 19101

Pennsylvania
State Manpower Services Council
Department of Labor and Industry
1700 Labor and Industry Building
Harrisburg, Pa. 17120

Virginia
Governor's Manpower Services Council
Office of the Governor
Richmond, Va. 23212

Delaware
State Manpower Planning Council
701 Shipley Street
Wilmington, Del. 19801

District of Columbia
D.C. Manpower Administration
District Building, Rm. 220
14th and E Streets N.W.
Washington, D.C. 20004

Maryland
State Manpower Planning Council
1100 North Eutaw Street
Baltimore, Md. 21201

West Virginia
Governor's Manpower Director
State of West Virginia
1703 E. Washington Street
Charleston, W.Va. 25305

REGION IV — Atlanta, Georgia

Regional Administrator for ETA
U.S. Department of Labor
Rm. 405
1371 Peachtree St. N.E.
Atlanta, Ga. 30309

Alabama
State Manpower Planning Staff
Rm. 279
Department of Industrial Relations
Industrial Relations Building
Montgomery, Ala. 36104

Florida	State Manpower Council 1720 South Gadsden Street Tallahassee, Fla. 32301
Georgia	Deputy Director for Manpower of the Employment Security Agency Rm. 525 501 Pulliam St. S.W. Atlanta, Ga. 30312
Kentucky	Kentucky Manpower Council 2nd Floor State Office Building Frankfort, Ky. 40601
Mississippi	Office of the Governor — Education and Training 3825 Ridgewood Road Suite 182, Universities Center Jackson, Miss. 39211
South Carolina	Chairman, State Manpower Planning Council P.O. Box 11450 Columbia, S.C. 29211
North Carolina	Chairman, North Carolina Manpower Services Council P.O. Box 1350 Raleigh, N.C. 27602
Tennessee	Manpower Planning Director State of Tennessee 1027 Andrew Jackson Building Nashville, Tenn. 37219

REGION V — Chicago, Illinois

Regional Administrator for ETA
U.S. Department of Labor

6th Floor
230 South Dearborn
Chicago, Ill. 60604

Michigan	Director, Michigan Department of Labor c/o State Manpower Services Council 300 East Michigan Avenue Lansing, Mich. 48926
Ohio	Governor, State of Ohio c/o State Manpower Services Council State House Broad and High Streets Columbus, Ohio 43215
Illinois	Governor, State of Illinois c/o State Manpower Services Council State Office Building Springfield, Ill. 62706
Minnesota	CETA State Manpower Services Council Office of the Governor St. Paul, Minn. 55155
Wisconsin	Governor of Wisconsin c/o State Manpower Services Council State Capitol Building Madison, Wis. 53702
Indiana	Indiana Office of Manpower Development 150 W. Market Street Indianapolis, Ind. 46204

REGION VI — Dallas, Texas

Regional Administrator for ETA
U.S. Department of Labor
Room 316
555 Griffin Square Building
Dallas, Tex. 75202

Arkansas

CETA State Manpower Services Council
2020 West Third Street
Executive Building
Little Rock, Ark. 72201

Louisiana

Governor of Louisiana
c/o State Manpower Services Council
Baton Rouge, La. 70804

New Mexico

Executive Director, OMA
P.O. Box 4218
Santa Fe, N. Mex. 87105

Oklahoma

Manpower Planning and Coordination
3033 North Walnut
Oklahoma City, Okla. 73105

Texas

Chief, Human Resource Section
Governor's Division of Planning
 and Coordination
311 East 14th Street
Austin, Tex. 78701

REGION VII — Kansas City, Missouri

Regional Administrator for ETA
U.S. Department of Labor
Federal Building, Rm. 1000
911 Walnut Street
Kansas City, Mo. 64106

Iowa

Office for Planning and Programming
523 East 12th Street
Des Moines, Iowa 50319

Nebraska

CETA State Manpower Services Council
P.O. Box 94600, State House Station
Lincoln, Nebr. 68509

Missouri	Governor's Manpower Section 226 East Dunklin Street Jefferson City, Mo. 65101
Kansas	State Manpower Administrator Governor's Committee on Manpower 535 Kansas Avenue, Ninth Floor Topeka, Kans. 66603

REGION VIII — *Denver, Colorado*

Regional Administrator for ETA
U.S. Department of Labor
16122 Federal Office Building
1961 Stout Street
Denver, Colo. 80202

Colorado	Director, State Manpower Office 770 Grant Street, Room 208 Denver, Colo. 80203
Montana	Montana Manpower Planning Advisory Council Governor's Office — State Capitol Helena, Mont. 59601
Utah	State Planning Coordinator Utah Manpower Planning Council Room 118, Capitol Building Salt Lake City, Utah 84114
North Dakota	CETA Administrator Office of the Governor State Capitol Building Bismarck, N. Dak. 58501
South Dakota	Department of Manpower Affairs State Office Building No. 2 Pierre, S. Dak. 57501

Wyoming

Wyoming State Planning Council
2103 Warren Avenue
Cheyenne, Wyo. 82001

REGION IX — San Francisco, California

Regional Administrator for ETA
U.S. Department of Labor
Box 36084
San Francisco, Calif. 94102

California

State Manpower Planning Office M177
800 Capitol Mall
Sacramento, Calif. 95814

American Samoa

Government of American Samoa
Department of Manpower Resources
Pago Pago, American Samoa 96799

Arizona

State of Arizona
c/o State Manpower Services Council
Department of Economic Security
1717 West Jefferson
P.O. Box 6123
Phoenix, Ariz. 85007

Guam

Office of the Governor
c/o State Manpower Services Council
P.O. Box 2950
Agana, Guam 96910

Hawaii

Hawaii State Manpower Planning Council
567 South King Street
Honolulu, Hawaii 96813

Nevada

State Manpower Services Council
State Capitol Building
Carson City, Nev. 89701

REGION X — Seattle, Washington

Regional Administrator for ETA
U.S. Department of Labor
Room 1145, Federal Office Building
909 First Avenue
Seattle, Wash. 98174

Alaska	Commissioner of Labor Manpower Planning Director P.O. Box 1149 Juneau, Alaska 99801
Idaho	Human Resources Development Council State House Boise, Idaho 83707
Oregon	Governor's Manpower Planning Council 772 Commercial Street S.E. Salem, Oreg. 93710
Washington	Employment Development Services Council Office of Community Development General Administration Building 2nd Floor, Room 208 Olympia, Wash. 98504

There are innumerable government programs from which you might be able to secure funds as an arts organization. Funding of this sort usually involves large sums of money, and is generally given to well-established organizations. While the stakes are high, the cost of procuring the funds is also high. It is not a logical place for a small arts organization to start looking. Should you be interested in this type of funding, or perhaps just in staying informed about what programs are available, the *Catalog of Federal Domestic Assistance* is sold on a subscription basis by the

Superintendent of Documents, U.S. Government Printing Office, Washington, D.C. 20402. The cost is $7 per year.

GRANT WRITING

Having singled out the foundations, corporations, individuals, or government agencies that are most likely to fund you, it is important to sit down and ask yourselves a number of very significant questions. First, is your group in a position to get funding from the sources that you have selected based on your current position and your past history. It is, for example, unlikely that a large foundation is going to give a million dollar grant to an amateur, community symphony in its first year of operation. The other side of this coin is being overly modest and feeling too insignificant to warrant serious attention from major funding sources. You want to make sure that your timing is right in terms of the development of your organization. Prove to yourself that you do indeed deserve to be considered for funding. Second, can you prove your stability and fiscal responsibility and worth on paper. Try to detach yourself and to look at your assembled materials as a critical outsider would. How does it look? Third, are you asking for the proper amount of funding. If you have a $50,000 budget and are asking for a quarter of a million dollars, a foundation might feel uncomfortable subsidizing so much of your program. Funding sources are also leery of creating permanent, dependent relationships. On the other hand, are you thinking of asking for too little, cutting too many corners, being too cheap with yourselves? Fourth, is there a real need for your project? Are others doing the identical work, and fulfilling those needs? Fifth, can you pull it off, and successfully complete the project?

If you can answer these five questions in the affirmative you should proceed to approach your funding sources. With private foundations, corporations, or individual donors I suggest that you begin the process with a letter, on your organization's stationery, addressed to the proper grants officer or corporate officer who deals with grant requests such as yours. The letter should include a brief, simple statement describing the project that you have

45

in mind, your reasons for approaching this particular funding source, and the amount of money that you are requesting. State that you are interested in making a formal application, if it is felt that it is desirable for you to do so. If you are fairly certain that the foundation funds activities like yours, request a meeting. By making this first approach short and simple you give the funding source a chance to tell you right away, before you have invested a lot of time and money working on the application, whether or not there is some chance that you will be funded.

If your funding source is still interested after this initial letter, try to set up a meeting with one of the grants officers to talk about your proposal in more detail. At this meeting try to have a more specific budget for the project and go into the details of the project itself. It is better to find out at this stage if there is something about your project that the funding source objects to, can't fund, whatever. You can also get a "feeling" for their interests, priorities, biases, and general orientation. These details that you pick up at this point could prove critical in the response to your final proposal.

If interest is still shown, you are in a position to proceed. In the case of the NEA and many state and local arts councils, forms will be standardized. The information below will still be relevant. If you are making up the format here is a simple, straightforward form to follow, and some things to keep in mind while you are composing and assembling your application.

The Cover Letter

- This letter should reiterate the history of the proposal, stating how you came into contact with the corporation or foundation, what contacts you have had, with whom you have had discussions. It should be brief and on your organization's letterhead.

The Proposal

- An outline of the project stated simply and concisely.

- An indication of the need for the project and its importance to the community, to the art, etc. Avoid hyperbole.

- Indicate how the project is unique, different, or superior.

- Make it clear that your timing is right for working on this project.

Financing

- On separate sheets include financial statements for the three previous years, and a projected budget for the succeeding year, as well as any other years covered by the project.

- Budgets should be clear and in acceptable form for your readers. They should give a complete financial picture of your organization without unnecessary detail.

- Separate budgets for the project. Indicate not only expenses but anticipated income and funds from other sources.

- Indicate on the project budget how, if possible, the project will become self-sustaining.

Personnel

- A listing of the positions that will be funded, an explanation of each position, and the responsibilities and experience required for each job.

- Resumes for the staff for each of the key positions in the project.

- Resumes for all of the principals in your organization.

Additional Information

- A copy of your organization's federal tax exemption.

- A copy of your by-laws or articles of incorporation.
- A list of the board of directors.
- Reviews, mailing pieces, posters.

Having assembled all of this information, try to look at your proposal critically and objectively. What have you omitted? What is vague? What sounds apologetic or uncertain? What questions does your application raise? An experienced foundation officer uses the following criteria for evaluating grant applications. Analyze your application in these terms.

Qualifications of the Personnel

- Do they have the backgrounds and the experience to complete the project.
- Are their references good.
- Are the supervisors within the organization qualified.

Feasibility of the Proposal

- Is their timing right.
- Is their analysis of the problem accurate.
- Is their solution the right one.
- Are they genuinely enthusiastic about the project.
- Do they have the personnel to complete the project.
- Do they have the facilities.

Importance of the Project to the Community and Society

- Is there a real need for the project.
- Who will benefit from the project.
- What are the implications for the community, the society, if the project fails.

Inventiveness of the Project

- Are these needs being met elsewhere.

- Is it a duplication of other projects and other services that already exist.

- Is it original or innovative.

- Could someone else do it better.

Foundation or Corporate Goals

- Is the project consistent with the stated goals and interests of this foundation or corporation.

- Is it a high priority activity.

Agency Goals

- Is the project consistent with the stated goals and interests of the agency.

- Is it a high priority activity.

- Will the successful completion of the project have wider implications in the field.

- Will any part of the project be applicable to other fields or other projects.

Financing

- Will this project attract support from the community, other foundations, corporations, or individuals.

- Could these other sources provide the funding for the project in its entirety.

- Is it more logical for them to fund this project.

- Is the budget too large, too small, wasteful, inadequate.

- Does the budget allow for over-run costs.

Project Evaluation

- Is it well planned.

- Will effective records be kept.

- Have evaluative mechanisms been built into the project.

- Who will be able to evaluate the project.

Two fine pamphlets to look at are, "What Makes a Good Proposal" by F. Lee Jacquette and Barbara L. Jacquette and "What Will a Foundation Look For When You Submit a Grant Proposal?" by Robert A. Mayer. Both pamphlets are published by The Foundation Center. Also check to see if your foundation, corporation, agency has such a publiation of their own.

Whether your grant application is approved, rejected, or partially funded, you have invested a good deal of time in establishing this relationship. Unless you get the feeling that the funding source is simply not interested in your work, try to sustain the relationship. Put key personnel from the funding source on your mailing list. Keep them informed about your activities. Invite them to openings, exhibits, performances, previews. Try to keep them engaged in your work. Remember, the foundation may have been short of funds when they rejected your proposal, or they might have been interested but wanted more information about you. They may fund your project the next time around.

If you have received a grant, you are now in a position to try to attract other funding on the basis of this grant. Even if the funding won't be directly applicable to the project, the grant itself is a seal of approval from your sponsor. Use it. Begin right away to identify new, potential funding sources. Start thinking about deferred giving programs and endowment funds. Don't sit back on your heels now; you are just starting.

Appendix A

THE FOUNDATION CENTER COLLECTIONS

NATIONAL COLLECTIONS

The Foundation Center
888 Seventh Avenue
New York, New York 10019

The Foundation Center
1001 Connecticut Avenue, N.W.
Washington, D.C. 20036

REGIONAL COLLECTIONS

Geographical Coverage

ALABAMA
Birmingham Public Library
2020 Seventh Avenue, North
Birmingham 35203

Alabama

ARKANSAS
Little Rock Public Library

Arkansas

Reference Department
700 Louisiana Street
Little Rock 72201

CALIFORNIA
University Research Library *California*
Reference Department
University of California
Los Angeles 90024

San Francisco Public Library *Alaska, Arizona, California,*
Business Branch · *Colorado, Hawaii, Idaho,*
530 Kearny Street *Montana, Nevada, Oregon,*
San Francisco 94108 *Utah, Washington*

COLORADO
Denver Public Library *Colorado*
Sociology Division
1357 Broadway
Denver 80203

CONNECTICUT
Hartford Public Library *Connecticut*
Reference Department
500 Main Street
Hartford 06103

FLORIDA
Jacksonville Public Library *Florida*
Business, Science and Industry Department
122 North Ocean Street
Jacksonville 32202

Miami-Dade Public Library *Florida*
Florida Collection
One Biscayne Boulevard
Miami 33132

GEORGIA
Atlanta Public Library *Alabama, Florida, Georgia,*

126 Carnegie Way, N.W.
Atlanta 30303

*Kentucky South Carolina,
Tennessee*

HAWAII
Thomas Hale Hamilton Library
Humanities and Social Sciences Division
2550 The Mall
Honolulu 96822

Hawaii

IDAHO
Caldwell Public Library
1010 Dearborn Street
Caldwell 83605

Idaho

ILLINOIS
Donors' Forum
208 South La Salle Street
Chicago 60604

National

INDIANA
Indianapolis — Marion County Public Library
40 East St. Clair Street
Indianapolis 46204

Indiana

IOWA
Des Moines Public Library
100 Locust Street
Des Moines 50309

Iowa

KANSAS
Topeka Public Library
Adult Services Department
1515 West Tenth Street
Topeka 66604

Kansas

KENTUCKY
Louisville Free Public Library
Fourth and York Streets
Louisville 40203

Kentucky

LOUISIANA
New Orleans Public Library *Louisiana*
Business and Science Division
219 Loyola Avenue
New Orleans 70140

MAINE
University of Maine at Portland-Gorham *Maine*
Center for Research and Advanced Study
246 Deering Avenue
Portland 04102

MARYLAND
Enoch Pratt Free Library *Maryland, District of Columbia*
Social Science and History Department
400 Cathedral Street
Baltimore 21201

MASSACHUSETTS
Associated Foundation of Greater Boston *Massachusetts*
One Boston Place, Suite 948
Boston 02108

Boston Public Library *Massachusetts*
Copley Square
Boston 02117

MICHIGAN
Henry Ford Centennial Library *Michigan*
15301 Michigan Avenue
Dearborn 48126

Grand Rapids Public Library *Michigan*
Sociology and Education Department
Library Plaza
Grand Rapids 49502

MINNESOTA
Minneapolis Public Library *Minnesota, North Dakota,*
Sociology Department *South Dakota*

300 Nicollet Mall
Minneapolis 55401

MISSISSIPPI
Jackson Metropolitan Library *Mississippi*
301 North State Street
Jackson 39201

MISSOURI
Kansas City Public Library *Kansas, Missouri*
311 East 12th Street
Kansas City 64106

The Danforth Foundation Library *Missouri*
22 South Central Avenue
St. Louis 63105

MONTANA
Eastern Montana College Library *Montana*
Reference Department
Billings 59101

NEBRASKA
Omaha Public Library *Nebraska*
1823 Harney Street
Omaha 68102

NEW HAMPSHIRE
The New Hampshire Charitable Fund *New Hampshire*
One South Street
Concord 03301

NEW JERSEY
New Jersey State Library *New Jersey*
Reference Section
185 West State Street
Trenton 08625

NEW MEXICO
New Mexico State Library *New Mexico*

300 Don Gaspar Street
Santa Fe 87501

NEW YORK
New York State Library *New York*
State Education Department
Education Building
Albany 12224

Buffalo and Erie County Public Library *New York*
Lafayette Square
Buffalo 14203

Levittown Public Library *New York*
Reference Department
One Bluegrass Lane
Levittown 11756

Rochester Public Library *New York*
Business and Social Sciences Division
115 South Avenue
Rochester 14604

NORTH CAROLINA
William R. Perkins Library *North Carolina*
Duke University
Durham 27706

OHIO
The Cleveland Foundation Library *Michigan, Ohio,*
700 National City Bank Building *Pennsylvania,*
Cleveland 44114 *West Virginia*

OKLAHOMA
Oklahoma City Community Foundation *Oklahoma*
1300 North Broadway
Oklahoma City 73103

Tulsa City-County Library System *Oklahoma*

400 Civic Center
Tulsa 74103

OREGON
Library Association of Portland *Oregon*
Education and Psychology Department
801 S.W. Tenth Avenue
Portland 97205

PENNSYLVANIA
The Free Library of Philadelphia *Delaware, Pennsylvania*
Logan Square
Philadelphia 19103

Hillman Library *Pennsylvania*
University of Pittsburgh
Pittsburgh 15213

PUERTO RICO Selected foundations
Consumer Education and Service Center
Department of Consumer Affairs
Commonwealth of Puerto Rico
P.O. Box 41059, Minillas Station
Santurce, Puerto Rico 00940

RHODE ISLAND
Providence Public Library *Rhode Island*
Reference Department
150 Empire Street
Providence 02903

SOUTH CAROLINA
South Carolina State Library *South Carolina*
Reader Services Department
1500 Senate Street
Columbia 29211

TENNESSEE
Memphis Public Library *Tennessee*

1850 Peabody Avenue
Memphis 38104

TEXAS
The Hogg Foundaton for Mental Health *Texas*
The University of Texas
Austin 78712

Dallas Public Library *Texas*
History and Social Sciences Division
1954 Commerce Street
Dallas 75201

Minnie Stevens Piper Foundation *Texas*
201 North St. Mary's Street
San Antonio 78205

UTAH
Salt Lake City Public Library *Utah*
Information and Adult Services
209 East Fifth Street
Salt Lake City 84111

VERMONT
State of Vermont Department of Libraries *Vermont*
Reference Services Unit
111 State Street
Montpelier 05602

VIRGINIA
Richmond Public Library *Virginia*
Business, Science, & Technology Department
101 East Franklin Street
Richmond 23219

WASHINGTON
Seattle Public Library *Washington*
1000 Fourth Avenue
Seattle 98104

WEST VIRGINIA
Kanawha County Public Library *West Virginia*
123 Capitol Street
Charleston 25301

WISCONSIN
Marquette University Memorial Library *Illinois, Wisconsin*
1415 West Wisconsin Avenue
Milwaukee 53233

WYOMING
I aramie County Community College Library *Wyoming*
1400 East College Drive
Cheyenne 82001

From *About Foundations*, The Foundation Center.

Appendix B

STATE FOUNDATION DIRECTORIES

ALABAMA (126 foundations)
A GUIDE TO FOUNDATIONS OF THE SOUTHEAST. Volume IV: Alabama, Arkansas, Louisiana, Mississippi. Edited by Jerry C. Davis. April 1976. viii, 165 p. Based on 1973 and 1974 990-PF and 990-AR returns filed with the IRS. Available from Davis-Taylor Associates, Route 3, Box 289, Mt. Morgan Road, Williamsburg, Kentucky 40769. $25.00.

ARKANSAS (104 foundations).
See Alabama.

CALIFORNIA (335 foundations).
GUIDE TO CALIFORNIA FOUNDATIONS. Prepared by Susan Clark Robinson, Patricia Tobey, and Mary Anna Colwell. 1976. viii, 235 p. Based on data from co-operating foundations

or from 1974 records in the California Attorney-General's Office. Available from The San Mateo Foundation, 1204 Burlingame Avenue, Room 10, Burlingame, California 94010. $4.00 prepaid.

CONNECTICUT (590 foundations).
A DIRECTORY OF FOUNDATIONS IN THE STATE OF CONNECTICUT. 3rd edition. Edited by John Parker Huber. 1976. xv, 168 p. Based on 1973 990-PF and 990-AR returns filed with the IRS. Available from Eastern Connecticut State College Foundation, Inc., P.O. Box 431, Willimantic, Connecticut 06226. $7.00 prepaid; otherwise $8.00.

DISTRICT OF COLUMBIA (282 foundations).
THE GUIDE TO WASHINGTON, D.C. FOUNDATIONS. 2nd edition. Edited by Francis de Bettencourt. 1975. x, 58 p. Based on 1973 990-PF and 990-AR returns filed with the IRS. Available from Guide Publishers, P.O. Box 5849, Washington, D.C. 20014. $8.00.

FLORIDA (487 foundations)
A GUIDE TO THE FOUNDATIONS OF THE SOUTHEAST. Volume III: Georgia and Florida. Edited by Jerry C. Davis. 1975. 309 p. Based on 1973 and 1974 990-PF and 990-AR returns filed with the IRS. Available from Davis-Taylor Associates, Inc., Route 3, Box 289, Mt. Morgan Road, Williamsburg, Kentucky 40769. $25.00

GEORGIA (340 foundations).
See Florida.

ILLINOIS (319 foundations).
ILLINOIS FOUNDATION PROFILES. Edited by James H. Taylor. 1976. vi, 99 p. Based on 1973 and 1974 990-PF and 990-AR returns filed with the IRS. Available from Davis-Taylor Associates, Inc., Route 3, Box 289, Mt. Morgan Road, Williamsburg, Kentucky 40769. $29.95.

INDIANA (334 foundations).

A GUIDE TO INDIANA FOUNDATIONS. Edited by James H. Taylor. 1975. vii, 111 p. Based on 1973 and 1974 990-PF and 990-AR returns filed with the IRS. Available from Davis-Taylor Associates, Inc., Route 3, Box 289, Mt. Morgan Road, Williamsburg, Kentucky 40769. $29.95.

KANSAS (205 foundations).

DIRECTORY OF KANSAS FOUNDATIONS. Edited by Jeannine A. Cansler. 1975. Based on 1973 990-PF and 990-AR returns filed with the IRS. Available from the Association of Community Arts Councils of Kansas, 117 West Tenth Street, Suite 100, Topeka, Kansas 66612. $1.25.

KENTUCKY (119 foundations).

A GUIDE TO FOUNDATIONS OF THE SOUTHEAST. Volume 1: Kentucky, Tennessee, Virginia. Edited by Jerry C. Davis. 1975. viii, 255 p. Based on 1973 and 1974 990-PF and 990-AR returns filed with the IRS. Available from Davis-Taylor Associates, Inc., Route 3, Box 289, Mt. Morgan Road, Williamsburg, Kentucky 40769. $25.00.

LOUISIANA (172 foundations).
See ALABAMA.

MAINE (62 foundations).
DIRECTORY OF MAINE FOUNDATIONS. 2nd edition. Edited by John Parker Huber. 1975. i, 27 p. Based on 1973 990-PF and 990-AR returns filed with the IRS. Available from Eastern Connecticut State College Foundation, Inc., P.O. Box 431, Willimantic, Connecticut 06226. $5.00 prepaid.

MARYLAND (278 foundations).
1975 ANNUAL INDEX FOUNDATION REPORTS. [August 9, 1976]. 33 p. Based on 1975 990-RF and 990-AR returns received by the Maryland State Attorney-General's Office. Available from

the Office of the Attorney-General, One South Calvert Street, 14th Floor, Baltimore, Maryland 21202. $3.20.

MASSACHUSETTS (998 foundations).
A DIRECTORY OF FOUNDATIONS IN THE COMMON-WEALTH OF MASSACHUSETTS. Edited by John Parker Huber. 1974. xii, 158 p. Based on 1971 990-PF and 990-AR returns filed with the IRS. Available from Eastern Connecticut State College Foundation, Inc., P.O. Box 431, Willimantic, Connecticut 06226. $11.00 prepaid.

MASSACHUSETTS (47 Boston Area foundations).
DIRECTORY OF THE MAJOR GREATER BOSTON FOUNDATIONS. 1974. 42 p. Based on 1972 990-PF and 990-AR returns filed with the IRS. Available from J. F. Gray Company, P.O. Box 748, Islington Station, Westwood, Massachusetts 02090. $14.95 plus postage.

MICHIGAN (267 foundations).
MICHIGAN FOUNDATION DIRECTORY. 1st edition. Prepared by the Council of Michigan Foundations [and] Michigan League for Human Services. 1976. vii, 70 p. Based on 1972-75 returns filed with the IRS. Available from the Michigan League for Human Services, 200 Mill Street, Lansing, Michigan 48933. $5.00 prepaid.

MICHIGAN (696 foundations).
DIRECTORY OF FOUNDATIONS IN THE STATE OF MICHIGAN. Edited by Janet C. Huber. 1974. ix, 123 p. Based on 1972 990-PF and 990-AR returns filed with the IRS. Available from the Dunham Pond Press, Storrs, Connecticut 06268. $10.00.

MINNESOTA (55 foundations).
MINNESOTA FOUNDATION DIRECTORY III. GUIDELINES AND DEADLINES. Edited by Beatrice J. Capriotti. 1975. iii, 105 p. Based on data from cooperating foundations or from 1973,

1974, or 1975 returns filed with the IRS. Available from Minnesota Foundation Directory III, Suite 305, Peavey Building, Minneapolis, Minnesota 55402. $50.00.

MISSISSIPPI (68 foundations).
See ALABAMA.

NEW HAMPSHIRE (138 foundations).
A DIRECTORY OF FOUNDATIONS IN THE STATE OF NEW HAMPSHIRE. 2nd edition. Edited by John Parker Huber. 1975. Based on 1973 990-PF and 990-AR returns filed with the IRS. Available from Eastern Connecticut State College Foundation, Inc., P.O. Box 431, Willimantic, Connecticut 06226. $5.00 prepaid.

NEW HAMPSHIRE (approximately 400 foundations).
DIRECTORY OF CHARITABLE FUNDS IN NEW HAMPSHIRE. 3rd edition. June 1976. Based on 1974-75 records in the New Hampshire Attorney-General's Office. Available from the Office of the Attorney-General, State House Annex, Concord, New Hampshire 03301. $2.00.

NORTH CAROLINA (415 foundations).
A GUIDE TO FOUNDATIONS OF THE SOUTHEAST. Volume II: North Carolina, South Carolina. Edited by Jerry C. Davis. 1975. x, 200 p. Based on 1973 and 1974 990-PF and 990-AR returns filed with the IRS. Available from Davis-Taylor Associates, Route 3, Box 289, Mt. Morgan Road, Williamsburg, Kentucky 40769. $25.00.

OHIO (2500 foundations).
CHARITABLE FOUNDATIONS DIRECTORY OF OHIO. 2nd edition. 1975. 135 p. Based on 1971-75 records in the Ohio Attorney-General's Office. Available from the Office of the Attorney-General, 30 East Broad Street, 15th Floor, Columbus, Ohio 43215. prepaid. $4.00.

OKLAHOMA (269 foundations).
DIRECTORY OF OKLAHOMA FOUNDATIONS. Edited by Thomas E. Broce. 1974, vii, 304 p. Based on data from cooperating foundations or from 1971 and 1972 990-PF and 990-AR returns filed with the IRS. Available from University of Oklahoma Press, 1005 Asp Avenue, Norman, Oklahoma 73069. $9.95.

OREGON (331 foundations).
DIRECTORY OF FOUNDATIONS AND CHARITABLE TRUSTS REGISTERED IN OREGON. Edited and compiled by Virgil D. Mills. Based on 1972 records in the Oregon Attorney-General's Office. Available from the Department of Justice, 555 State Office Building, 1400 S.W. Fifth Avenue, Portland, Oregon 97201. $5.00 prepaid.

PENNSYLVANIA (approximately 1,200 foundations).
DIRECTORY OF CHARITABLE ORGANIZATIONS 1974. April 1974. v, 149 p. Based on records in the Pennsylvania Attorney-General's Office. Available from the Office of the Attorney-General, Capitol Annex, Harrisburg, Pennsylvania 17120. Out of print.

RHODE ISLAND (117 foundations).
A DIRECTORY OF FOUNDATIONS IN THE STATE OF RHODE ISLAND. 2nd edition. Edited by John Parker Huber. 1975. i, 39 p. Based on 1973 990-PF and 990-AR returns filed with the IRS. Available from Eastern Connecticut State College Foundation, Inc., P.O. Box 431, Willimantic, Connecticut 06226. $5.00 prepaid.

SOUTH CAROLINA (131 foundations).
See NORTH CAROLINA.

TENNESSEE (238 foundations).
See KENTUCKY.

TEXAS (1020 foundations).
DIRECTORY OF TEXAS FOUNDATIONS. Compiled and edited by William J. Hooper. 1976. vi, 180 p. Based on 1974 data from cooperating foundations or 990-PF and 990-AR returns filed with the IRS. Available from Texas Foundations Research Center, 306 West 29th Street, Austin, Texas 78705. $10.95 prepaid.

TEXAS (214 foundations).
THE GUIDE TO TEXAS FOUNDATIONS. 1975. 104 p. Based on data from cooperating foundations or from 1973 and 1974 records in the Texas Attorney-General's Office. Available from the Southern Resource Center, P.O. Box 5593, Dallas, Texas 75222. $7.50 (includes postage and handling).

VERMONT (41 foundations).
A DIRECTORY OF FOUNDATIONS IN THE STATE OF VERMONT. Edited by Denise M. McGovern. 1975. i, 24 p. Based on 1972 990-PF and 990-AR returns filed with the IRS. Available from Eastern Connecticut State College Foundation, Inc., P.O. Box 431, Willimantic, Connecticut 06226. $3.00 prepaid.

VIRGINIA (319 foundations).
See KENTUCKY.

WASHINGTON (458 foundations).
CHARITABLE TRUST DIRECTORY. 1975. 92 p. Based on 1974 records in the Washington Attorney-General's Office. Available from the Office of the Attorney-General, Temple of Justice, Olympia, Washington 98504. $3.00 prepaid.

WISCONSIN (700 foundations).
FOUNDATIONS IN WISCONSIN: A DIRECTORY. Compiled by Barbara Szyszko. 1976. xiii, 263 p. Based on 1974 990-PF and 990-AR returns filed with the IRS. Available from Marquette University Memorial Library. 1415 West Wisconsin Avenue, Mil-

waukee, Wisconsin 53233. $10.00 prepaid.

Compiled by Lesley M. Stern, Librarian, The Foundation Center.

Appendix C

PROJECT GRANT APPLICATION
National Endowment for the Arts

Applications must be presented in triplicate and mailed to the Grants Office (Mail stop 500), National Endowment for the Arts. Washington, D.C. 20506.

I. Applicant Organization — (name and address with zip)

II. Visual Arts Program
 Category

III. Period of Support requested

Start_____
 Month Day Year

End_____
 Month Day Year

IV. Summary of Project Description

V. Estimated Number of Persons expected to Benefit
From this Project

VI. Summary of Estimated Costs
(Recapitulation of Budget Items in Section IX)

Total Costs of Project
(rounded to nearest
ten dollars)

A. Direct Costs

Salaries and Wages _____ $ _____

Fringe Benefits _____ $ _____

Supplies and Materials _____ $ _____

Travel _____ $ _____

Special _____ $ _____

Other _____ $ _____

Total direct costs _____ $ _____

B. Indirect Costs _____ $ _____

Total Project Costs _____ $ _____

VII. Total Amount Requested From the
National Endowment for the Arts _____ $ _____

VIII. Organization Total Fiscal Activity

 A. Expenses

 Act. Most Recent Fiscal Pd.

 1. $ _____

 Est. For Next Fiscal Pd.

 2. $ _____

 B. Revenues, Grants, and Contributions

 Act. Most Recent Fiscal Pd.

 1. $ _____

 Est. For Next Fiscal Pd.

 2. $ _____

IX. Budget Breakdown of Total Estimated Costs of Projects

 A. Direct Costs

 1. Salaries and Wages

 Details not required when requesting $10,000 or less on a project of $20,000 and less.

 Title and/or Type of Personnel _____

 Number of Personnel _____

 % of Time Devoted to this Project _____

 Annual or Average Salary Range _____

 Amount each $ _____

 Total Salaries andWages $ _____

 Add fringe benefits $ _____

Total Salaries & Wages including fringe benefits $ _____

2. Supplies and Materials
 (list each major type separately)

 *Details not required when requesting $10,000
 or less on a project of $20,000 and less.*

 Amount each $ _____

 Total Supplies and Materials $ _____

3. Travel

 *Details not required when requesting $10,000
 or less on a project of $20,000 and less.*

 Transportation of Personnel

 No. of Travelers _____

 from _____ to _____

 Amount each $ _____

 Total transportation of personnel $ _____

 Subsistence

 No of travelers No. of Days Daily rate

 Amount each $ _____

 Total Subsistence $ _____

 Total Travel $ _____

4. Special (list each item separately)

 *Details not required when requesting $10,000
 or less on a project of $20,000 and less.*

 Amount each $ _____

 Total Special $ _____

5. Other (list each major type separately)

This section must be completed on every application.

Amount each $ _____

Total Other $ _____

B. Indirect costs

Rate established by attached rate negotiation agreement with National Foundation on the Arts and the Humanities or another Federal agency.

Rate _____ % Base $ _____ Amount $ _____

X. Contributions, Grants, and Revenues *(for this project)*

A. Contributions

1. Cash (do not include direct donations to the Arts Endowment

Amount each $ _____

2. In-kind contributions (list each major item)

Amount each $ _____

Total contributions $ _____

B. Grants (do not list anticipated grant from the Arts Endowment)

Amount each $ _____

Total Grants $ _____

C. Revenues

Amount each $ _____

Project Grant Application

Total Revenues $ _____

Total Contributions, Grants, and Revenues $ _____

XI. State Arts Agency Notification

The National Endowment for the Arts urges you to inform your State Arts Agency of the fact that you are submitting this application.

Have you done so? _____ Yes _____ No

XII. Certification

We certify that the information contained in this application, including all attachments and supporting materials, is true and correct to the best of our knowledge.

Authorizing Official (s)

Signature _____

Name (typed) _____

Telephone AC _____

Date signed _____
 month day year

Title _____

Project Director

Signature _____

Name (typed) _____

Telephone AC _____

Date signed _____
 month day year

Title _____

Payee (to whom grant payment will be sent)
(if other than authorizing official)

Signature _____

Name (typed) _____

Telephone AC _____

Date signed _____
 month day year

Title _____

CHECK LIST

1. Have you attached a copy of your organization's Federal Tax exemption letter or a document identifying the organization as a part of state or local government?

2. Have you summarized the project description in the space provided?

3. Have you completed the summary of estimated costs for Items I through VIII, also provided all details required on Items IX and X, and attached all documentation required to substantiate proposed travel cost, purchase of equipment and indirect cost?

4. Have you provided required detail under Other Support section?

5. Has the application been signed and dated in appropriate places?

6. Have you filed an Assurance of Compliance form?

A negative response to any of the above questions will cause delay in the consideration of this application and will increase the cost of processing.

Fund Raising

The Public Support of the Arts

To put fund raising for nonprofit organizations into perspective, it is important to understand a number of facts about philanthrophy in the United States. In 1976 the total amount of money given to all charities of all sorts totalled $29.42 billion. The amount given to cultural institutions was $2.08 billion. This last figure represents 7.1% of the total amount. Though this figure represented a 7.2% increase over the previous year, culture's share of the total amount given fell from 7.2% to 7.1%. Individual contributions accounted for 80.1% of the total contributions for 1976. These figures, taken from a 1977 study by the American Association of Fund-Raising Counsels, clearly indicate the significance of individual contributions to the support of the arts in this country. For most arts organizations this broad-based public support represents a major source of actual or potential contributions.

Often arts organizations wait for the "deux ex machina" to appear, rather than trying to establish stable, though mundane, fund raising campaigns. In this chapter I want to deal with the

problem of creating a fund raising strategy for your organization.

Arts organizations are notorious for waiting until financial disaster is on the doorstep before deciding to take some action. Most of us have attended benefits for failing arts groups, received distressed phone calls, gotten urgent appeals in the mail. In some cases it is a yearly, predictable, bit of hysteria. After a while one begins to wonder whether it wouldn't be more benevolent to allow the tortured wreck of the organization to die a natural death. Stating it differently, might it not be better to support groups of equal artistic merit which are more together on the financial plane?

What this could mean is giving more support to groups that recognize their financial needs and take steps on a regular basis to resolve their economic problems. For groups that know that they are dependent on "unearned income", fund raising must be recognized as an ongoing process. These groups must invest time and energy in thinking up new ways of presenting their financial needs, finding new ways of attracting potential sponsors, and perhaps most important, building on their base of existing donors. Whatever choices you make about fund raising, the following points should at least be considered.

1. Identify your prospective donors. If this is your major fund-raising effort of the year, it is probably desirable to approach your audience in a variety of ways. Draw up lists indicating who is to be contacted, who is responsible for contacting them, what method is to be used in each case (phone call, personal letter, interview). Decide which part of your public should be notified through the mails. Figure out if it will be economic to buy mailing lists and to send out a larger mailing. Determine whether it will be effective to invest in a broad-based advertising campaign using the newspapers, radio, television.

2. Step back from the problem, and figure out if you are in fact approaching the right group of people. If your work appeals to the young and hip, is it appropriate to approach, or to direct your campaign to, a well-to-do, middle-age audience? You can't

have everything, so decide where you can raise the most money with the time and money that you have available.

3. For each of these groups work up an effective brochure, letter, rap, or ad with which to approach them. It is desirable to have one theme for the whole campaign. Theatres frequently build their fund raising into their subscription campaign.

4. State your case clearly and definitively. There is nothing worse than a vague, inexplicit approach for money. Get the point across that you have an *urgent* and a *legitimate* need for money.

5. Organize the whole campaign. Try to have a campaign manager. Draw up a list of responsibilities for each person involved. Make your plans, goals, timing, individual responsibility clear and explicit.

6. Make sure that *everyone* involved with your organization is behind the campaign, as well as informed about it. This should extend from phone operators and receptionists to artists, staff, and board of directors.

7. Have clear and realistic goals for the campaign. If your goal is too low it will be hard to work up much enthusiasm for the campaign; if it is too high your workers will get discouraged and feel in the end that the campaign was a failure.

8. Make sure that your timing is right. The campaign should take place during a period of maximum exposure, rather than say during your summer vacation. Make sure that it doesn't fall directly on the heels of another campaign.

9. It may be desirable to tie the fund raising in with solicitations from your board or your major benefactors. It may be an inducement for them to give more money in the midst of the excitement of the campaign — the herd instinct at work.

10. This may be the right time for your board to approach their friends and colleagues for donations.

11. Keep accurate records of contributions and contributors. This information will provide the base for your next campaign.

12. Thank each benefactor as intimately and as quickly as possible.

13. Make sure that solicited funds are used for the function specified in the campaign. It is disastrous to be criticized publicly for misuse of funds, or to have conducted a misleading campaign.

14. Evaluate your campaign in terms of total costs, manpower, donated services and goods and the amount of money raised. Begin to plan your next campaign based on the successes and the failures of this one.

Professional fund raisers stress "special gift campaigns" as being one of the most effective ways of raising money. Special gifts are basically one-to-one solicitations of individuals who are in a position to make a sizable donation to your group. They may well be part of your general fund raising campaign, or can be carried on throughout the year. Depending on the needs of your organization you might want to organize the campaign around a specific project: a building improvement, a special exhibit, a guest lecture, a touring program in the schools. For solicitations of this sort it is essential to have some personal rapport with the donor, and to have a clear, attractive project in mind. It is desirable to make lists of all such potential donors, to figure out the best person to approach the prospective donor, and to work out a strategy before seeing the person. With donors of this sort, acknowledgments and periodic contacts are essential.

Other substantial, and efficient, ways of raising money include *bequest programs* and *endowments*. Bequests require fairly extensive organization. The sums are usually large ones which are

being willed to the organization, and the services of lawyers and accountants are usually required. It is desirable that the potential donor be approached by someone who may already have made such a bequest to the organization. The input in terms of time and professional services required is great, but then so are the stakes. Endowments have many of the same characteristics, and are also quite efficient ways of raising money if your organization has the connections and the appeal to people in a position to give away substantial funds.

Perhaps the most important point to remember about fund raising is that it should be an ongoing function of your organization, not a last minute, desperate activity. Have a clear strategy, be well organized, and invent good themes to build your campaigns around. After your first few attempts, your fund raising should cease to be so burdensome, and should develop a momentum of its own. One friend of mine — a successful fund raiser — when asked how he went about raising money, replied, "You stick your hand out and you ask for it." Not bad advice.

Marketing, Publicity, and Promotion

Every major decision that an organization makes, from deciding to form a corporation, to moving into a new space, to the types of plays to produce in a given year, involves marketing decisions. In most organizations these decisions are made intuitively by an individual or group that has a "feeling" for their market and for their product — though at times with a willful disregard of the chances of success or failure. It is my belief that the most complete marketing survey cannot compete with the intuitive responses of someone who knows his or her field, and has a good "nose" for the public's tastes. But market surveys can be useful tools in the decision-making process of your group. They may highlight some issues which you have not thought of, uncover some problems that are not immediately apparent or perhaps just confirm what you believe and provide assurance that you are about to make the right decision.

The mechanics of marketing research are not as obscure as they may seem from the outside. Most of it is common sense combined with method and diligence. The information about

how to conduct a market survey is readily available, and you, with an insider's knowledge of your field, will have a tremendous head-start over even the professional firm which may or may not know what your business is about. If they are fully reputable you will be paying them to find out, for starters, what you are up to. On the other hand, market research is akin to psychiatry in that though you may know yourself better than an outsider, and friends of yours may know you well and be sympathetic to your problems, there is something effective about paying someone who is detached from your life to help you to deal with your problems.

Should you decide to undertake the survey yourself, the following marketing audit should provide you with all of the basic questions which you should ask about your organization. You will have to decide a number of issues. First, how many people are going to be included in your sample? This number can vary from half a dozen to several thousand. You must decide how many people you need to interview to satisfy yourself that you have gotten a representative sample of staff, board members, patrons, community members, students, etc. You want to make sure that you haven't forgotten any important groups, and that you have included a sample that will give you a good sense of what the "potential", as well as the actual market is.

Second, you will have to decide how to approach your interviewees. You can do it through the mail, over the telephone, in person, or in some combination of these. Probably you will want to use all of these methods, choosing the one that is most appropriate for the group that you are dealing with.

Third, it will be necessary to do some research about the community that you are a part of. This will entail a demographic study which will include information about the ethnic composition of your area, economic data relating to individuals and businesses, educational levels, population figures, religious backgrounds, etc. Most of this information will be readily available at local libraries in publications of the federal government or the local government. It may already exist and be in the hands of the local Chamber of Commerce, business league, or advertising

council. You will also want to get a clear picture of the physical characteristics of the area: parking facilities, public transportation, accessibility via highways, traffic patterns, density, and safety. This information will provide basic background material for study.

Worksheets can be drawn up based on the marketing audit which I have included in the text. Customize it so that it fits your situation. If you are *not* interested in actually conducting a formal audit, at least look through the questions in the audit and see which ones you can't answer, which areas are problematic in your own organization, what questions you haven't thought of asking. Use it to suggest future problems, or potential conflicts. If nothing else, it should force you to think about the totality which you have created, and perhaps give you a better perspective for thinking about it.

A COMPLETE MARKETING AUDIT

A. *The Market Place*

I. The Market

1. What are the group's major markets and audiences?
2. What are the sub-divisions in each of these?
3. What characterizes each market and each sub-market?
4. What is the present size of each one?
5. What is the future potential of each?

II. Clients

6. What are the feelings of this group of current clients, audience, students, etc. about the organization?
7. Why do clients choose to come to this organization?
8. Is this group currently being satisfied?
9. What are their future needs?

10. Why do clients leave the organization or not continue to support it?

III. Competition

11. Is this market competitive?
12. Who are the competitors?
13. What does the future hold vis a vis the competition and modifying current services?

IV. The Local Environment

14. What economic, cultural, political, or demographic factors will affect the organization in the near future? In the more distant future?

B. *The Organization Itself*

I. Goals

15. What are the short-term goals of the organization?
16. What are its long-term goals?
17. Are the goals explicit enough so that it is possible to plan for them and to measure the degree to which they are achieved?
18. Are these goals reasonable ones for the organization at this time and in this place?

II. The Program

19. Does the organization have a clear, primary strategy for achieving its stated goals?
20. Is the organization spending enough money to meet its goals?
21. Is it allocating enough staff time?
22. Are these resources being directed sensibly to the different markets serviced by the organization?

23. Are there any weak points in this allocation, e.g., poor promotional materials, lack of follow-up, inadequate advertising?

III. Making the Program Work

24. Is there an annual market program developed?
25. Is there a periodic check during the course of the year to see if objectives are being met?
26. Are marketing activities broken down and analyzed individually?
27. Does this information get related to staff members and board members when it is relevant?

IV. The Organization

28. Is there a person in charge of these marketing activities?
29. Is this person qualified?
30. Is his/her staff capable?
31. Could the staff be reorganized to make it more efficient?
32. Are the marketing goals clearly understood by all of the staff?

C. *The Marketing Process*

I. Goods and Services

33. What are the primary goods and services produced by the organization?
34. What are the secondary goods and services?
35. Are all of these essential and profitable?
36. Should any be eliminated?
37. Should any be added?
38. Do they fit together as a whole?

II. Cost

39. On what basis are prices for goods and services determined?
40. How would the market respond to higher costs?
41. Lower costs?
42. Are services being undervalued?
43. Overvalued?
44. Is price used effectively to promote sales?
45. Should more of this be done?

III. Promotion

46. Do individuals in the organization promote it successfully?
47. Are there enough of them?
48. Are all of them adequately trained and informed?
49. Are members encouraged to promote the organization?
50. Is there any evaluation of their effectiveness at this?

IV. Advertising

51. Are the results desired from the advertising clearly stated?
52. Is enough money spent on advertising?
53. Too much?
54. Is there a clear organizational identity in all of the advertising?
55. Is this visual identity appropriate for the organization?
56. Are the ads visually effective?
57. Is the copy effective?
58. Are the ads placed in the proper media?
59. Is there an overall advertising plan?
60. Is this plan followed?

61. Is it successful?

V. Media

62. Is the media handled well?
63. What could be done to improve the media image?
64. Is there a formulated plan for getting media coverage?
65. Is there enough attention paid to the local media?
66. The national media?

D. Fund Raising

67. Is there a clear plan for raising funds for the organization?
68. Is this plan understood by the staff? By the board of directors?
69. What foundations are approached?
70. Are these the right foundations?
71. Are grant proposals effectively presented?
72. What other foundations should be approached?
73. How would these questions be answered with respect to corporations?
74. With respect to individual sponsors?
75. With respect to the larger public?
76. With respect to government funding agancies?

Another useful tool in figuring out where you are, and where you might be going, is the audience survey. If you are in close contact with your clients and audience, it is possible that you will know who they are and why they come to you without going through the process of doing an audit. On the other hand, it may make it more explicit who this group is, as well as who it isn't, how it finds out about your activities, and to what degree it is satisfied with what you are presenting. It can also give you a clearer sense of how to reach other potential patrons, where to spend your advertising money, and what other promotional

activities might be effective in reaching this audience. Finally, the audience audit should prove useful as a predictive tool for estimating future audience, changes in taste, changes in reading habits, etc.

There are a number of points to keep in mind when you do your audit.

1. Make sure that you get a sufficient number of responses so that you can feel that you are getting a meaningful sample of your audience.

2. Make sure that the responses come from all of the different segments of your audience. For example, if you have afternoon and evening shows, you want to make sure that you are getting responses from both groups.

3. Explain in your opening paragraph why you are making the survey.

4. Don't ask any personal questions.

5. Make it clear that each respondent will remain anonymous.

6. Make your form simple so that the respondent only has to check off boxes.

7. Make the form itself short so that it will take no more than one or two minutes to complete.

8. Have enough containers readily available for patrons who have filled out the questionnaire.

The following questions should give you most of the information that you might want. The sample questionnaire is included to give you an example of a possible format.

AUDIENCE SURVEY

1. What is your age?

2. Sex?

3. Married or Single?

4. Number of children?

5. Are you attending by yourself, with your spouse, friends, children?

6. Where do you live?

7. What is your occupation?

8. Is this a good time for you?

9. What is your educational background?

10. What is your income?

11. How long does it take you to get from home to here?

12. How do you get here?

13. What is your primary reason for coming?

14. How did you first hear of this event? (TV, radio, newspaper, word of mouth, mail, poster)

15. Do you have any other connection with us? (student, teacher, board member)

16. Which of the following newspapers do you read regularly?

17. Which of the following magazines do you read regularly?

18. Which radio stations do you listen to?

19. Which TV stations do you watch?

20. How many other events have you seen here this year?

21. How many other events of this sort have you seen elsewhere this year?

22. Did you like this event?

23. Will you return for future events?

24. How do you feel about the price of your ticket?

PEACOCK PLAYERS

Welcome to PEACOCK PLAYERS! We would appreciate it if you would take the time to fill out this form and to return it to us. Please drop this form in the boxes in the lobby on your way out.

1. How old are you?
 under 18 _____
 18–30 _____
 30–40 _____
 40–60 _____
 over 60 _____

2. Sex?
 female _____
 male _____

3. Are you?
 married _____
 single _____

4. What is your income?
 under $5000 _____
 $5000–$10,000 _____
 $10,000–$20,000 _____
 over $20,000 _____

5. How did you travel here this evening?
 bus _____
 car _____
 subway _____
 walk _____
 cab _____
 other _____

6. How did you find out about this performance?
 newspaper _____
 radio _____
 TV _____
 poster _____
 mailing _____
 word of mouth _____
 other _____

7. How do you get most of your information about entertainment?
 daily newspapers _____
 The Reader _____
 Chicago Magazine _____
 campus newspaper _____
 radio _____
 TV _____
 other _____

THANK YOU

PUBLICITY

It is essential to work out a clear, thoughtful system for your publicity. It doesn't matter if you have a publicity budget of $200 per year or $50,000. You must understand where you are spending your money, and what returns you are getting for each item in your budget. Too often groups work without an overall plan for their publicity, either for one event or for their whole season. They do a little bit here, a little bit there, decide on the spur of the moment to place an ad in this newspaper, in that magazine, and in the end wonder why things didn't work the way they wanted them to. The main point of this chapter is that more important than the effectiveness of each item of publicity

is the organization of the whole campaign. Though I deal with each of the items in turn, in the end, it is the blend of all of them that will be the most important.

Posters, mailing pieces, stationery, billboards, and signs may seem like an arbitrary lumping together of different things, but what they have in common is that they are all visual presentations of your group. Each of them makes a strong visual statement about who you are and what you do — even if that statement is a negative one. Ideally, each of the visualizations of your organization is distinctive, yet held together with the others by some visual theme that runs through all of them. All of this to say that your visual materials make two statements: first, that this activity is going to take place at this time and this place; second, that the activity is being presented by this organization which existed before this production, and will be around when this production closes. The two elements should play off of one another over time. This new and exciting event is being presented to you by an organization which will present more scintillating activities in the future — keep your eyes open for us.

Creating a coordinated visual identity is no easy task. We have all had the experience of getting posters or mailing pieces from a group all of which look the same, so that our impression is that they are presenting the same program time after time, that there is no change or development. On the other hand there are groups which send out announcements that look so different that it is difficult to get any sense of continuity, or to figure out from the announcements what exactly it is that they are doing, and who they are.

In the midst of all the advertising with which we are continually confronted it is difficult to create work which will stand out from all of the rest. And the people who are the best at creating these images are paid handsomely to continue to create yet more striking, imaginative advertisements. It is rare that the work of non-professional designers — even the design work of artists who are experienced at dealing with visual materials — approaches the effectiveness of an experienced pro. It is a special talent, and one which you will probably have to pay for — though many peo-

ple in advertising are delighted to get a chance to do some "worthwhile" work on the side. But even if you have to pay, it is money well spent. A good designer will work with you in creating a visual identity that will highlight who you are and what you do. This extends beyond just your logo and choice of type faces, and includes design elements which can be combined over time, printed in different colors, enlarged or reduced. Good designers will know about printing and can design pieces for you that will be cost efficient, perhaps because they know the relative costs of printing on different size presses, or because they can minimize wasted paper; maybe they can use two colors and make it look like three colors, or design posters and mailers that can be printed on the same press run. Keep in mind, though, that all designers are not sensitive to cost considerations, and from their point of view, they want to have their work realized as perfectly as possible — and this way is never cheap. Perhaps the greatest single flaw of designers is their tendency to be obsessed with how things look, and not with the total effect — what the work says to a viewer. It is possible to end up with a beautiful poster that you turn away from and wonder what is was advertising. The best work for small arts organizations combines explicitness, beauty, and economy.

Remember that it is important that your visual image conform to who you are and where you want to be going. If you have an elegant theatre, you will want your posters and stationery to reflect that. If you have an alternative, slightly funky space, your visual identity should conform to this. Good design simply highlights who you are, and shouldn't mislead or do violence to that image.

Press releases and press conferences are one of the principle means of notifying the media of upcoming events, and hopefully of generating some free advertising. While it is difficult to write inspired copy for press releases it is quite easy to produce poor releases. Nothing will turn off your hard-core professional mediaman than flowery or self-important prose, misspellings, grammatical mistakes, informational mistakes, or a sloppy typing job. This is not to say that your release should be dry as bones. There

has to be something newsworthy that you are notifying the press of, and there must be some spark of excitement in the release. In writing and distributing your press release try to keep the following points in mind:

1. Write simple and straightforward copy.

2. Include the who, why, where, when, and how in the first paragraph.

3. Try to include all of your information on one 8½" x 11" sheet of paper.

4. At the beginning of the release write "For Immediate Release" and date it, or "For Release on . . . "

5. Make it clear whom to contact for additional information. "For More Information Contact _____ at 549-1100."

6. Find out what the deadlines are for local newspapers, radio stations, TV shows. Make sure that they get the announcements on time.

7. Keep an up-to-date press list that includes all of the media: newspapers, radio, TV, magazines. Make sure that your releases are addressed to the proper people at each place. If you are a gallery make sure that the art critic gets a copy of the release, or the person in charge of public service announcements.

8. Make sure that the press release is reproduced as well as possible. Be sure that is is legible, and printed, if possible, on your letterhead.

9. Check your copy carefully for typos, misspellings, grammatical mistakes, informational errors.

10. Follow the editorial conventions for newspaper copy.

11. Consult your local media and see what else they may be able to use. The critic in your field may want photographs, radio stations might want your public service announcements written out for them, television and radio programs could be interested in interviews with your key people, newspapers may want to run a feature on what you are doing.

12. Maintain good press contacts. Remember that you are working with the media — you are the news that they write about.

If there is some possibility that the newspaper or magazine will run a photograph either with a review of your work, or as an announcement of your opening, you should deliver one to the author or critic in person. The standard press photograph is an 8″ by 10″ glossy print. Reproduction techniques and quality vary so much that it is hard to say exactly what to look for. Photographs should be sharp and clear. There should be adequate contrast — you don't want all murky tones, though many photographs that abound in light grays reproduce very well. Try to get images that are simple and direct, one or two people or a single work. It is often helpful to talk to the editor or one of the press photographers about your photographs. He can tell you precisely why they would or wouldn't run a photograph of yours, and what they want. A standard convention is to paste an identifying label on the back of the photograph indicating who or what is in the photograph, the name of the photographer, and any other information that may be applicable.

There is always a need for photographs for feature articles, promotional packers, grants, etc., so keep a photographic library of your best pictures. If possible try to get the negatives of the most important photos, though most photographers are loath to part with these.

In addition, your archives should include old articles about your group, resumes of all of the major personnel, a brief written history of your organization, old playbills, programs, posters, catalogues, and articles. These materials are always being used for grants and articles, so it is essential to keep them around.

Under certain circumstances you may want to highlight some dramatic change in your organization — moving into a new space, hiring a new director, receiving a large grant — by conducting a press conference. Make sure that the event is important enough in the eyes of the media to warrant calling a conference. Also decide whether or not you can assemble the press representatives that you want. If you are confident about these two factors schedule the conference during the day, during the working hours of the press, and send out notices indicating why you are calling the conference and when it will be. At the conference itself, have your written materials assembled, including photographs, and any other special information that might be relevant. And be sure that you produce the event well. Not many things will be worse for your image with the media than a poorly conducted press conference.

Mailings are possibly the single most important means of contact between you and your audience. With the high cost of mailings it is desirable for most nonprofit organizations to use their IRS tax exemption to get a bulk, nonprofit mailing permit from the post office. This entails paying a $40 yearly fee, and paying a unit price for each piece mailed, at the time of the mailing. For items under one ounce, the cost is now $.021. The only drawbacks to this system are that you have to sort the mailing by zip codes and bind the packets according to some simple but stringent rules. Delivery of the mailing will also take from several days, in the same zip code, to several weeks, so you must allow yourself sufficient lead time. Nevertheless, the price incentive is great enough to offset most of these hassles.

It is important to keep your mailing list well organized, and as error free as possible. If you are doing bulk mailings, using your nonprofit mailing permit, you will probably want to have your mailing list organized alphabetically by zip code. There are innumerable systems both for organizing the lists and for actually printing and affixing the labels. Look into your options and decide how much money you are willing to spend, how much free labor you have, and any other factors that may influence your choice. It is also desirable, if you have a large list, to break

it down so that you can do small mailings to a core list, large mailings to a more general population, press mailings, donor mailings, and institutional anouncements. You may want to buy lists from other organizations to supplement your list, or to use for special events.

The problem with mailing lists is that they are almost always out of date and to varying degrees inaccurate. People are always moving, sometimes leaving forwarding addresses, sometimes not. Mistakes can occur in typing the labels, programming them for computer use, or filing them. Consequently, lists must constantly be checked and cleaned out, eliminating old names and addresses. By specifying to the post office that you want returns on undeliverable mail — paying thirteen cents per item — you will be able to clean out your list to some degree, but this system is by no means totally effective.

Though each of the items that we have talked about in this chapter — posters, mailers, press releases, advertisements — are important, their effectiveness is a function of a number of other factors. First, it is important that the timing be right for them. Announcements should give your audience time to prepare to come to your events, but not so much time that they will forget about them. Second, it is desirable to hit as large an audience as possible, and in as many different ways as you can. The first time someone sees your poster they may not notice it, but after they have heard a public service announcement on the radio and perhaps seen your picture in the newspaper, they will be ready to see and recognize your name when it appears again. Third, you have to analyze your promotion in terms of what the return is for each item in your budget. Would you have been better off putting more time and money into your press relations and less into an expensive poster? Questions like this must be answered as well as they can be and the next campaign planned on the basis of the results of this one. Remember, audiences change, as do tastes, so your promotion should be in a continual process of revision and refinement.

Buildings and Spaces

Well, when *The Respectful Prostitute* opened, it got rave reviews and it became an instant hit. We jumped from being this place that nobody could find, to a spot on the map . . . It shows you if they want to see a show, they'll go anywhere and they'll find it. So much so that the second night after the reviews came out, there was a line of limousines. And at intermission all the people, the two hundred and ninety nine of them, would crowd into these terrible bars on the street where whisky sold for ten cents a glass.

Morton Gottlieb (Producer)
from *Producers on Producing* by Stephen Langley

Whatever art form you are working in, you will need space in which to rehearse, perform, exhibit. With the boom in small arts organizations, many of the traditional sites for the arts have been abandoned and new ones developed. When concert halls and clubs ceased to be receptive to new music, or found it economically unfeasible to present it, new formats emerged. Concerts were presented in lofts, churches, small auditoriums, galleries. Simi-

97

larly, with the prohibitive cost of presenting performances in traditional concert halls, performers began to use gymnasiums, social halls, lofts, garages. The vitality of the arts in America is nowhere more clearly reflected than in the imaginative use of space in which art is presented or performed.

It is a commonplace now to see arts centers in every imaginable type of space, so I won't deal with the possible places in which you can do your work. It is assumed that you will not discount the abandoned gas station, the oil storage tank, the jail, or the railroad station.

A good place to begin your search for space is to estimate your needs. It is desirable to sit down and figure out the minimum amount of space which you need to work in. At this end of the spectrum you want to make sure to include room for offices, storage, shop area, conferences, rehearsals, lobby, etc. It is a good idea to list all of the activities that will take place in your space. With the list in hand, estimate how much space each of the activities requires. Eliminate activities which are a secondary use of a primary space, say an occasional meeting which could take place in your main exhibition area after hours. Assign a figure in square feet to each function, and total them. At the other pole, figure what the *ideal* amount of space would be, including room for future expansion. You are in all likelihood looking for a space that is somewhere between these two figures in size. Don't be inflexible, though, it is possible that you will find a larger space which will be ideal for you, and will provide you with the option of sub-letting part of the space to someone else. If you feel like yours is going to be an ongoing venture, it might be desirable to take responsibility for more than your own needs: to become a landlord. This may prove to be an ideal way of defraying some of your own costs. Also be open to the possibility of creating a small arts center, whereby a number of arts groups could occupy a large space.

Having figured out your requirements for space, the next question is determining where you want to be. In all likelihood the most desirable areas are already too expensive for you. Don't despair. Your problem is to find an area which is not too expen-

sive, but one with potential; an area to which the public can be induced to come. Areas of this sort are frequently fringe areas — sections adjacent to the downtown, neighborhoods in which your clientele may live rather than work, changing neighborhoods, industrial areas. The essential question to ask is, will the public come to the location that you have selected? Is there convenient public transportation? Will people feel relatively safe in your area? What is it like at night? On weekends? Many industrial areas which are terrific, bustling places during the day, are ominous at night. Is there parking for people? Is the area noisy? Will you have security problems? The simple problem of needing someone to be at the door at all times can turn into a nightmare requiring eighty hours a week of receptionist time. It is unlikely that all of the questions can be answered affirmatively; one rarely finds a "perfect" space. Remember, though, audiences will go where there is something to see. Sometimes all it takes is one gallery, studio, or theatre to open up a whole neighborhood.

The addition of an arts organization to a community is not necessarily going to be met with the applause of the neighborhood. So having found a building, figure out if it will be possible to work out good relations with the neighbors. If there are businesses, get a sense of whether they feel that you are an asset or a liability to the community. Your audience may or may not be their clientele. If you are in a residential area, your neighbors may view your presence in terms of added noise and people pollution — a threat to the quiet of their lives. Be diplomatic. If there is a local unit of government such as a councilman, alderman, or community zoning board, approach them and notify them of your interest in moving into the area. Listen to their advice and try to find out what other community institutions you should approach. Talk to as many people and groups as you have to, to get a sense of the community and how you will be received. If you are in a commercial area spend enough time on the street to get a feeling for the kind of people who shop in the area.

You are also going to want to find out if your occupancy of the building is legal, if it complies with the zoning restrictions for that location. You can probably find all of this out for your-

self by going to city hall, checking the records, and asking the clerks to explain any technical information that you may not understand. If the zoning is not right, you can always think of filing a zoning appeal to get an "indulgence" to use the building.

Having found your building, it is important to see if you can afford it. Make a budget starting with the rental cost or the amortization cost of the space. The next figure will be the cost of utilities. Find out what the previous tenant was paying for utilities, if the building had been occupied. Make sure that you get a clear sense of what their usage was. Perhaps in an old warehouse it was possible for the previous tenant to keep the temperature at a constant 55 degrees during the winter, but for your dancers it will be essential to keep the temperature at 72 degrees for at least twelve hours a day. If the figures are not available, ask the utility companies to come in and to give you estimates. Make sure that there will be fuel available for you. Gas shortages will most likely continue, and prices are going to continue to rise. You also don't want to find yourself in the position of being cut off, or unable to convert your service.

Pay particular attention to the cost of renovating the heating system, the air-conditioning, wiring, plumbing, roofing, ventilation system, as well as any major structural changes. These are major expenses. You can perhaps find a maintenance engineer from a local college or business — someone used to inspecting all aspects of a building, who will be able to look over all of these systems. An experienced general contractor or architect might also be able and willing to do this. You can try the local chapter of the American Institute of Architects if you are having trouble finding someone. Another alternative is finding a plumber, heating man, electrician, etc. And if you are going to attempt a legal occupancy of the building, and are in an area with stiff building codes, you will want to have some very clear sense in advance of whether you are going to meet fire codes, plumbing codes, electrical codes, etc. Codes tend to be particularly strict where crowds of people are involved, and usually are even more exacting if children are involved in the use of the building. Once again, these are very specialized areas, so get your information from as

authoritative a source, and in as much detail, as possible. Perhaps your local arts council can make the necessary arrangements to have a preliminary inspection made of your building by the city. Inspectors, on the other hand, will be more interested in giving you a notice of a violation after your occupancy, than in determining whether or not it is feasible to renovate the building in question. Inspectors are willing at times to work with a contractor in advance of the actual construction to see that the work is done properly. Depending on the political climate of your locale, these questions may be solved simply by knowing the right people, or having the "fix" put in for you.

When you have assembled all of this information, figure out the minimum amount of work that has to be done to make your building operational. Have two sets of plans, the first a minimum budget that accounts only for essentials, and the second an ideal budget which would allow you to make all the necessary changes to create your perfect space. If you are short of cash, try to schedule the renovation over a three, five, ten year period — whatever seems the most realistic.

To complete your budget assemble figures for garbage removal, security, and general maintenance. Separate the figures so that you can figure out what your start-up costs are going to be — including renovation, deposits for rent, utilities, and material purchases — as well as what your monthly building costs will be after you are underway. On the basis of these calculations you should have a good idea of whether or not you can afford the space.

Given a variety of options, what will be the most desirable form of tenure for you. Once again there are many variables, but here are some things to think about. If you are fairly certain that you are going to be around for the indefinite future, and that the building is right for your current and projected needs you might consider buying. Try to figure out in advance if you will be able to sell the building should things not work out for you. Some commercial spaces are always in demand and easy to dispose of, others are too large and quirky to be of general interest. You might be lucky with a building of this sort and sell it right away, or you might have to sit on it for years. If you buy, you have the

security of knowing that the building is yours, that you are not going to be evicted, the rent will not be raised arbitrarily, your landlord will not be negligent about repairs, and there will be a greater incentive to put money into the building. On the other hand, you will be responsible for taxes, maintenance, building code violations. It is possible, though, to organize a good fundraising campaign around the issue of buying and renovating your building. People feel more secure about donating money to institutions that they feel are going to be around for a while. There are also government and foundation funds that are available for renovation if you own your building.

Another desirable option is to get your local government or a business or foundation to give you the use of a building for an extended period of time, with them retaining ownership, maintaining the costs of major repairs, paying taxes, taking care of insurance, but with you having the use of the building. You may be taking a white elephant off of their hands that might otherwise be sitting vacant or awaiting demolition. There may be tax advantages for them in this arrangement. Deals of this sort usually require a lot of time to put together.

The final option is leasing a building. There are a number of desirable things about this arrangement, particularly if you are just starting. The landlord will in most cases assume full responsibility for all major repairs, taxes, insurance. You will be responsible for your own renovation, which, if it is extensive, may well benefit your landlord when you leave. It is not uncommon for an arts organization to renovate a space on a short term lease, for the neighborhood to change, rents to rise dramatically, and the arts organization to be forced to leave to make room for a boutique or more profitable venture. Ideally, you will get a rent abatement for the money that you put into the space. It is not uncommon for landlords to grant rent abatements at least to the extent of material costs. Whatever you do, though, figure the cost of the renovation into your rental to give you a true picture of what the space is costing you. If you have a two-year lease and you spend $2400 renovating the space, add $100 to your monthly rent to see what the space is really costing you. It is always ad-

visable to get a lease that has a built-in extension clause which can be exercised at your option. You could have a four-year lease with an option to renew for another four years at some set rental. If there is a chance that you are going to buy the building, see if at the time of the signing of the lease you can't make some arrangement whereby you can get an option to buy the building at a specific price. Ideally, some or all of your rent could be applied to the purchase price. In all leasing arrangements, try to make all of the terms as explicit as possible. Find out who is responsible for the maintenance of the boiler, hallways, air conditioning, etc. Know what kinds of changes you can make in the space, what will become the property of the owner, and what you can take with you when you leave. Most commercial leases are standardized and heavily weighted in favor of the landlord. It is probably desirable, though not necessarily essential, to have a well-informed lawyer look over the lease before you sign it.

You may find it necessary to engage professionals of many varieties in the process of securing and renovating your space. Arts organizations are in a position to get a certain number of these services donated, to get discounts on others. Don't feel that you have to have professional advice to do everything, but when you are uncertain, it is best to have the security of knowing that you at least have gotten an informed opinion.

In Summary:

1. In looking for space don't dismiss any options in advance. Be open to unconventional uses of space.

2. Estimate your space needs figuring out a minimum requirement, as well as an ideal figure which accounts for normal growth.

3. Don't eliminate the option of renting a space that is considerably larger than what you need, but one that will allow you to sub-let, and possibly defray some of your overhead.

4. Figure out where you want to be. Take into account costs, security, public transportation, parking, noise, and whether or not the public will come to the area.

5. Get a sense of the community into which you are thinking of moving.

6. Check the zoning for the building.

7. Estimate rental costs, purchase costs, utilities, renovation costs. See if you can afford the space.

8. Check building codes to see what you will have to do to satisfy the building department.

9. Decide which form of tenure is most desirable for you.

10. Make sure that your lease or purchase agreement accounts for all likely contingencies.

11. Get professional help when you need it.

12. Make a budget indicating start-up costs, and the cost of operating for one or more years.

Financial Management, Budgeting, and Bookkeeping

Arts organizations hoping to reach a point of self-sufficiency and stability must have good financial management to provide them with a clear and current picture of their financial situation. It is critical for arts organizations to know where their money is being spent, which of their activities are generating profits and which are losing money, how much cash is going to be needed by the organization during its off-season, etc. These questions are possibly even more important for arts organizations, which are usually borderline economic activities with far less room for error, than for-profit businesses. Yet arts organizations have been terribly negligent in this area. I sometimes feel that this negligence is in part an over-reaction to the prevailing materialism in this country and the tendency to ignore everything but the "bottom line"; and the fear that to succeed is to "sell out". Whatever the reasons, the fact remains that the arts have historically had poor financial management.

In the arts, and with nonprofit organizations as a whole, there is a potential conflict between profit motives and art or service

105

activities. In most business there is no such division — the business provides a good or a service in order to make money. In the arts, one must not only provide the goods and services, but be able to attract other resources in the form of grants and contributions to make it possible for the primary activity to continue. It is rare for one person to produce good art and to be a promoter as well. Arts organizations too, are inclined to be good at one or the other. Hence, it is common to find poor art which is well promoted and economically successful, and good art which is poorly promoted and unsuccessful.

Financial management in the arts poses some unique problems. Taking a hard look at the finances of an arts organization involves assigning an economic value to activities, to work, and to people. Not only are the standards which one must use to assign value to a product or to an artist's work unclear, but there are a considerable number of non-economic considerations which can enter into the picture. An arts organization can exist for its least profitable activity, and all of the other activities which on paper may look like they are the most profitable, may only be justified internally because they make it possible to do some work which is not remunerative.

In any event, it is necessary to assign a dollar value to activities, to work, and to people in an arts organization. It is also essential to ask some crucial questions of the organization — to determine what activities are central to it and its continued existence, and which activities exist to support these primary activities. This is a process of self-definition, which most of us resist to the death, but one which is necessary to determine which programs may be marginal and uneconomic, and which are central or profitable.

BUDGETING

Budgeting is both an analytical and historical activity, and a predictive one. By the time a budget is actually created, these aspects are combined into a plan of action for the coming financial period. For an on-going operation it is common to simply take

the figures for the previous year — the revenues and the expenditures — and to estimate what the percentage of increase or decrease will be for the various items, and then to insert these new figures into the budget for the coming year. This process, known as *incremental* or *step budgeting*, is perfectly adequate if your organization's plan is in full tilt, if the economic situation is stable, and the organization is in good financial shape. It does not entail asking basic questions, though, and usually fails to analyze the exact position of individual organizational activities. Step-budgeting implies a continuation of policy decisions that took place at some time in the past.

A more hard-headed approach — though one that is also more time consuming — is to require that every activity justify itself both financially and in terms of the goals of the organization. This type of budgeting, known as *zero-based budgeting*, is rigorous and potentially disquieting to an organization. The implicit question that is asked is "prove that this activity is worth supporting." Though it is time-consuming and unsettling, few arts organizations are in a position not to ask this question on a regular basis.

Personnel costs in the arts are high, so it is desirable to begin your zero-based budget by allocating staff time to activities, to figure out how much employee time is devoted to each of the programs of the organization. A distinction should be drawn between the activities for which the organization exists, and those activities which sustain these primary activities. A simplified *Program Budget* is drawn up in Illustrations I and II.

Program Budgets are useful for determining how much different programs cost, and for determining how much "support" these activities require. Looking at Illustrations I and II, we can see that the Peacock Players would be operating with a $5,600 deficit for 1978. A closer look at the budget reveals that of the three primary activities, the school is the least profitable, operating at a loss of $7,200. In analyzing the budget, the directors of the Peacock Players might decide that the school is not an essential part of the program of the organization, and that it is desirable to eliminate it, thereby balancing the budget. The directors might feel that the school was capable of generating more

revenue, and that an intensive promotional campaign for the school which would cost $500 could generate another $10,000 in revenues, thereby justifying its existence. On the other hand, the directors could decide that the school was not profitable, but that it was an essential part of the program of the organization because the majority of the actors and actresses in the company were trained at the school. In the last instance it would be necessary to draw up a new budget which would attempt to alleviate the projected deficit in another way. Zero-based budgeting is not a decision-making process in itself, but it frequently presents financial information in a new light, which then facilitates decision-making.

The same analysis should be applied to the major productions planned for the coming season — as well as to those of the previous seasons — to determine which plays will be generating and which will be losing money, and to justify each of the program choices. Though in this instance we are talking about theatre, the same principles would apply to any other programmed arts activity.

A major dilemma for many arts organizations is how to deal with a deficit budget. Historically, arts organizations have tended to be a bit schizophrenic on the subject, operating as though there was no way of altering the projected program — so that all costs tended to be thought of as fixed — and defending this position against critics by calling on such shibboleths as "artistic freedom". All the while hoping that some "angel" would step in at the last moment and magically make up the deficit with one grand flourish of the checkbook. Clearly this is not a reasonable way to exist in a world where there have never been many, and are now fewer and fewer, such beneficent angels. All of this is not to say that you shouldn't take risks, but that you should know when you are taking them and be prepared to suffer the consequences. Take comfort in the words of one seasoned arts administrator who confesses, "Since I went back into the 'culture business', I do nothing else from five in the morning, when I wake up sweating with anxiety, till I go into a troubled sleep, than think about money" (John Houseman, *Producers on Producing*).

In addition to program budgets and a general operating budget, it is desirable for most organizations to draw up a *Cash Budget*. The function of this budget is to give the administration an idea of when they are going to actually have the money that they will be spending in the course of the year. If all revenues were to come in at the first of the year and cou'd be allocated over the next twelve months when bills came due, there would be no problem. This is rarely the case, and it is in fact more common for revenue such as grants and donations to come in after the close of the financial year. There may be several periods in the course of the year when most of the revenue comes in, for example with schools where tuition is due at the beginning of each term. The purpose of a Cash Budget is to predict when cash is going to be available, and when cash will be required. See Illustration III for a *Cash Budget: Projected* which can be used to anticipate cash needs and revenues. Illustration V shows a *Budget Report* which is dated and shows current figures, the original budget allotments, new projected figures, and the anticipated differences between the original estimates and these revised estimates.

Arts organizations have a generally bad reputation with businesses. Innumerable arts organizations default, procrastinate and don't pay their bills when they are due. It is not uncommon for organizations to be reduced to paying for every purchase with cash – a very inconvenient position to be in. It is desirable to do everything that you can to avoid putting yourself in this position. Try to pay your bills when they are due. If it is impossible, notify your creditors that your payment will be delayed, but that you will pay by a specific date. If you make a promise of this sort, though, it is essential that you keep it and meet this second deadline. Word of mouth – particularly badmouth – travels far.

There is, however, one way to turn this troublesome situation of a cash shortage around. When you anticipate a cash shortage, and know, for example, that you have been awarded a $5,000 grant from the National Endowment for the Arts, this may be the time to establish a line of credit at your bank, using your

grant notification as collateral. Talk to an officer of the bank or savings institution who can appreciate the secondary benefits that might accrue to his/her institution from having you as a customer. Community involvement, helping the arts, developing good public relations material, may motivate your bank. Take out a small loan which will cover your expenses. Be sure to repay this loan when it comes due. Don't create any administrative problems for the bank. And remember, it is easier to borrow money when you aren't desperate.

One further budgeting tool is to do a *cost analysis* of a particular program or production or event over time to determine its profitability. A theatre company, for example, might want to decide how long to run a show, and could use this kind of analysis to determine what their break-even point is, or how long a show could be run profitably. Let's assume that the pre-production costs for *Hamlet* are $25,000. This will be a *fixed cost;* whether the show runs for one performance or a thousand, this figure will not change. After the show opens, it will cost $5,000 a week to run the show. A projection of audience attendance indicated that the play can generate $10,000 in revenues for the first two weeks, $8,000 for the second two weeks, $7,000 for the next four weeks, and $4,000 per week thereafter. Diagramming this reveals the following progression:

	Expenses	Income	Profit (Loss)
Week I	$30,000	$10,000	($20,000)
Week II	$35,000	($20,000)	($15,000)
Week III	$40,000	$28,000	($12,000)
Week IV	$45,000	$36,000	($9,000)
Week V	$50,000	$43,000	($7,000)
Week VI	$55,000	$50,000	($5,000)
Week VII	$60,000	$57,000	($3,000)
Week VIII	$65,000	$64,000	($1,000)
Week IX	$70,000	$71,000	$1,000
Week X	$75,000	$75,000	-0-

This analysis would indicate that at the end of Week IX *Hamlet* would be in the black with a profit of $1,000. Thereafter, the show would be losing $1,000 per week. Ignoring other considerations, it would appear that a nine week run would be desirable. Should any of the fixed costs become variables — say the rental of the theatre were to be reduced by $1,500 per week after the ninth week — you would have to alter the chart to determine at what point it would then be desirable to end the run.

To summarize, try to keep the following general points in mind when you do your budgets:

1. Centralize the budgeting process. Have one person in charge who will know the ins and outs of the budget.

2. Make sure that there is a broad information base: that is, make sure that you get your facts from informed sources. Your shop manager may be the one person who knows that your $5,000 lathe is going to have to be replaced next year, but he will only indicate this if asked.

3. Don't take any of your programs for granted. Figure out what the costs are and what the returns are. Many organizations have small and insignificant programs which require a great deal of attention, or have small energy leaks which aren't significant in themselves, but taken as a whole result in a great waste of resources.

4. Make sure you know where and how people are spending time. You may not want your producer handling subscriptions over the phone, or spending a disproportionate amount of time doing the payroll. See that these investments of time are appropriate.

5. Make long range plans for the organization on a regular basis. Figure out where you want to go, and how to get there. Decide for the long haul, which revenue sources are going to be the most important. You may, for example, feel that foundation

or corporate funds are going to be an important source of revenue three years from now if you are willing to make the investment of time and energy now. You could decide that your children's art education program, which is marginal now, will be lucrative in five years. Everything changes, so try to get into the habit of projecting into the future so that you can attempt to anticipate these changes.

6. Remember to check your current expenses and revenues against your budget throughout the course of the year. The budget is a yardstick which should indicate the extent to which you are fulfilling your goals.

7. Allow some funds in your budget for emergencies or miscellaneous expenses. Past experience should give you some indication of what this figure should be, whether it is 2% or 5%. If this figure is too high, and you have chronic shortages as a result of unexpected expenses, there is probably too little foresight in your budget planning.

PROTECTING RESOURCES AND ASSETS

It may seem self-evident that it is important to secure such things as cash and the corporate records, but often it is at this level that insurmountable difficulties originate. Getting down to basics, there should be adequate space to maintain a filing system, copies of unpaid bills, current correspondence — the day-to-day paperwork of the organization. It is important also to make sure that the corporate records are secure. Items that cannot be replaced, such as bank books, the corporate minutes, the charter, your IRS tax exemption, should be stored in a fireproof file, safe, or safety deposit box. Other records which give a detailed history of the finances of the corporation should also be stored in a secure, fireproof place. It is desirable that someone — your attorney or registered agent — keep xerox copies of all of these permanent documents. For small and impecunious arts organizations, you might think of storing your records in an old refrigerator, which will

provide some protection against fires, floods and other natural disasters.

The following check list includes most of the documents that you will want to secure:

1. Cancelled checks, deposit slips, bank statements.

2. Paid bills.

3. Charter.

4. Insurance policies.

5. Operating budgets.

6. Reports to governmental agencies: IRS, state, or local.

7. Unemployment compensation reports.

8. Corporate minutes.

9. Board of directors.

10. Payroll book and tax deposits.

11. Loan agreements.

12. List of donors.

13. Mailing list.

14. Securities, savings account books, certificates of deposit.

Other resources which it is important to keep track of are the physical properties owned by the corporation. Typewriters, stage lights, sound equipment, sets, costumes, should be inventoried on a regular basis. Records should be kept which indicate the source of the item, the date purchased, cost, and serial number. Any items which are particularly valuable — a dimmer board for example — should be recorded with all of the above information and a copy of the original invoice.

A minor headache in most organizations are records relating to cash. Even organizations that don't have a significant currency flow must still deal with a petty cash account which must be

balanced on a regular basis. It is customary to assign a small sum to a petty cash fund — say $100. When this amount is disbursed, the account is balanced with receipts provided for all expenditures, or in their absence a petty cash slip which indicates that so and so spent such and such an amount for this or that, plus the date. If $89 has been spent from the fund, a check for that amount is issued to the fund to bring the total back up to $100. It is desirable to have someone other than the person who disburses the money reconcile the account when new funds are added to the account.

For theatres and performing arts groups where there is a large amount of cash floating around, it is essential to have an efficient system for handling cash, tickets, change, and deposits. When there is a group involved in handling subscriptions and a large box office staff, I would recommend getting hold of a copy of an excellent booklet prepared by FEDAPT on *Box Office Guidelines.* (FEDAPT, Foundation for the Extension and Development of the American Professional Theatre, 1500 Broadway, N.Y., N.Y. 10036, (212) 869-9690. The booklet is $5.75 postage paid.) For organizations whose needs may not be quite so complex, I have included a *Box Office Report,* Illustration VI, which can be used to keep track of box office receipts. When you set up your box office system, keep the following points in mind:

1. Select reliable people to handle your box office funds. You may want to get them bonded, which will insure you against any loss should your box office personnel turn out to be thieves. Insurance or bonding companies handle this type of insurance.

2. Have separate change funds for each cashier.

3. Reconcile each change fund after every performance.

4. If possible use preprinted tickets with the date, performance, and price printed on each ticket. Have a detachable stub on each ticket which can be used to reconcile attendance with the cash receipts.

5. Reconcile ticket stubs with box office receipts after each performance.

6. Deposit all cash in the bank as soon as possible.

The other major source of cash will be the funds in the checking and saving accounts. These funds are less vulnerable than currency which is setting around your office, but must still be protected. Here are some things to consider when you set up your system for handling your checking and savings accounts.

1. Consider requiring two signatures on checks and withdrawals from the savings account. This system may create more problems than it is worth because it will necessitate the presence to two authorized employees any time that it is necessary to write a check.

2. Limit the number of people with authority to write checks.

3. Someone other than the individuals who write the checks should monitor the account and reconcile the bank statements.

4. Require a reconciliation of the account at the end of the month.

5. Consider bonding employees who handle checks or cash.

6. Clearly specify who and what amounts can be paid out by any individual at their own discretion.

In most organizations these financial functions and decisions are determined at different levels. The board of directors is responsible for setting the overall financial policy and approving budgets, and is ultimately liable for the financial actions of the corporation. The managing or executive director is responsible for seeing that the directives of the board are carried out by the staff, and within the guidelines set by the board, responsible for making the day-

to-day financial decisions. The staff is then assigned the function of disbursing cash, submitting budget information, keeping records, etc. The accountant sets the policies regarding how the records are kept, what kind of documentation is required for each transaction, and which procedures are to be followed. The bookkeeper assembles this information and records it in the various journals and ledgers set up by the accountant. Finally, an outside auditor may be called in to verify that the system designed by the accountant is adequate and that the information is being properly handled by the bookkeeper. In smaller organizations many of these functions will be assumed by the same person.

BOOKKEEPING

"*Accounting* is the system for collecting, summarizing, and reporting financial information. *Bookkeeping* refers to the process of recording financial information within the structure of the accounting system." These definitions made by Mary Wehle are useful for distinguishing the two related and at times overlapping activities. The two together create a system which makes it possible for you to understand your current economic situation and to project for future needs.

The basic financial instrument for a small arts organization is the checkbook. Most of the information relating to receipts of funds and disbursements can be obtained from the deposit slips and the check stubs that are retained in the checkbook. If you are just starting, or are dissatisfied with your current bank, you should establish a checking account in a bank that will be likely to service your current and future financial needs. You should look for a bank that is sympathetic to the arts, and willing to go out on a limb for "worthwhile" activities. You should also look for a bank which will give you free checking because of your not-for-profit status.

In actually selecting a checking system, look through all of the possibilities, and select the system that fills your needs. For organizations with a limited number of employees — under fifteen — I recommend a system which makes it possible to write pay-

roll checks and general checks from the same account. In this system, there is a detachable stub for the employees payroll record, and space in the checkbook stub for the same withholding information.

If you are in a position to, you might think of buying a computerized bookkeeping system right from the start. They require a checkbook with a carbon record of each transaction. The carbon copies are sent to the service at the end of the month. The cost of these services varies, depending on the number of transactions each month, plus a figure for setting up the system. These services are probably too sophisticated and costly for very small organizations, but for larger organizations they provide a simple way of getting detailed financial information very quickly. Usually included in the service is preparation of your monthly or quarterly statements for the IRS, the state, and FICA.

No matter which system you choose and what kind of account you set up, you will usually have to present the bank with your articles of incorporation, a list of officers, and a list of board members. You will also have to decide who can write checks, and how many signatures are required for each check. Though it affords some additional security, from my experience it is awkward to require two signatures on each check. It is advisable, though, to limit the number of people authorized to issue checks.

With respect to writing checks, make sure that the check stub accurately records to whom the check was written, the date, the amount, and what the payment was for. It is useful to include a precise description of the item — "flyers for Installation Show" — and then the account to which the item should be charged — "printing" or "account #471". For each check that is written there should be supporting documentation which can include an invoice, petty cash slip, or note. On this document indicate the check number, the date payment was made, and the person who wrote the check. I have found that a good way of dealing with these invoices is to purchase an alphabetized, expanding cardboard file ($6 or $7) and to file invoices alphabetically and by date. At the end of the year the folder can simply be stored with the records for that financial year, and a new file purchased.

For receipts and deposits I recommend having two systems. The first system will be a "Cash Receipt Book" which should have at least one original and one copy for each receipt. (Illustration VII) In this book you can record individual receipts of income: tuition, donations, sales of books, performance income, grants, etc. In addition to providing you with supporting documentation for your deposits, this book can provide you with information for your donors list and student mailing list as well as receipts for your clients. It is possible that you will only want to record individual sales in this book, excluding performance income, grants, etc.

The deposit slips in your checkbook will record the actual deposits to the bank, and will be the basis for additional record keeping. On these stubs you should indicate the date, the account to which this money is being deposited, e.g., "tuition" or "#359", the source of the funds, e.g., "$50 from Jay Pearl". Try not to make deposits to more than one account on each deposit slip. This will complicate your handling of the information when the transaction is recorded in your journal.

At the end of the month you will receive a statement from your bank. Reconcile your figures with the bank's as soon as possible. There are a number of common problems which sometimes make it difficult to reconcile the two. First there are bank charges — either a monthly charge for your account, or charges for special services like stopping a check or for printing new checks and deposit slips. Be sure to record these charges in your checkbook. Second, outstanding checks may have to be carried forward from previous months, and may remain uncashed for the entire year. These should be carried through the year, then cancelled, and rewritten if necessary. Finally, there will be deposits which you have made which will have been returned to you because the checks bounced. These checks must either be destroyed or redeposited. In either case you will have to account for a double deposit, offset by a single bank charge in the amount of the check, or a deposit offset by a bank charge of the same amount.

Once you have reconciled your bank statement and your checking account, you can proceed to the next step, which will

be to summarize all of this financial information in a *Journal* or *Book of Original Entry.* We begin with a *Cash Receipts Journal,* Illustration VIII. This journal includes the period which is being summarized — in this case the month of January, 1978, the source of the funds, the date of deposit in the bank, the account in which they were deposited, and the income account to which they are to be attributed. In the Journal we encounter for the first time double-entry bookkeeping. You will note that in this Journal there is a summary of the account in which the funds were deposited on the left hand side — the *debit* side, and a corresponding break-down of the deposits in terms of the accounts to which the deposits are to be *credited.* The two halves of the system should total the same amount — because the same funds are being accounted for on each side. What we have done is to create a mathematical check on the accuracy of our system. In accounting, debit and credit have different meanings than in real life, and are used to indicate that in the case of a debit, an amount has been entered in the left column, and with a credit that an amount has been entered in the right column. The two are sometimes abbreviated *dr* for debit and *cr* for credit.

On the credit side of the Journal we have set up accounts which indicate the origin of the funds that have been deposited. For small organizations there may be just a few sources of income. For larger organizations the sources of funds may number in the hundreds, in which case it would make things easier to assign code numbers to them. In the appendix we have included a "Chart of Acounts" which provides a convenient system applicable to the arts, and adaptable to your system. One further detail. When you transfer information from the checkbook to the Journal, a process known as *posting,* you should indicate in the checkbook that the transaction has been recorded in the Journal. Our second journal is the *Cash Disbursement Journal,* which categorizes and summarizes the money that has been paid out during the course of the month — Illustration IX. This information is gathered from the check stubs in the checkbook. This journal is set up in such a way that it indicates the period for which the Journal is kept, in this case the month of January, 1978, the per-

son or company to whom the payment is made, the date, the check number, the amount, and the account to which the transaction is to be charged. In this case we are assuming that there is no separate Payroll Account, so that in item five, the amount of John Smith's payroll check plus the amount deducted for federal and state withholding taxes appears on one side of the journal page, while on the other the gross salary or total "payroll" figure is recorded. The same double-entry system is used here as in the Cash Receipts Journal. Similarly, all of the accounts could be coded so that instead of the titles of the accounts we could simply have a numerical description of the account. With this Journal also, the two halves must balance, indicating that it is at least mathematically accurate.

Two other Journals which supplement the Cash Receipts Journal and the Cash Disbursement Journal are the *General Journal* and the *Payroll Journal*. The General Journal — Illustration X — is set up to deal with mistakes from previous months, and to record transactions that have not resulted from cash receipts or disbursements, such as payment made by board members for goods or services. Finally, this Journal can be used to record taxes that have been withheld, and their subsequent payment into separate tax accounts. Note that in this case the taxes for the quarter were held and deposited in toto at the conclusion of the quarter.

Payroll records are generally summarized in a separate journal which facilitates filing the monthly, quarterly, and year-end reports with the government. These record books are readily available at stationery stores. See Illustration XI for a sample. In addition, the IRS publishes and distributes a complete payroll packet which includes all of the forms that you will require, tables of deductions, and a calendar indicating when forms which employers must file are due. The same information should be available from your state. You will probably have an employer identification number which you received when you filed your application for an IRS tax exemption. If not, you must acquire one in order to report all of your payroll information.

Non-profit organizations can apply for an exemption from social security payments. If your organization is flush, you should

elect to make these payments for the benefit of your employees. Many organizations for the sake of economy choose not to. Unemployment compensation poses a more complicated problem. Arts organizations have historically used unemployment insurance as a way to finance their activities; it is not inappropriate to think of unemployment compensation as a form of middle-class welfare in this case. Arts organizations frequently employ personnel for part of the year and then have them apply for unemployment compensation for the rest of the year. Though your unemployment compensation rate will go up — currently the range is from 2.7% of total wages to 3.5%, if you have a poor record for unemployment claims — it is a lucrative option, should you choose it.

The Journals, or Books of Original Entry, constitute the first part of a bookkeeping system. When they have been completed, this information is summarized once more in *Ledgers, Books of Secondary Entry.* In the Ledger each account that appears in the journals — "tuition", "grants", "Utilities", "rent" — is totalled on a separate page or in a separate column. In this fashion it is possible to see how much income has been generated by any given activity, and how much cash has been disbursed for any function — Illustration XII.

If your organization is small, and there are a limited number of categories for income and expenses, you can simply label each account in your journals and in your ledger. In larger organizations this becomes cumbersome, and it is common to set up a *Chart of Accounts,* which provides an account number for each item, and a guide on how to handle problematic or discretionary items. As an appendix to this chapter I have included a Chart of Accounts prepared by Mary Wehle for performing arts companies. In setting up your Chart of Accounts you should select those items which apply to your organization, and use the accounts that you might need that aren't listed by selecting an unused number in the proper account category. You should of course make up your own list and include a description of your whole bookkeeping procedure in this separate handbook. Your Chart of Accounts, in addition to providing a listing of accounts and account

numbers, is also a guide book to your particular bookkeeping system.

Additional reports such as a Trial Balance, Balance Sheet, and Income Statement can then be taken from the Ledger.

FINANCIAL POLICY

Before you set up your accounting system there are a number of questions of financial policy which you must decide. The most basic question is whether to use a *cash* or an *accrual* accounting system. To explain the difference between the two as simply as possible, a cash system records income when cash is received, and expenditures when cash is paid out. An accrual method records income when it is *earned,* and expenditures when goods or services are *used.* In an accrual system it is not important when a bill is sent or cash received, but when the activity takes place. An accrual system remedies one significant problem with cash accounting, which is that with a cash system it is possible to incur large, unrecorded debts which don't appear in any financial reports until the bill is actually received or payment made. Poorly run organizations can find themselves in awful, and unexpected, financial shape as a result. The other side of the coin is that an organization could have substantial grants which were promised but not received during an accounting period which would bias the financial reports in the other direction. Or a group could receive a three-year grant with payment made in the first year. In a cash system the total amount would be recorded as income in the first year, and none of it would appear as income in financial reports for the second and third years. The problem with the accrual system, however, is that it requires considerably more time and energy.

I recommend that small- and medium-size arts organizations use a *modified* accrual system. In this system critical adjustments of large sums can be included in the financial reporting. A report of this sort appears as Illustration XVIII.

A second area which poses financial problems has to do with recording income that comes in the form of donated services.

Historically arts organizations have relied heavily on these. To give a true picture of the operation of the organization, these donations should be recorded. The question is where to draw the lines. For example, should the chairman of the board — a fancy corporate attorney — be considered to have donated services, and if so in what amount? When an accountant donates his services to the organization in order to prepare financial statements, how should his donated services be accounted for? What of the time put into mailings and clean-up and answering the phone by volunteers? The guidelines are unclear for these questions, but a rule of thumb which you could use, is to include donations, and assign a dollar amount to, services which are rendered that *would be paid for*, under normal circumstances. Hence. if you would do the mailing yourself in the absence of volunteers, and if you would only consider an unpaid chairman of the board, you should not include these as donated services in financial reports. If on the other hand you're willing to pay an accountant for preparing your financial statements, but you get someone to donate his or her services, you should count this as a donation.

A third question for arts organizations is the capitalization of assets. The materials of the arts are distinctive in that they have value, in large part, only to the organization that is using them, or perhaps to a few similar organizations. Scores, plays, scenery, costumes may only have value to your group. If you were to fold this year, they might be unsalable. Even though you may use costumes for several years, it is conservative and desirable to expense them in their entirety for the years in which they are purchased. On the other hand, a stereo sound system, which could be disposed of readily, should be capitalized in the normal way. It is best to be conservative, and to allow for all of the uncertainties that exist in the art world. At some point the AICPA (American Institute of Certified Public Accountants) will issue decisions on these questions, but for now, these issues are decided pretty much at the discretion of individual accountants.

Nonprofit organizations have one problem to deal with that relates to gifts or grants to the institution which are allocated for specific purposes. To account for these gifts, *funds* are established

by the organization so that donors can receive financial reports on the disposition of their gifts. Of course some gifts will simply be given to the organization with no strings attached. These unrestricted funds pose no accounting problems. Restricted gifts must, for accounting purposes, be dealt with as isolated entities with their own assets, liabilities, and funds which must balance. These *funds* will be self-balancing microcosms within the larger world of your accounting system. There are a considerable number of different kinds of funds that your organization might have to account for — Endowment Funds, Annuity and Life Income Funds, Plant Funds, Agency Funds — all of which must be dealt with differently. A good introduction to funds appears in *Financial Management for the Arts*, published by the Associated Council Council of the Arts. (See *Bibliography*.)

In the final analysis it is worthwhile to keep in mind that accounting by its very nature is conservative and understated, and that members of the profession tend to conform to those same biases. Arts organizations usually come into existence through leaps of faith and are sustained by acts of will. Most sound financial advice would argue against starting in the first place, and caution against most expansion thereafter. So though accountants and financial managers are useful, think of these professionals as "hired guns" — go to them when you want a job done. As one business mogul I know puts it, "Good accountants are great at saving money, but I never met one who knew how to make it."

Appendix

CHART OF ACCOUNTS

From *Financial Practice for Performing Arts Companies — A Manual,*
by Mary M. Wehle.

ASSETS

Items in italics are OPTIONAL ACCOUNTS

CASH ACCOUNTS (101-119)

101. General Checking Account
102. Payroll Checking Account
103. Box Office Account
104. Tax Account
105. Petty Cash
106. General Account Savings: demand
107. General Account Savings: time
108. Equity Deposit

111. Marketable Securities

ACCOUNTS RECEIVABLE (121-129)

*121. Accounts Receivable: Subscribers
*122. Accounts Receivable: Other Ticket Sales
*123. Accounts Receivable: Other

125. Advances to Employees
*126. Grants Receivable
127. Reimbursable Costs
*128. Other Receivables

FIXED ASSETS (141-149)

141. Production Equipment: Lighting
142. Production Equipment: Sound
143. Production Equipment: Other

144. Office Equipment
145. Land
146. Buildings
147. Leasehold Improvements

ALLOWANCE FOR DEPRECIATION (151-159)

151. Allowance for Depreciation: Lighting
152. Allowance for Depreciation: Sound
153. Allowance for Depreciation: Other Equipment
154. Allowance for Depreciation: Office Equipment

156. Allowance for Depreciation: Buildings
157. Amortization: Leasehold Improvements

TRANSFERS FROM OTHER FUNDS (171-179)

171. Due from Endowment Fund

OTHER ASSETS (191-199)

191. Prepaid Insurance

193. Utility Deposits
194. Deferred Charges

199. Clearing Items

(*Accrual basis accounts)

Appendix

LIABILITIES AND GENERAL FUND
Items in italics are OPTIONAL ACCOUNTS

CURRENT LIABILITIES (201-229)

201. Federal Income Tax Withheld
202. F.I.C.A. Withheld
*203. F.I.C.A. Accrued
204. State Income Tax Withheld
*205. State Unemployment Payable

209. State Sales Tax Payable

*211. Equity Dues Payable
*212. Equity Pension Payable
*213. Equity Welfare Fund Payable
*214. Hospitalization Payable
*215. Disability Insurance Payable

*219. Accrued Wages

*221. Accounts Payable
222. Notes Payable

227. Bank Loans Payable

229. Loans from Trustees and Others

(*Accrual basis accounts)

NON-CURRENT LIABILITIES (231-239)

231. Long-term Loans: Trustees and Others
232. Long-term Loans: Banks
233. Long-term Loans: Foundations
234. Long-term Loans: Other

DEFERRED INCOME (241-249)

241. Deferred Income: Subscriptions
242. Deferred Income: Memberships

245. Deferred Income: Ticket Sales

247. Deferred Income: Other

OTHER LIABILITIES (251-259)

251. Due to Endowment Funds

RESTRICTED FUND BALANCES (261-269)

261. Restricted Fund Balance: Designated

GENERAL FUNDS (291-299)

291. General Fund Balance

UNRESTRICTED AND RESTRICTED INCOME

SUBSCRIPTIONS AND TICKET SALES (301-309)

301. Subscription sales

304. Ticket sales: full price
305. Ticket sales: special sale
306. Ticket sales: student
307. Ticket sales: groups

309. Ticket sales: other

MEMBERSHIP (311-319)

311. Memberships: individual
312. Memberships: family
313. Memberships: patron

126

UNRESTRICTED AND RESTRICTED INCOME — Continued

Items in italics are OPTIONAL ACCOUNTS

UNRESTRICTED GIFTS (321-329)

321. Unrestricted gifts: individuals
322. Unrestricted gifts: foundations
323. Unrestricted gifts: corporations
324. Unrestricted gifts: bequests
325. Unrestricted gifts: arts councils

BENEFITS AND FUND RAISING (321-349)

331. Proceeds of Benefits
332. Costs of benefits (debit account)
333. Proceeds of fund-raising auction
334. Cost of auction (debit account)

336. Program Advertising

342. Concession Income

OTHER INCOME (351-359)

351. Fees from other companies

352. Interest and dividends from temporary investment
353. Unrestricted income from endowment fund

359. Other income

CONTRACTED SERVICES (361-369)

361. School tour income
362. Contracted performances
363. Other performance grants

EXPENDABLE RESTRICTED GIFTS AND GRANTS (371-389)

371. Income from Endowment Fund for restricted purposes
372. Gifts for special purposes

OVERHEAD EXPENSE

Items in italics are OPTIONAL ACCOUNTS

PERSONNEL (401-429)

401. Artistic Director
402. Managing Director
403. Business Manager

406. Business Office personnel: secretarial
407. Business Office personnel: other

409. Stage Manager
410. Maintenance Staff
411. Promotion Director

419. Allocated overhead personnel costs (credit account)

FRINGE BENEFITS (431-439)

431. F.I.C.A.
432. Pension (Equity or non-Equity)
433. Welfare
434. Hospitalization
435. Vacation
436. Unemployment, State

OVERHEAD EXPENSE — Continued

Items in italics are OPTIONAL ACCOUNTS

437. Insurance (disability or workmen's compensation)
438. Other Fringe Benefits
439. *Allocated fringe benefits (credit account)*

FACILITIES (441-449)

441. Rent
442. Building depreciation
443. Building maintenance
444. Heat
445. Electricity
446. Insurance

449. *Facilities Cost (credit account)*

OFFICE EXPENSE (451-459)

451. Telephone
452. Stationery and supplies
453. Postage and mailing
454. Office Equipment: rental
455. Office Equipment: depreciation

458. Office expense: other

459. *Allocated office expense (credit account)*

FUND RAISING (471-479)

471. Printing
472. Mailing
473. Entertainment
474. Travel

479. *Allocated fund raising (credit account)*

OTHER OVERHEAD EXPENSE (481-499)

481. Professional fees: legal
482. Professional fees: accounting
483. Purchased services
484. Publications and subscriptions
485. Dues

491. Interest on loans
492. Filing fees

498. Bank charges
499. *Allocated other overhead expense (credit account)*

PRODUCTION EXPENSE

Items in italics are OPTIONAL ACCOUNTS

PRODUCTION PERSONNEL (501-529)

501. Artistic Direction
502. *Artistic Direction: Allocated (credit account)*
503. Stage Manager

504. *Stage Manager: Allocated (credit account)*
505. Costumer
506. *Costumer: Allocated (credit account)*

Appendix

511. Actors, Equity: Salaries
512. Actors, Equity: Wages
513. *Equity Actors: Allocated*
 (credit account)
514. Actors, non-Equity: Salaries
515. Actors, non-Equity: Wages
516. *Non-Equity Actors: Allocated*
 (credit account)
517. Actors: fees (independent contractors)
518. *Actors' fees: Allocated*
 (credit account)
519. Stage crew: Salaries
520. Stage crew: Wages
521. *Stage crew: Allocated*
 (credit account)
522. Front of House: Salaries
523. Front of House: Wages
524. Front of House: Fees
525. *Front of House: Allocated*
 (credit account)

527. Other non-performing personnel

529. *Others: Allocated (credit account)*

PERSONNEL COSTS (531-539)

531. F.I.C.A.
532. Equity Pension
533. Equity Welfare
534. Equity, Hospitalization
535. Vacation
536. Unemployment, state
537. Insurance: disability or workmen's
538. Other fringe benefits
539. *Allocated fringe benefits*
 (credit account)

Items in italics are OPTIONAL ACCOUNTS

COSTS OF STAGING (541-555)

541. Theater rental
542. Theater depreciation
543. Royalties
544. Scripts, scores
545. Costumes
546. *Allocated staging (credit account)*
547. Scenery and Props

551. Sound equipment: depreciation
552. Sound equipment: rental
553. *Sound: Allocated*
554. Lights: depreciation
555. Lights: rental
556. *Lights: Allocated*
557. Other pre-production and production costs

559. *Other costs: Allocated*

TRAVEL AND PER DIEM (561-569)

561. Travel
562. *Travel: Allocated*
563. Means or per diems
564. *Per diem: Allocated*
565. Housing

567. Transport of scenery, etc.
568. Other travel costs
569. *Other travel: Allocated*

PROMOTION (571-579)

571. Advertising: radio, TV
572. Advertising: other

574. Tickets
575. Programs
576. Posters
577. Photographs
578. Other promotion

RESTRICTED EXPENDITURE ACCOUNTS

CONTRACTED PERFORMANCES
(601-669)

601. Artistic Direction
602. Stage management
603. Costumers

605. Actors, equity. Salaries
606. Actors, equity. Wages
607. Actors, non-equity. Salaries
608. Actors, non-equity. Wages
609. Actors, fees (independent contractors)

611. Stage crew: Salaries
612. Stage crew: Wages

613. Front of House: Salaries
614. Front of House: Wages
615. Front of House: Fees

619. Other personnel

631. F.I.C.A.
632. Pension
633. Welfare
634. Hospitalization
635. Vacation
636. Unemployment, State
637. Insurance
638. Other fringe benefits

641. Theater rental
642. Theater depreciation
643. Royalties
644. Scripts, scores
645. Costumes

647. Scenery and props

651. Sound equipment: depreciation
652. Sound equipment: rental

654. Lights: depreciation
655. Lights: rental

657. Other pre-production and production costs

661. Travel

663. Per diem

667. Other transportation

RESTRICTED GIFT EXPENDITURE
(571-599)

Reserved for expenses attributable to restricted gifts recorded in accounts 371-389.

ENDOWMENT AND FIXED ASSET FUND

ASSETS

ENDOWMENT FUND ASSETS (801-819)

801. Checking Account
802. Savings Account
803. Marketable Securities
804. Other Investments
805. Due from other funds

FIXED ASSET FUND: BUILDING (821-839)

821. Checking Account
822. Savings Account
823. Marketable Securities
824. Other investments
831. Building
839. Due from other funds

LIABILITIES AND FUND BALANCES

ENDOWMENT FUND LIABILITIES AND BALANCES
(901-919)

901. General Endowment Fund, Balance
902. Board Designated Endowment
903. Current year gifts
904. Interest and dividends required to be added
905. Interest and dividends due to general funds
906. Interest and dividends, due to restricted funds
907. Due to other funds

921. Building fund, balance
922. Transfers from general fund
923. Current year gifts
924. Interest and dividends required to be added
939. Due to other funds

Illustration I

Program Budget: Expenditures, Peacock Players 6-1-77 to 5-31-78

| | Primary activities | | | | Support activities | | | |
| Expenditures | main stage | show-case | school | | admin-istrative | subscrip-tion | general | totals |
	1	2	3	4	5	6	7	8
1 salaries	$14,000	4,000	10,000		6,000	4,000	2,000	40,000
2 office supplies	200	50	300		500	200	200	1,450
3 utilities	1,100	300	1,400		1,000	200	400	4,400
4 promotion	2,000	50	700		50	1,000	300	4,100
5 insurance	1,000	500	200		50	50	50	1,850
6 rent	600	200	600		100	100	200	1,800
7								
8 totals	18,900	5,100	13,200		7,700	5,550	3,150	53,600

Illustration II

Program Budget: Revenue, Peacock Players 6-1-77 to 5-31-78

| Income | general funds | main stage | show-case | school | totals | | | |
	1	2	3	4	5	6	7	8
1 subscriptions		18,000			18,000			
2 ticket sales		6,000	4,000		10,000			
3 tuition				6,000	6,000			
4 foundation grants	1,000	2,000	1,000		4,000			
5 government grants	6,000	2,000	1,000		9,000			
6 contributions	1,000				1,000			
7								
8 totals	8,000	28,000	6,000	6,000	48,000			

131

Illustration III

Cash Budget Projected – 1st Quarter 1978

		January	February	March	
	Opening Balance	16,000—	15,600—	14,800—	
	Income				
1	subscriptions	2000—	1,000—	1,000—	
2	ticket sales	500—	500—	500—	
3	foundation grants	1,000—			
4	government grants	—	2000—	—	
5	contributions	500—	—	—	
6	Total income	4,000—	3500—	1,500—	
7					
8	**Expenses**				
9	salaries	2100—	2000—	2500—	
10	office supplies	100—	100—	200—	
11	utilities	200—	300—	400—	
12	promotion	200—	100—	500—	
13	insurance			500—	
14	rent	1800—	1800—	1800—	
15	Total Expenses	4400—	4300—	5900—	
16					
17	Closing Balance	15,600—	14,800—	10,400—	

Illustration IV

Cash Report January 31, 1978

	Accounts	opening balance	add deposits	subtract withdrawals	closing balance
1	Continental Bank checking acc't	6000—	4000—	4400—	5600—
2	Aetna Bank savings account	5000—	∅	∅	5000—
3					
4	totals	11,000—	4000—	4400—	*10,600—
5					
6	Short Term Investments				
7	certificate of deposit due 2-28-78	5000—	∅	∅	5000—
8					
9	totals	5000—	∅	∅	*5000—
10					
11	total cash 1-31-78				
12					15,600—

132

Illustration V

BUDGET REPORT March 31, 1978	Annual Budget	Actual March 31	Projected to Dec. 31	Favorable (unfavorable) difference
Income				
Subscriptions	18,000—	4,000—	13,000—	(1,000-)
Ticket Sales	10,000—	1,500—	10,000—	1,500—
Foundation Grants	4,000—	1,000—	2,000—	(1,000-)
Gov't Grants	9,000—	2,000—	5,000—	(2,000)
Contributions	1,000—	500—	500—	Ø
Total Income	42,000—	9,000—	30,500—	(2,500-)
Expenses				
Salaries	30,000—	6,600—	24,000—	600—
Office Supplies	1,150—	400—	400—	(350-)
Utilities	3,000—	900—	2,200—	100—
Promotion	3,400—	800—	2,000—	(600-)
Insurance	1,650—	500—	900—	(250-)
Rent	1,800—	5,400—	Ø	3,600—
Total Expenses	41,000—	14,600—	29,500—	3,100—
less expenses	1,000—	(5,600-)	1,000—	(5,600-)

133

Illustration VI

Box Office Report – Performance "Trance Dance" January 16, 1978	1	2	3
COIN			
Denomination	Total		Amount
$.01	300		$ 3.00
.05	50		2.50
.10	60		6.00
.25	40		10.00
.50	40		20.00
1.00	1		1.00
TOTAL			42.50
CURRENCY			
Denomination	Total		Amount
$1	86		86.00
5	20		100.00
20	40		800.00
50	10		500.00
100	6		600.00
Total			2,086.00
Total Cash			2,128.50
Original Amount (minus)			100.00
Box Office Sales			2,028.50

Illustration VII Illustration VIII

RECEIPT Date 1/16 1978 No 5021
Received From Richard Todd
Address 210 W. 108th St. NY
NY 10015 781-4320 Dollars $90
For Tuition - Beller T

	HOW PAID	
AMT OF ACCOUNT	90	CASH
AMT PAID	90	CHECK 90
BALANCE DUE	0	MONEY ORDER

By TH

RECEIPT Date 1/17 1978 No 5022
Received From Hortense Walton
Address 806 W. Diversey Chicago
60614 422-0710 Dollars $50
For Unrestricted Donation

	HOW PAID	
AMT OF ACCOUNT	50	CASH 50
AMT PAID	50	CHECK
BALANCE DUE	0	MONEY ORDER

By TH

RECEIPT Date 1/18 1978 No 5023
Received From Box Office (theatre)
Address "Ashes" Dollars $1065
For Performance Income

	HOW PAID	
AMT OF ACCOUNT	1065	CASH 1000
AMT PAID	1065	CHECK 65
BALANCE DUE	0	MONEY ORDER

By TH

RECEIPT Date 1/18 1978 No 5024
Received From National Endowment for the Arts
Washington, D.C. Dollars $300
For "Dance in the Schools" Grant
Summer - 1978

	HOW PAID	
AMT OF ACCOUNT	300	CASH
AMT PAID	300	CHECK 300
BALANCE DUE	0	MONEY ORDER

By TH

CASH RECEIPTS JOURNAL January 1978

		DEBIT		CREDIT					
		1	2	3	4	5	6	7	8
Source	date	checking amount	savings amount	subscriptions	ticket sales	contributions	Foundations	Gov't	miscellaneous
subscriptions	15	200 —		200 —					
ticket sales	8	150 —			150 —				
ticket sales	9	220 —			220 —				
Paul Smith	14	500 —				500 —			
Lilly Foundation	16	2000 —					2000 —		
NEA	21		1500 —					1500 —	
Peoples Gas (refund)	26	70 —							70 —
Total		3140 —	1500 —	200 —	370 —	500 —	2000 —	1500 —	70 —
		4440 —							4440 —

Illustration IX

Cash Disbursements Journal January 1978

* No separate account for payroll. Taxes withheld and payments to Federal & State gov't are noted in the General Journal.

	date	check #	amount	Federal Tax	State tax	promotion	production	office	utilities	payroll	General account	General amount
Payee												
1 OX Office Supply	13	101	46 —					46 —				
2 Edison Co.	7	102	114 —						114 —			
3 Daily News	9	103	75 —			75 —						
4 AA Lumber	12	104	106 —				106 —					
5 John Smith *	15	105	500 —	150 —	50 —					700 —		
6 City of Chicago	18	106	110 —								theatre license	110 —
7 Philip Orno Inc	23	107	80 —			80 —						
8 State of Illinois	28	108	50 —								State Tax	50 —
9												
10 Totals			1081 —	150 —	50 —	155 —	106 —	46 —	114 —	700 —		160 —
11					1281 —							1281 —
12												
13												

Illustration X

General Journal

	amount	date	check #	amount	
date	Account				
1 Jan	Federal WH tax	150 —			
2 Feb	"	40 —			
3 Mar	"	150 —			
4					
5	totals	340 —	4/30	183	340 —
6					
7					
8					

Illustration XI

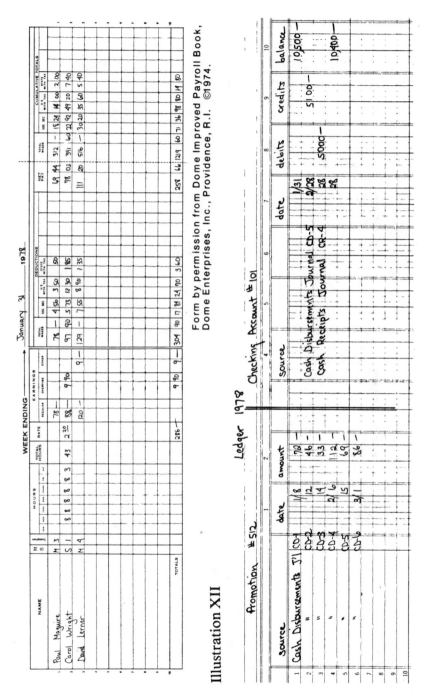

Form by permission from Dome Improved Payroll Book,
Dome Enterprises, Inc., Providence, R.I. ©1974.

Illustration XII

Illustration XIII

INCOME & EXPENSES : CASH, ACCRUAL, & MODIFIED ACCRUAL

December 31, 1977 (end of year)

	CASH	ACCRUAL ADJUSTMENT	ACCRUAL
Income			
subscriptions	17,000 —	-1,000 — ①	16,000 —
ticket sales	14,000 —		14,000 —
foundation grants	4,000 —	-2,000 — ②	2,000 —
gov't grants	8,000 —		8,000 —
contributions	2,000 —		2,000 —
Total Income	45,000 —	3,000 —	42,000 —
Expenses			
salaries	30,000 —		30,000 —
office supplies	1,000 —		1,000 —
utilities	3,000 —		3,000 —
promotion	3,500 —	-1,000 — ③	2,500 —
insurance	1,500 —	-500 — ④	1,000 —
rent	1,500 —		1,500 —
Total Expense	40,500 —	1,500 —	39,000 —

① $1000 in subscriptions for 1978 season
② $2,000 of grant allocated for program in 1978
③ $1,000 in brochures printed for summer of 1978
④ $500 prepayment of liability insurance for 1978 and 1979

Law and the Arts

The not-for-profit method of doing business among cultural organizations has become increasingly popular as operational costs have risen and government, foundation and corporate support for the arts has grown. This chapter will outline some of the things one should consider when deciding whether to incorporate not-for-profit, the procedure by which a not-for-profit corporation is formed and tax exemption recognized, and the operational problems and features of not-for-profit, tax exempt organizations. Laws regulating not-for-profit corporations differ from state to state, so much of this text must necessarily be presented in terms of general rules which may or may not hold true in your own state. Reference will also be made to the law in Illinois when that will be helpful. Because differing laws require this generality, and because properly organizing a not-for-profit corporation to qualify for and then obtain tax exemption may be quite complex, the services of a skilled attorney will be needed for most beginning organizations. Familiarizing oneself with the information in this chapter will nevertheless be beneficial, for the better prepared and more knowledgeable a group is about the processes they are setting in motion, the better professionals will be able to serve them.

It is important to keep the distinction between not-for-profit and tax-exempt in mind throughout this chapter. Not-for-profit refers to the legal structure which an organization adopts under the not-for-profit laws of the state. This not-for-profit corporation then applies to various taxing authorities for an exemption from the tax which the authority is attempting to impose. Although it is necessary to be not-for-profit to be recognized as tax exempt, not-for-profit status does not guarantee tax exemption. And exemption from one tax, such as income tax, will not grant an exemption from other taxes such as sales or property taxes. Although not-for-profit and tax-exempt status are important legal distinctions, most not-for-profit corporations contemplate a subsequent application for tax exemption. Therefore this chapter will speak separately of the two concepts, but they must necessarily intertwine.

WHY NOT-FOR-PROFIT?

While many cultural organizations operate on a not-for-profit basis today, the decision to go the not-for-profit route should not be an automatic one. What are the considerations one should take into account when deciding which method of organization is most appropriate?

One should first ask the question: Is this enterprise being entered into solely as a vehicle for my own individual talents or the talents of a few, or is the benefit of the operation intended to be more broadly based? Is this venture intended to advance and promote a specific work, such as a film, stage play, literary property or dance, or specific careers, or to promote appreciation of a particular art form? If the interest promoted is to be private, a regular corporation or partnership or sole proprietorship may be more appropriate than a not-for-profit corporation for several reasons. First, if the economic benefits of an organization seem to be accruing to a closed circle of people, it may be difficult to obtain an exemption from income tax for the organization. For example, if an individual has a corporation in

his/her own name and is a director, officer, performer, or employee of the corporation, the aggregation of these several roles in one person may suggest to the Internal Revenue Service that the corporation lacks a donative intent or charitable purpose and that it is organized primarily for private gain. So too, if the activity proposed for an organization is indistinguishable from regular commercial ventures, such as an art gallery that sells work, a management agency selling its services, or a film intended for commercial distribution. To gain exemption, an organization must demonstrate that beyond the personal benefit which may come to its employees, the *public* is also benefiting, in a way that it does not benefit from ordinary tax-paying businesses. This will be explained more carefully later, but if one of the reasons for incorporating not-for-profit is to become tax exempt, and that tax exemption is unlikely, then not-for-profit incorporation may be unwise.

The second reason follows from the assumption that those who intend to promote their own talents through an organization also hope that the economic rewards which accrue as a result of the organization's activities will go to them. This may be difficult with a not-for-profit corporation. Salaries are restricted to what is "reasonable", which may be very generous and comfortable, but possibly not enough to pass all the earnings resulting from an individual's work through the corporation to the individual. Additionally, it may be difficult or impossible to pass the assets of a not-for-profit corporation when it is dissolved onto anything other than another not-for-profit corporation, thereby preventing a sole proprietorship, partnership or regular corporation controlled by an individual from obtaining the rewards at that time. As a condition for recognizing an organization as exempt from income tax, the Internal Revenue Service requires that the corporation have in its articles of incorporation a statement that all the assets of the corporation go to another tax exempt organization when the first is dissolved. Most state laws also require that assets held for a charitable purpose must pass to organizations operated for a similar purpose. Of course one always takes one's reputation, knowledge, experience, personal contacts and other

such intangibles along wherever one goes, but if you feel that the project you are beginning will go gangbusters, and you want to retain complete economic control of the rewards of that success, a not-for-profit corporation is inappropriate.

Another important question to ask is: Will this enterprise be self-sustaining, or will it need to rely on financial assistance from other sources? And, if financing from other sources is necessary, what are the likely sources available to the organization, given its purpose and composition? Will the corporation be able to obtain gifts and grants, or will it be more likely to attract investors interested in a financial return? If a group is able to be self-sustaining, there may be no need to become tax exempt, and perhaps the economic rewards and the greater freedom permitted to for-profit organizations may make another structure preferable. If the project to be undertaken involves exploiting a single property, such as a motion picture, stage show, or novel, gifts and grants are less likely to be available while private investor interest may be high. A limited partnership might therefore be the appropriate form of organization. Non-commercial ventures likely to attract gifts and grants may be more appropriately conducted by not-for-profit corporations. The point is that each venture must be examined by itself, and that financial considerations are often critical. Only after considering these matters can the decision whether to incorporate not-for-profit be made.

OTHER FORMS OF ORGANIZATION

In order to place the discussion of not-for-profit corporations in a context, this section will outline the basic forms of business organization.

The three primary methods of business organization are the sole proprietorship, the partnership, and the corporation. A *sole proprietor* is the sole owner of his or her business, such as an independent artist or free-lance designer. The proprietor may have employees, but these employees have no further economic

interest in the business beyond their right to a salary. If you are not an employee, or if you conduct business apart from your responsibilities as an employee, and you do not have a partner and are not a corporation, then you are a sole proprietor. Sole proprietorships do not legally exist apart from their owners, and the personal assets of the owners may be reached by creditors to satisfy the obligations of the proprietorship.

Partnerships are formed when two or more people agree to conduct a business for profit. Although written partnership agreements are the preferred method of organizing, such instruments are often not necessary; partnerships may be formed by verbal agreements and courses of conduct. Partnerships also do not exist apart from the individuals involved as partners, and each partner may be individually personally liable for the entire debts and obligations of the partnership. Partners are entitled to whatever percentage of the partnership profits the partners have agreed to; no partner is entitled to a salary from the partnership except by agreement of the partners. *Limited partnerships* are a statutory form of partnership that operate primarily as investment vehicles and are used often in the entertainment industry to finance the production of a motion picture or stage show. Limited partners are able to limit their personal liability for partnership obligations to the amount of their capital contribution to the partnership, but they, in return are not allowed to manage in any manner the affairs of the limited partnership. *Associations* may be thought of as large partnerships organized about a constitution or articles of association.

Corporations, which are the favored, contemporary form of conducting business, are of two types: regular and not-for-profit. Both are created by the issuance of a charter by the state in which the corporation is formed. Corporations may be thought of as fictional legal persons which exist apart from the directors, officers and employees who run them. They can own property and assume obligations in their own name, sue and be sued, have perpetuity of life, and incur their own tax obligations. Regular

corporations issue shares of stock which, when sold, provide the corporations with capital to conduct their business. The shareholder in turn becomes the owner of the corporation to the extent of his ownership of outstanding shares. Shareholders have the right to vote for the board of directors of the corporation, who in turn elect the officers. The officers manage the day-to-day operations of the corporation and hire additional employees. Dividends are paid to the shareholders from the corporation's earnings. The shareholders, as owners of the corporation (this can be a strained use of the word "owner" in the case of large corporations) are not personally liable for corporate obligations and liabilities except under unusual circumstances. In small corporations formed to conduct the business of one to a dozen people, the shareholders, directors, officers and employees may all be the same group of people.

The most basic difference between regular corporations and not-for-profit corporations is the fact that not-for-profit corporations either have no shareholders, or, if shareholders are allowed, the corporation is not allowed to pay dividends to these shareholders. While not-for-profit corporations in states which prohibit shareholders may issue membership certificates which confer certain rights and privileges, these members are not entitled to a share of the net earnings of the corporation. Not-for-profit status does not require operation on a cost-recovery basis only; a not-for-profit corporation may make a profit from its activities and pay reasonable compensation for services rendered to it and other reasonable expenses of operating. Since not-for-profit corporations either have no shareholders or are prohibited from paying dividends, however, the net earnings of the corporation must therefore be retained by the corporation to further the purposes for which it was formed.

STEPS IN THE INCORPORATION PROCESS

Assuming that your group has decided to incorporate not-for-profit, some of the first issues to resolve will be the corporation's

name, the identity of the initial board of directors and registered agent, and the purposes of the corporation. Most states require that this information be included in the organization's articles of incorporation, which operate as a combination legal description/birth certificate for the corporation. The articles give substance to the corporation by empowering it to act in certain manners and pursue certain purposes while prohibiting it from others. The articles provide a limit, however broad, on the scope of the activities of the corporation.

Generally, each state requires that the name of a not-for-profit corporation be in the English language, not identical to or confusingly similar to the name of another corporation operating in the state, and not misdescriptive of the purpose or functions of the corporation. Usually a name may be reserved for up to sixty days before incorporation, allowing an individual or group with a name important to them time to properly prepare organizational papers if that is necessary. While non-English language names are prohibited, acronyms constructed of a foreign language name may be adopted. For example, in Illinois, an arts organization devoted to increasing the public interest in and appreciation of Latin American Artists, called Movimineto Artistico Chicano, was incorporated as MARCH. Initials are also sometimes permissible.

Incorporation also gives an organization some protection for its name to the extent that a state may refuse to incorporate another group with a name confusingly similar. However, the greater protection for an organization's name in connection with its products or services arises through that organization's *use* of its name and proper state and federal trademark registration. While trademarks and how they are obtained will not be discussed here (consult a trademark attorney if name protection is important) it will be noted that although names may be protectable by legal means, they cannot be protected by copyright statutes. Note also that if a corporation does business under a name other than the one under which it was incorporated, it may have to register with either the state or local government that it is doing business under an assumed name.

Most states require that there be at least three members of the initial board of directors of a not-for-profit corporation. The reason for this is that one person is therefore prevented from having complete legal control of the corporation; any one director may be outvoted by the other two. While we all know that in real life one person may have practical control of a whole room of people, this legal requirement remains. The responsibilities and liabilities of directors will be explained below. While three may be the minimum, in most cases only good judgment will set the upper limit on the number of directors. Groups that are successful in attracting community support, talent and funds will have larger boards reflecting the interests and skills they wish to obtain. As will be explained later, obtaining tax exempt status may also be easier with an expanded board. Often it is the scope of one's project and the speed with which one wishes to see it implemented that will determine when, if ever, the initial three board members are increased.

Not-for-profit corporations are required to designate one person as a registered agent and a registered office within the state of incorporation or operation to receive communications from the state and to be served with a summons for suit in the event that other service is unavailable or inappropriate. In most instances, when an attorney prepares your articles of incorporation, and when the registered office need not be the same as the principal office of the corporation, that attorney will designate himself as the agent. This is a recommended practice if the attorney is to continue as counsel for the corporation, for he will be in the best position to evaluate correspondence addressed to the corporation. If the attorney will not continue as counsel, another person must be designated, which may be one of the original board members.

The articles of incorporation will also contain a statement of the corporation's purpose. This section of the articles is the most critical, and if not properly worded, may cause an organization to fail to be recognized as exempt. In most states, in order to successfully incorporate, it is legally sufficient merely to state the corporation's purposes in language which follows the phras-

ing of the states' not-for-profit corporation statute. Each state specifies the purposes for which a not-for-profit corporation may be formed. These purposes are usually charitable, educational, religious, civic, benevolent, agricultural, fraternal, or something of that kind. A theatre company, for example, could describe its purposes merely as "charitable" or "educational" and successfully incoporate. Problems will arise, however, when such a corporation attempts to gain tax exemption. The reason for this is that the Internal Revenue Service requires greater limitations on a corporation's purposes and activities than the state's not-for-profit corporation laws require. One previously-mentioned example is that state law may require that the assets of a not-for-profit corporation at dissolution go only to other not-for-profit corporations. The IRS more narrowly requires that the assets go only to other tax-exempt organizations. Because the IRS is more restrictive, additional paragraphs must be added to a not-for-profit corporation's articles of incorporation to limit the corporation's power to act in accordance with those purposes for which the IRS will grant an exemption. This language usually tracks language found in relevant sections of the Internal Revenue Code. Of course, if tax exemption is not desired, a corporation would be unnecessarily limited by including the corporate purposes required by the IRS.

Assuming that the basic state not-for-profit corporation laws and the IRS requirements, if applicable, have been complied with, other provisions may be added to the articles. For example, an organization may wish to embellish its statement of purpose with language stating the corporation's high aspirations for quality, achievement and public service. This language must be carefully worded, however, to avoid suggesting that the corporation will be conducting a regular business which may be prohibited by the state's not-for-profit law. The standards by which these articles are measured to determine whether purposes are proper may at times seem inexplicable. For example, in Illinois a theatre company was allowed to incorporate with the following among its purposes: "to establish and maintain a theatre company to perform and present theatrical plays, dramas, musical revues and

other productions of all kinds, with a particular focus on theatre for children." However, a folkmusic society was forced to delete the following purpose before it could incorporate: "to establish and maintain a publishing company to publish and distribute both new and original and newly rediscovered musical compositions, literary works, and other works of authorship for the education and enlightenment of the general public and for the development, encouragement and exposure of writers whose creative expression may or may not be considered for publication elsewhere." The distinction drawn by the state to determine that establishing a theatre company did not connote doing business but establishing a music publishing company did was lost on this writer, but similar eccentricities may arise in your own state. Also be alert to the consequences of indicating that the corporation will be teaching courses or classes. It is sometimes advisable to state that the corporation will not operate as a trade, vocational or business school, for such activity usually requires special licensing from the state. Degree granting institutions are also usually regulated by the state and require special approval to operate. Indicating that the corporation will conduct less formal workshops and seminars usually does not raise any educational licensing issues. Depending on a state's not-for-profit statutes, additional provisions in the articles relating to membership, directors, officers and other by-law type regulations for the corporation may be included.

When the form of articles of incorporation for each state have been completed, they are usually filed with the office of the Secretary of State, where they are examined for compliance with the state's rules and regulations. The Secretary of State will then issue a charter representing the creation of the legal status of the corporation. This charter must often also be filed with the clerk of the county in which the registered office of the corporation is located.

After the incorporation is completed, the initial board of directors of the corporation will meet to conduct the first business of the newly created not-for-profit corporation. At this meeting several important actions will typically be taken. First, the cor-

poration's by-laws will be adopted. If there are provisions in those by-laws for the selection of additional or new directors, that action will also be taken. It is common at this time for checking accounts to be authorized, seals adopted, debts arising from the process of incorporating to be assumed by the corporation and the treasurer ordered to pay them, authorization given to proceed with applying for recognition of tax-exemption, officers elected, if that is the method stated in the by-laws, leases approved, and membership certificates adopted and issued if the corporation has members. All these actions will be noted in the corporation's minutes, which may be kept in a bound book available at most stationery stores. It will be important to maintain adequate and complete records of board meetings and official corporate acts to demonstrate that the corporate formalities have been observed and that the corporation operated as a separate entity rather than as the alter ego of the individuals involved. This is important for maintaining the limited liability that directors and officers share for the liabilities and obligations of the corporation.

BY-LAWS

The by-laws of a corporation structure its internal method of operation. They are the rules of order, dictating how the corporation's affairs will be conducted and what rights and responsibilities are to be assumed by the different people involved with the corporation. The following are typical by-law categories with explanations of the considerations one might take into account in choosing one's own by-law provisions.

Directors — What are the requirements for becoming a director? Legally, there may be few qualifications imposed by a state. In Illinois, for example, directors need not be residents of the state or members of the corporation unless the by-laws or articles so require. The by-laws might require residence in a specific area such as a county or municipality, a certain age range, special interests or skills, or the achievement of a special status or professional accomplishment. These qualifications will depend solely

on the intentions of the incorporators. Just as the board of a regular corporation may be structured to reflect the powers and interests of the corporation's principal shareholders, so the board of a not-for-profit corporation may be structured to reflect the various organizations, communities or interests which the corporation wishes to represent. This may be accomplished by stipulating that certain directorships be occupied by individuals representing the various categories the corporation feels are important.

How many directors will there be? How will they be elected? If the corporation has members, will they elect the directors, or will the directors elect themselves, becoming a self-perpetuating board? In Illinois, members have no constitutional right to vote for directors; the members' voting rights are fixed by the articles or the by-laws. What is the term of office for a director? Will there be variable terms, or will the election of portions of the board be staggered so that the board does not completely turn over at each election? If the board has been divided into several categories requiring different types of people in each, the categories could have variable terms, therefore allowing a preferred category to gain greater board power through their longer term of office. How are directors replaced if they leave before their term expires? How may directors be removed? What are the responsibilities of a director? How often do they meet, and how is notice of the meeting provided? How may special meetings be called? Will the directors be paid? Will there be an Executive Committee of the board of directors to conduct some of the business of the board? What are the quorum requirements for board action? Many state's statutes provide answers to these questions in the absence of by-law provisions to the contrary, or set guidelines which the by-laws may follow. In Illinois, for example, a quorum of the directors shall be a majority unless otherwise provided for, provided that in no event may a quorum consist of less than one-third of the directors.

Members — Will the corporation have members? If so, what rights will they have? Will they elect directors or officers, be entitled

to vote on amendments to the by-laws or articles, will they have no voting rights at all? Will membership certificates be issued? May these certificates be transferred? (In Illinois, mere possession of a membership certificate will not entitle the holder to membership status when there are further qualifications to be met.) What are the qualifications for membership? Geographic location, age, interest, skill, achievement? How are members accepted or rejected? May members be expelled and, if so, for what reasons? How are members reinstated? Are there different categories of membership? Will there be dues? When do members meet, if ever; where do they meet, and what are the notice requirements of the meeting? How may special meetings be called? What are the quorum and voting requirements for members' meetings? May members vote by proxy, and how?

Generally, it will be preferable for smaller cultural organizations to be non-membership corporations or, if there are members, to specify that they have no voting rights. This permits centralization of decision-making authority in the board of directors and allows the board to structure itself by self-election according to the needs which it recognizes. An example of poor membership planning arose with an unadvised Illinois theatre company which made everyone who appeared in a production a member with voting rights. There were no provisions for membership termination. When it was necessary to submit a proposal to the membership, the theatre found they faced an enormous logistical problem in locating everyone and obtaining a quorum for a membership meeting. They then needed to convince the membership of the merit of the proposal in question. The point is that granting members voting rights should be considered carefully, for not only does the organization assume the burden of maintaining membership lists, but those who are the founders of the group and who may have been setting an aesthetic policy unencumbered may find some of their decisions being submitted for group consideration. Just as a cow is a horse designed by committee, so is an arts organization directed by egalitarian notions of consensus likely to produce creative sows.

Even if a group has no members, it is not prevented from

soliciting individual supporters who contribute to the organization in return for certain privileges such as seating or admission priority, gifts, receiving a newsletter, etc. In many instances, these persons may be called *members, subscribers, associates* or a similar name without acknowledging their existence formally in the organization's by-laws. If informal membership is important for your organization, consult an attorney to see whether it is legal in your state.

Officers — What are the officers of the corporation, what are their responsibilities, terms of office, how are they elected, how are they removed or replaced, will they be paid, and what qualifications do they need?

In Illinois, by statute, a corporation shall have a president, one or more vice-presidents, a secretary, a treasurer, and other such officers and assistant officers as are deemed necessary. They may be elected in any manner for terms not to exceed three years, and one person may hold any two or more offices except president and secretary. Officers may be removed by the persons authorized to elect or appoint such officers whenever in their judgment the best interests of the corporation will be served thereby.

A president is typically the chief executive officer of the corporation who supervises and conducts the activities of the corporation. Vice-presidents perform duties assigned to them by the president or board of directors. The secretary is generally responsible for maintaining corporate minutes, giving and serving all notices of the corporation, and acting as custodian of the corporate records and seal. The treasurer keeps a record of the receipts and disbursements of the corporation and is responsible for providing financial reports and statements. These officers may be responsible for the day-to-day operation of the corporation, or an executive director — a staff position — may be created to handle and carry out these responsibilities.

Committees — What committees will the corporation have, if any? Will there be any standing committees? What will be their

responsibilities? Who will be on the committees and how will they be chosen? What will be the terms of the committees? Who will chair them, how will vacancies be filled, what are the voting and quorum requirements for the committees? In Illinois, it is possible to form a committee of directors with two or more directors to act with the authority of the entire board except in certain major areas, such as amending the by-laws. Other committees may be formed as the board deems necessary.

Special Boards — A corporation may wish to form special boards, such as a board of sponsors or an auxiliary board, which will provide services to the corporation as the board of directors delegates. These are non-decision-making groups, except as necessary in fulfilling the responsibilities delegated to them. Such boards are frequently used in fund-raising efforts. Qualifications for membership on these boards may be determined by the corporation, but it is preferable to have the board of directors select the members of the affiliate board or boards, perhaps upon the recommendation or nomination of the affiliate board.

Amendments — How will the articles of incorporation or by-laws of the organization be amended? By whose vote, members or directors? What voting margins are necessary to amend? In Illinois the articles of incorporation may be amended by an affirmative vote of two-thirds of the members, if they have voting rights, or a majority of the directors. The by-laws may be amended as the by-laws specify, such as by a majority, two-thirds, or three-fourths margin.

Miscellaneous Provisions — What is the corporation's fiscal year? Where are the corporation's offices and where are the books kept? What are the purposes of the corporation? (This provision may repeat the language of the articles or may expand upon it.) What are the procedures for mergers or consolidations? How may the corporation be dissolved? Will the corporation indemnify its directors and officers? These and any other rules which the corporation wishes to adopt to regulate its internal organi-

zation, and which are not inconsistent with the articles of incorporation, may become part of the by-laws of the organization. The incorporators should also attempt to envision conflicts which might arise given the special purposes, activities or makeup of the corporation. These conflicts should be capable of resolution by procedures adopted in the by-laws.

It quite often happens that disputes arise within an organization that are not resolved amicably by reference to the by-laws, or where there is disagreement on how the by-laws should be construed or whether they have been fairly complied with. A legal action might therefore be brought seeking relief for a complaining party or the proper interpretation which the by-laws should be given. Courts are usually reluctant to interfere with an organization's internal affairs. They will, however, grant relief to members against by-law provisions that are unreasonable or contrary to law or public policy. Members may also seek relief to insure that fair procedures for such things as expulsion and censure established by by-law provisions are complied with, particularly when economic interests are at stake, as well as professional or career enhancement. Generally, however, an organization's by-laws will be the rules by which the organization is run and should be tailored to the needs of the organization. While state statutes may provide a method of procedure in the absence of a by-law provision, an organization's own set of by-laws may be important to change the effect of those statutes to the extent permitted, when such change fits the needs of the organization.

<div style="text-align: right">THOMAS R. LEAVENS</div>

Liabilities of
Directors and Officers

The qualities of the board of directors and officers of your corporation will be one of the keys to the success of your organization. A board will be the ultimate decision making group for the corporation, with the authority to make "life and death" kinds of decisions about the corporation such as dissolution, merger, sale of major assets and the like.

As a general rule, directors and officers will not be personally liable for the obligations of the corporation of which they are a part. Because the corporation exists apart from the directors and officers involved with it — with those directors and officers acting on behalf of the corporation — it is the corporation's assets which will be looked to to satisfy the corporation's debts and liabilities. There are instances, however, when directors and officers may face personal liability for actions which they have taken. The following are some examples.

Liability for violation of duty — The duty which directors and officers owe to the corporation is termed a *fiduciary duty*, which

means that because they are agents of the corporation, each director and officer must act in the utmost good faith and with due diligence to fulfill the responsibilities of their respective offices. This means that directors and officers cannot secretly profit from their corporate position, cannot acquire an interest in property adverse to the corporation's, cannot use corporate property for personal gain, or in any way act, in their corporate capacity, in a way adverse to the interests of the corporation. Directors and officers will be personally liable for losses which occur to the corporation as a result of a breach of this fiduciary duty due to their negligence, fraud or breach of trust.

The standard by which the acts of directors and officers are measured is called the "business judgment" rule, which means that if a director or officer acts the same as a hypothetically prudent person would under like circumstances, then, even if the act results in loss or harm to the corporation or a third party, the directors or officers will not be personally liable. All business decisions involve risk of failure, but if the decision is made with thought, skill and care, the risk will be borne by the corporation, not the director or officer. This also means that decisions must be informed decisions, and that unquestioned acquiescence to the representations of others, or, in a more extreme example, the abandonment of one's duties in the belief that others will fulfill those responsibilities, will be considered negligent acts. Directors and officers, as a basic duty, must attend meetings and vote on proposals only after becoming fully informed of what they are voting on. They may rely on the reports of experts in seeking to become informed, but again, this reliance must be in good faith.

Liability for ignoring corporate formalities — Because the corporation is a separate legal entity, it must be treated as such by observing what are called corporate formalities. This means that board meetings must be held, by-law provisions followed, corporate funds segregated and not mixed with personal funds, and business conducted with the recognition that the corporation exists apart from the people who serve it. If directors or of-

ficers ignore the corporation or treat it as if it were their alter ego, then a court may look to the actual substance of a transaction rather than its form and find that those directors or officers are personally liable for obligations that would otherwise belong to the corporation.

Personal liability on contracts — Because officers and directors are agents for a corporation, they should sign all contracts on behalf of the corporation in their agency capacity. Specifically, instead of simply signing one's name, one would write the name of the corporation first, followed by the word "by", followed by one's signature and then a recitation of one's corporate capacity. For example, "Arts Corporation, by Thomas R. Leavens, Secretary". One's signature alone, in the absence of language indicating that it is really the corporation that is meant to be bound by the contract, may create personal liability for you. In addition, if you misrepresent that you are contracting for yourself and not the corporation, it is obvious that a person who relies on that misrepresentation will probably be able to enforce personal liability against you.

Liability for failure to deposit withheld taxes — When your organization begins employing people, it will be required to withhold certain sums of money for income tax payments according to various tax schedules. If such sums are not deposited with the proper tax authorities after they are withheld, the persons responsible for the withholding will be personally liable for such sums not remitted. Although this statutory requirement seems obvious and easy to comply with, many organizations run into severe problems with failure to report. Quite often, a decision is made to defer a tax deposit so that the same money can be used for some other pressing need, such as promotion expenses or rent, with the vow that the tax payment will be made up "soon". Meanwhile, the obligation becomes greater as additional withholding amounts accrue, thereby making the next payment more burdensome. The result is that many groups fall behind and have great difficulty recovering. This author knows of two arts groups,

of relatively modest size, which ended up owing back withholding deposits of five figures. Therefore, plan your budget wisely and deposit withholding sums when they are due.

Liability for statutory violations — Most states by statute will prohibit certain acts by corporate directors and officers and impose personal liability or penalties for the harm or loss suffered by violations of the statute. In Illinois, one may not divert funds owing to or for the account of employees. Loans from the corporation to officers and directors are also prohibited, and those who participate in or vote for such loans are jointly and severally liable for the amount of the loan until it is repaid. There are also criminal penalties that may be imposed upon directors and officers for their failure or refusal to answer interrogations, or written requests for information regarding the corporation requiring written answers, which are propounded to them by the Secretary of State, or for knowingly filing false reports with the Secretary of State. Your own state may have similar or additional statutory provisions, so it would be best to check with an attorney before becoming a director or officer to ascertain those acts which are prohibited in your state.

The act of a director or officer may create liability to a third party, such as a creditor of the corporation, or the expenses of defending against such claims, which may be entirely beyond the personal means of that director or officer. In order to attract capable people who might otherwise refuse to serve because of the potentially great liability, some states allow a corporation to indemnify its officers and directors and to purchase indemnification insurance for this purpose. Essentially, indemnification means that if a director or officer actually and necessarily incurs an expense in connection with a dispute which involves them by reason of their position with the corporation, then the corporation will repay them for the expense they have suffered. This indemnification is usually prohibited where liability results from the wilfull misconduct of the director or officer. Check your own state statutes for this provision. Also note that this chapter does not address the rules pertaining to the operation of private

foundations, such as the taxes on investment income, excess business holdings, self-dealing transactions, failure to distribute income, the making of investments which jeopardize the charitable purpose of the foundation, and others. These rules are quite complex and beyond the scope of this work. Be advised, however, that if your organization is classified as a private foundation, any officer, director or trustee who has responsibility for a prohibited act under these rules faces heavy personal tax penalties for the violation. Most cultural organizations will not be classified as private foundations, but counsel should be sought to ascertain the status of your organization to avoid this liability if it does apply.

THOMAS R. LEAVENS

Obtaining and Maintaining Tax-Exemption

The federal government, as a matter of public policy, chooses to encourage certain types of activities through the tax laws. It recognizes that certain organizations operate for a public rather than private gain, and that to burden such organizations with taxes would discourage their formation or that the amount of tax which would be collected from such groups would be small when compared with the greater public benefit which accrues from the operation of the organization. Therefore there has been written into the tax codes an exemption from the payment of income taxes for certain groups formed to further certain favored purposes. These groups are defined in *Section 501 (c)* of the IRS Code and number nineteen in all. The category of exemption which most cultural organizations will be concerned with is *Section 501 (c) (3)*, which is for organizations "organized and operated exclusively for religious, charitable, scientific, testing for public safety, literary, or educational purposes." While exemptions granted under any of the categories of 501 (c) will allow an organization to escape taxation, only donations to organizations

161

recognized as exempt under Section 501 (c) (3) will be deductible against ordinary income by the donor. Organizations classified as exempt under Section 501 (c)(3) also enjoy special status because of the laws regulating the relationship between foundations and the recipients of their grants. If foundations give grants to any individuals or groups other than a 501 (c)(3) organization, then the foundation must undertake fairly rigorous supervisory responsibilities for how that money is used. These responsibilities do not apply to grants to 501 (c) (3) groups. Therefore, most foundations, as a matter of policy, elect to give only to 501 (c) (3) groups to avoid the extra responsibilities.

What are some of the purposes for which exemption has been granted under Section 501 (c) (3)? The list is long, but some examples include art promotion, apprenticeship training, helping musicians, producing concerts, plays and other works of performing art, dancing schools, career planning, promotion of ceramics, financial management assistance, creative arts grants, discussion groups, and many others. "Organized and operated" means that before exemption will be granted to an organization, the IRS will examine the organization's instruments, meaning its constituition, articles of incorporation, by-laws, or trust agreement, and its activities, or the way in which the organization is actually conducting itself to fulfill its stated purposes. It is possible for an organization to pass the organizational test by having properly worded organizational instruments, but fail the operational test by not operating in the manner the IRS believes organizations should operate which are pursuing exempted purposes.

The IRS does not require an organization to be a corporation before being recognized as exempt. Trusts and associations may also be recognized as exempt. Generally, however, it is advisable for most cultural organizations to incorporate rather than attempt to gain exemption as an association, since the laws dealing with associations are more limited and vague and the structure more informal, making the necessary limitation on activity which the IRS requires more difficult to prove. Moreover, operating as a corporation has the other advantages mentioned earlier in this chapter.

Application for exemption — Exemption is obtained by filing Application Form 1023 with the IRS. This application is more properly termed a notice to the IRS of operation in an exempt manner. If this form is filed within fifteen months of the end of month in which the organization was formed, the effective date of the exemption, if granted, will be retroactive back to the date of formation. Otherwise the exemption will date from the receipt of the application with the IRS. If an organization exists as an association for several years, then incorporates and files for exemption, the date of formation will be the date of incorporation. If an organization is not a private foundation, which means essentially that less than one-third of its support is derived from investment income and more than one-third of its support is from the public, or, more generally, that the organization is supported by a broad range of public sources, and the gross receipts of the organization are normally not more than $5,000, then the IRS does not require this notice to be filed. However, as a practical matter, fund raising is impossible without formal recognition of exemption from the IRS, so most organizations file the Form 1023 notice even if they have no receipts whatsoever. Applications typically require two to four months to process and usually require the submission of additional information after the initial application is filed. (See Appendix 2, page 216.)

The IRS will examine the organization to determine whether it is organized and operated exclusively for the proper purposes. There must be evidence of donative intent with the organization, that the activities of the organization will not be engaged in primarily to make a profit, but will be non-commercial in the sense that they are not identical to or compete directly with regular commercial enterprises. For example, a typical arts organization, in order to obtain exemption, should be organized to promote appreciation and support of and interest in a certain type of art or to assist promising but unknown artists who may or may not otherwise have the opportunity to exhibit, perform, or publish. If services, information, exhibits or performances are provided, they should be explained to the IRS as not being available elsewhere, generally because of their non-commercial appeal. It is

163

often suggested that an organization adopt an educational component consisting of classes, workshops and the like in skills relating to the arts in which the organization is involved. These technical and educational services should be offered on a cost-recovery or no-charge basis.

These are only general outlines of the types of purposes typically associated with exempt arts organizations. Specifically, a tax-exempt art gallery, for example, may exhibit work, but is not allowed to sell that work or take a commission from the artist for a sale. The gallery may inform visitors how the artist may be contacted directly to make a purchase of an exhibited work, but it may not act as the artist's agent or as a conduit for the sale. A theatre company presenting original drama may find its exemption rescinded if it produces only the works of a few selected directors or officers who also direct, design, produce or perform in the productions. If the benefit of the economic activity of the organization seems to be accruing only to a small group of people, the IRS may consider that the organization lacks a charitable purpose or donative intent. As another example, an organization whose purpose is to produce original television studio drama obtained exemption upon the representation that the distribution of the videotapes so produced would be limited to non-commercial broadcast or cablecast outlets. Similarly, many arts service organizations obtain exemption only if the services are limited to other not-for-profit or tax-exempt organizations or to those who could not otherwise afford to obtain those services.

The IRS regularly issues revenue rulings which describe certain organizational purposes and activities and then issues a determination whether, given those purposes and activities, tax exemption is appropriate. These revenue rulings serve as guideposts for setting up similar organizations and should be referred to before any application for exemption is filed. Although it is not necessary to have an attorney complete and file this application, such assistance is recommended. Obtaining exemption may be critical for your organization, and it would be unfortunate to organize your activities improperly or to misstate your operations to the IRS. New applications may be filed, or appeals taken on

rejected applications, but the time lost by such false starts may critically impair the momentum of your emerging group. It is therefore advisable to seek experienced representation prior to your dealings with the IRS.

Maintaining Tax Exemption — When the problems of obtaining tax exemption have been solved, the problems of maintaining this exemption begin. The areas of most concern for organizations are unrelated business income, profit sharing arrangements, and lobbying activities.

Unrelated Business Income — The problem of unrelated business income may be briefly stated as follows: the IRS grants an exemption from the payment of income tax on income earned from activities which further certain favored purposes. However, if the organization conducts other activities constituting a trade or business which are unrelated to the purposes for which the IRS has recognized an exemption, and these activities are regularly carried out, then, under certain circumstances, a tax will be owed on the income earned from the unrelated activities.

For example, assume that a theatre company has been recognized as exempt to present works of performing art and to conduct classes in the theatre arts. Income from these activities would not be taxable. However, if the theatre sold advertising, operated a food store, or conducted some other form of unrelated business, income from these activities would be taxable if the activities were regularly carried out. If the theatre company sold advertising for a program booklet distributed throughout an entire season, for example, the advertising income would be taxable. If the advertising was not regularly sold, however, but was obtained for a booklet distributed at a single event held annually or irregularly, then, while unrelated, the income would not be taxable because the trade or business was not regularly carried out.

Even when a trade or business is unrelated and regularly carried out, income from that activity will be exempt from taxation if 1) it is derived from the sale of donated goods; 2) the

people staffing the trade or business are volunteers; or 3) the trade or business is for the benefit of the employees of the organization. For example, if a theatre company regularly operates a second-hand shop selling donated merchandise, the operation is clearly a business and is clearly unrelated. However, the income will not be taxable because the goods are donated. Or, even if the goods were purchased, if the staff of the store were volunteers, again the income would not be taxable. If the same theatre company operated a lunch counter open to the general public that used paid staff and purchased its food, income from that business would be taxable if regularly carried out. However, if the lunch counter was set up for the *employees* of the theatre company — and not for the public, the income would not be taxable.

Income from debt-financed property, such as rent from a building which an organization purchased by taking a mortgage, is also unrelated business income which is taxable.

What does this mean for your own group? The main points to be gained from this are that 1) there are enough variables brought to bear upon the question of unrelated business income to allow creative groups to structure their unrelated activities in a manner which avoids taxation; and 2) it may be necessary to keep separate records of the receipts and disbursements involved with unrelated activity. Also keep in mind that if a tax is imposed, it will be on income, not revenue. Therefore, if you operate on a cost-recovery basis, where expenses equal revenue, there is no income to be taxed. Note also that tax will be due only upon unrelated business income in excess of $1,000; the first $1,000 is exempt.

Profit Sharing Arrangements — It quite often happens with tax-exempt performing arts organizations that, upon the successful presentation of a production, they are approached by groups or individuals interested in investing in that production or another production in which they or the investor hold an interest. These offers differ from offers of contributors or gifts to the group, for the expectation is that a profit will be made which will be shared between the investors and the arts group. Such arrange-

ments raise questions about the extent to which tax-exempt groups may engage in profit-sharing activities.

As a basic premise, a tax-exempt organization cannot, other than to an insubstantial amount, engage in activities which are not in furtherance of their exempt purpose. To the extent that a production is a regular commercial enterprise which does not further the corporation's purposes, profit sharing participation might threaten the organization's continued exemption if it becomes a major corporate activity. Certainly, if the resources of a tax-exempt company are continually risked in ventures which result in private profit, the charitable purpose and donative intent of the exempt company might be questioned.

The point is not to advise that profit sharing arrangements should not be undertaken — for they may be very beneficial to a company and are common in the performing arts — or that such plans are sinister, but to suggest caution and counsel in arranging such ventures to avoid undesirable tax consequences. Alternatives to profit sharing may be loan arrangements, purchase of services of the exempt company by the commercial organization, or the licensing of the right to present a production commercially from the exempt company to the commercial company. Competent legal advice should be sought to inform your group of the tax implications of any such venture it enters.

Lobbying — Tax exempt organizations face an absolute prohibition against campaigning on behalf of candidates for public office or contributing to such campaigns, and, until recently, could only lobby if such lobbying activity constituted an "insubstantial" amount of the group's total purpose and activity. While the ban against electoral politics is still the law, the Federal Tax Reform Act of 1976 provided the means by which 501 (c) (3) corporations may now expend up to 20% of their exempt purpose expenditures for lobbying.

In order for an exempt organization to lobby, it must first examine its corporate charter to determine if such lobbying is allowed. Because the prior law allowed only insubstantial lobbying, many corporate charters still include provisions inserted by

attorneys limiting the corporation's lobbying activity to satisfy earlier IRS requirements on the matter. If your corporation's charter bans or limits lobbying, an amendment of the charter may be necessary before the corporation may begin the more vigorous lobbying effort now allowed.

Second, the organization must file Form 5768, "ELECTION BY AN ELIGIBLE SECTION 501 (c) (3) ORGANIZATION TO MAKE EXPENDITURES TO INFLUENCE LEGISLA-TION", with the IRS. This form notifies the IRS of the group's intentions and will trigger reporting requirements at the end of the year to document this lobbying.

If the lobbying election is made, the organization will be permitted to expend up to 20% of the first $500,000 of its exempt purpose expenditures for the year, plus 15% of the second $500,000, plus 10% of the third $500,000, plus 5% of any additional expenditures — subject to an overall maximum of $1 million for any one year. Lobbying is defined as an expenditure for the purpose of influencing legislation. Within these limitations is a separate limitation for "grass roots" lobbying, which is "any attempt to influence any legislation through an attempt to affect the opinions of the general public or any segment thereof". The limit on grass roots lobbying is 25% of the group's total lobbying expenditure. This means that while 20% of one's expenditures may be used to communicate with legislators or other government officials or employees who may participate in the formation of legislation, only 25% of that amount may be used to communicate with the general public directly. However, to the extent that executive, judicial and administrative bodies such as schools and zoning boards and special authorities do not participate in the formation of legislation, contact with them will not be considered lobbying.

There are other types of activities in which an organization may engage which are not considered to be lobbying. Groups may 1) make available the results of nonpartisan analysis, study or research; 2) provide technical advice or assistance (where such advice would otherwise constitute the influencing of legislation) to a governmental body or to a committee or a subdivision thereof in response to a written request by such body or

subdivision; 3) appear before, or communicate to, any legislative body with respect to a possible decision of such body which might affect the existence of the organization, its powers and duties, tax exempt status, or the deduction of contributions to the organization; 4) communicate between it and its bona fide members with respect to legislation or proposed legislation of direct interest to the organization and such members unless these communications constitute grass roots lobbying; and 5) communicate with a government official, other than a) a communication with a member or employee of a legislative body (where such communication would otherwise constitute the influencing of legislation) or b) a communication, the principal purpose of which is to influence legislation.

Staff time of an organization will be counted as an expenditure of the organization if the time is paid. Therefore, if there is some question whether your organization will be able to stay within its lobbying limits, and there are volunteer hours to be assigned, it might be advisable to have the volunteers devote their time to the lobbying effort, since their time would not be included within the organization's expenditures. Other expenditures would include telephone, postage, travel and printed material used in the lobbying effort.

REPORTING REQUIREMENTS

The reporting requirements of not-for-profit corporations will of course vary from state to state. There are, however, federal forms which are required of all organizations and some general types of additional reports which may be noted.

If a not-for-profit corporation has not been recognized as tax exempt, it must pay corporate tax at the rates established for regular corporations on its taxable income, subject to the $5,000 exemption mentioned earlier. A 501 (c) (3) exempt organization must file an informational return, an *IRS 990 and Schedule A*, annually on or before the 15th day of the fifth month following the close of the organization's accounting period. If the corporation

has unrelated business income exceeding $1,000, then an additional form *IRS-990T* must be filed. If the corporation begins a payroll, then it must begin withholding money for federal tax payments and remitting that money to the IRS. Organizations exempt under Section 501 (c) (3) do not have to make Social Security payments (FICA taxes) unless they *elect* to make payments either by filing *IRS Form SS-15* or making FICA payments for three consecutive quarters. If the corporation elects Social Security participation, then it will file a quarterly *Return of Withheld Income Tax, IRS Form 941*, due on or before the last day of the month following the last month of the quarter. If it does *not* pay FICA taxes, then it will file a different quarterly report, an *IRS 941E* within the same period. An organization exempt under 501 (c) (3) is also exempt from paying federal unemployment tax.

On the state level, not-for-profit corporations will generally be required to file annual informational returns along with the appropriate withholding payments if there is a state income tax. Liability for state unemployment compensation will also vary from state to state. Generally, not-for-profit corporations must pay into their state's unemployment compensation fund, although many states allow not-for-profit corporations to be self-insurers. This means that instead of paying a regular tax, the corporation only repays to the state those amounts which former employees draw from the compensation fund. Workman's compensation coverage varies from state to state, although generally the activities of most cultural organizations would not be such that state law would require the organization to obtain insurance coverage for its employees. Check with an attorney to see whether your state requires coverage. Of course, with both state unemployment and workman's compensation, a corporation may elect to have coverage even if it is not required by law. In many cases, unions representing performing artists require, as a matter of contract, that an employing corporation provide this coverage for its members before they are allowed to work.

Because one of the important reasons an organization becomes tax exempt is to solicit funds from foundations, govern-

ment and the general public, such groups should investigate the laws that may exist in their states regarding registering for charitable solicitation and the reporting requirements, if any, which may be imposed. In Illinois, for example, all organizations receiving or attempting to solicit more than $4,000 during any twelve month period ending June 30th of any year must register with the Attorney General. Annual reports are also required, and in some cases, particularly when professional fund raisers are employed, certified audits must be conducted of the organization's records. Moreover, in Illinois, if an organization sends free goods to potential contributors as part of their solicitation, no more than 25% of the total funds raised by such method may go to the manufacturer or supplier of such goods. The Attorney General is also empowered to enjoin fradulent fund raising schemes and may, in extreme situations, revoke the corporate charter of an organization employing such tactics. Municipalities also typically have provisions regulating street corner and door-to-door solicitation. Fund raising is a sensitive area of public relations and skill, and the law of your own state should be carefully complied with to avoid the possible embarrassment or distrust which a finding of noncompliance might cause.

SUMMARY

In sum, forming and operating a not-for-profit corporation requires special knowledge and a commitment to undertaking certain functions wth a sense of business order and practice that may or may not have been apparent in the initial excitement of thinking about a group. Don't let business handicap your creative activity. If business intrudes or hampers your creative effort, recognize that it nevertheless needs to be taken care of and bring someone into the organization who can deal with it. But don't ignore sound business and legal practices, for the result will generally be the loss of the creative vehicle that you've worked to create. Technical assistance is often offered through state and local arts organizations.

THOMAS R. LEAVENS

Three Interviews
and Case Studies

The three arts administrators whom I chose to interview for this book come from three successful arts organizations. All three are respected by their peers, and by any set of standards must be judged extremely capable administrators. All of them have, or have had, serious involvements with the arts which they now administrate. At the same time, each has made different choices about the structure and internal operations of their organizations.

The Chicago Alliance for the Performing Arts (CAPA), as a membership organization and advocate for other arts groups, tends to be the most conventional in structure. Their board is carefully chosen with membership from many different segments of the community. Their funding comes primarily from large grants from prominent foundations. The decision-making process at CAPA comes from the top down. The success of the organization is a function of the need for the services that the group provides and the competence and drive of the staff. The choices that they have made reflect, in part, their need to be the respect-

able representative of performing arts groups which sprang from the anti-establishment theatre underground of the sixties.

At the other pole is N.A.M.E. Gallery, which has an unconventional board of directors composed of friends and other artists of kindred spirit, financing from within the group itself and the government, and a more collective decision-making process. The success of N.A.M.E. is a function of the passion that the members and the administrators have for what they are doing, the wide-ranging scope of the gallery's activities, and their successful promotion of these diverse activities.

Somewhere between these two is The St. Nicholas Theater Company, which seems to bridge both worlds successfully. To administrators, foundations, and government arts agencies St. Nicholas is professional, organized, business-like. Peter Schneider, the managing director, has even been seen with the *Wall Street Journal* sitting on his desk. To the community of artists St. Nick is an adventurous and flexible theatre. Their ability to sustain this double identity comes from the ability of the Managing Director to work both sides of the street, and to keep the administrative and artistic halves of the theatre working together.

In all three instances the success of the organization is to a great extent the result of the effectiveness of the chief administrators. Though all of them are dealing with the same set of problems, their solutions have been dramatically different. These differences suggest that there are not cut and dried rules for running arts organizations, only general guidelines which must be altered to fit each individual situation, and each group of living, working, people.

The purpose of this chapter is not to present three perfect administrators or institutions, but to give the reader a more vivid sense of how the elements of an arts organization that I have talked about in this book fit together in active, fertile, real-life situations.

RUTH HIGGINS AND THE CHICAGO ALLIANCE FOR THE PERFORMING ARTS

CAPA — The Chicago Alliance for the Performing Arts is an arts service organization which was set up in the summer of 1974 to act as an advocate for small theatre groups. CAPA is a membership organization. We operate on three basic principles. One, we are set up to lead groups to information or to people so that they can take care of their own business — we are facilitators. The second principle is that we never promise to do more than we can. Third, we try to respond to the *overall* needs and requests of the performing artists by providing programs and services which affect all performing arts groups and which are aimed at developing new forms of support.

Three years ago several theatres in Chicago got together and went to the Chicago Community Trust — which is the city's oldest foundation. They spoke with the Executive Director, Bruce Newman. The Trust had funded one or two small theatre groups, but hadn't felt terrific about these grants, sensing that they didn't know enough about what was going on to properly evaluate these groups. With their broad-based community orientation they suggested that they would like to do something for all the theatres. They told us to go away, to get ourselves together, and then to come back to see them.

At that time I was on sabbatical for a year from the college where I was teaching, and felt that I had the time to get the then Chicago Theatre Coalition organized. In September of that year we came out with our first news letter, ". . . Asides", which we sent out to that first group of fifteen. Now we send out 800 a month to the entire performing arts community. In October of 1974 we went back to Bruce Newman of the Trust with a brief proposal. His reaction was that we had one major "asset" — me, which was to say, one person with the time and the inclination to do the work. He said that he was prepared to give me free office space, use of the telephone, the xerox, postage meter, etc. We were to take it from there.

The first year was spent laying the groundwork for the organization. Bruce Newman, through a contact, found us a lawyer from a prestigious Chicago law firm to help us set up our by-laws, our corporate structure, and to get our tax exemption from the IRS. This is a contact which has proved invaluable. Our lawyer is terrific and has given us excellent advice over the years. The first year we had endless meetings; the organization met every two weeks, the executive committee met every week. And *oh* those meetings. They were something. Some of them went on for five or six hours hashing over things; people coming to terms with what they were giving up and what they were getting in return. It seemed endless. Those meetings were very important, though, because our membership was shaping the organization. At that point our membership was up to about twenty-five. Of course some of the groups weren't very organized themselves. But I think that as a result of being part of an umbrella organization, and seeing what other groups were doing, these groups had an additional motivation to get themselves better organized.

In addition, during that first year, we attempted to get the press to give our groups more attention. In this we were moderately successful. It is hard to influence the press, but we were able to at least get them to provide more comprehensive listings for the groups. Also by providing a listing of opening nights, and trying to avoid conflicts on these nights, we made it easier for them to get around, and to find out from a single listing what was happening.

In February of that same year I went back to Bruce Newman to talk about the idea of a voucher system set up on the order of the one in New York. I had been in New York in the fall of that year and had been taken on tour of the Theatre Development Fund's (TDF) voucher program and other ticket programs. Then Bruce arranged for us to visit the TDF people together, and was quite impressed with it. He felt that this was a way of helping everyone, and of working on audience development. TDF's recommendation was to set up two days of meetings with representatives from all the performing arts institutions large and small, and potential funding sources, to get some sense of what

was going on in the city. We did a preliminary survey before the meetings to determine how many empty seats the thirty-three groups had that we had surveyed the year before. People of course don't like to tell the truth about how many empty seats they have, but we came up with a rough estimate of 77,000 empty seats from the previous year. That looked significant to us.

Bruce was still interested after this. I was interested, but had to make a decision about going back to teaching the next year, or of having to repay my salary for the year I was taking off. I decided not to go back. The Trust wanted to do more preliminary work on the voucher system. We put together a committee of people involved in theatre, and some not so closely involved, to try to figure out what the voucher program should look like, and to whom we should sell these vouchers. The Trust hired me as a Summer Intern to work on the steering committee for the voucher program.

In September of that year, our second year, we got one CETA position to hire an assistant for myself, and in November of that year we moved into our new offices and I was officially hired.

During that period I was working on writing the main part of the proposal to the Trust. That stage of funding got us $4,000 from the Borg Warner Foundation, $7,500 from the Illinois Arts Council, and the bulk of the start-up money from the Trust — $30,000. We had a six-month period to do all the design and computerization for the program, to do our printing, to figure out all the preliminary work for the system. At this time also we published the *Publicity Survival Manual,* a nuts and bolts, "how to do your own PR cheaply but well if you have the manpower."

In the course of working through that first year I met many additional funding sources and some doors were opened through the Trust. Even some foundations which seemed rather skeptical gave us some money. It was encouraging to meet with some of our most severe critics a year later and to see how their feelings about us and small theatres in Chicago had changed. Our problem was a complicated one. These foundations knew about the Art Institute and the Lyric Opera but had little information about small performance groups. And from the other side, these thea-

tres were an outgrowth of the anti-establishment, radical, hippie theatres of the sixties. The fact that the Trust put their seal of approval on us was a most important step in our development.

CAPA's emphasis currently is on corporations. I am making two calls a week now, just trying to get my foot in the door using contacts I have, and those of friends. It's rough. You have to do this in person. You have to convince people that you are organized, that you have your figures and facts together, and that they *should* be interested. The ball is just starting to roll. Corporations are beginning to give small amounts. In addition, we sent out a study to explain to businesses and foundations how to evaluate small performance groups, so maybe the individual companies will get funding, too. There is a lot of money in this city, and just because the major institutions get support, doesn't mean that smaller groups shouldn't get any help at all.

There are more and more people in the business community and in foundations who are getting involved in the arts. The reason I think is simple, the arts are fun for them.

When we first got started the people in the Chicago Theatre Coalition were afraid to give up control of any sort. When we were getting incorporated they wanted to be on the board. Our lawyer was appalled at this. The compromise that we reached was that there would be a board of nine; three of the directors would be from the member organizations and six would be from the outside. We have plans to increase that number to fifteen. In the beginning , the three members of the board from the membership tended to control the board — because the three were very involved in setting up the organization and were actively involved in its development. So for the first two years the board worked in this way with the directives coming from the membership to the board. This has begun to change a little, with the board accepting more responsibility. As a result of the changes in the organization, criticism of the board from the Black Theatre Alliance, and our own thinking on the subject, we began to feel that there was a huge community out there which we were to serve, as well as our own members. So the nominating committee decided that the board should reflect the varied communities and

aspects of Chicago. All the board is elected by the members based on a ballot prepared by the nominating committee. Now, we have on our board a lawyer from a prominent law firm, A VP from a sizable company, a high school teacher who was on the board of the Guthrie and other arts organizations, an ex-alderman, a visual artist on the faculty of Northwestern University, a woman with an urban research group. It is quite a diverse mixture of people, but a stimulating one, one that is genuinely concerned with the arts and the communities of Chicago. And the board is getting to be more active in fund raising, selling vouchers, and making contacts for us. Right now it is basically a policy making board, though there is some involvement in the day-to-day operation of CAPA. This board is giving us access to groups that we need to approach to make them aware of the performing arts in the city. The staff tries to do what is necessary to bridge the gap between members, the board, and the general public.

We now have five people on the staff, and CAPA has become an effective spokesman for the performing arts. We have new plans such as *The Learning Directory*, and *Chicago Performs*, but are beginning to plan for the next few years, trying to see in what ways we can service the performing arts community in Chicago. The future of CAPA? Maybe if we do a great job, ten years from now there won't be a CAPA; our programs will have worked so well that there won't be empty seats in any Chicago theatres and concert halls.

I think that it is important to remember that the Chicago Symphony and the Art Institute got where they are because they were given both the necessary financial and moral support of this community. We should have several theatres and dance companies that are comparable in quality. This doesn't happen overnight, but in order to make it happen our performing arts groups need and deserve to be nurtured so that they can reach maturity.

RUTH HIGGINS

PETER SCHNEIDER FROM ST. NICHOLAS THEATER COMPANY

I am from St. Nicholas Theater. We are a theater producing our own work and offering a series of professional classes in theater and dance. We have a main stage subscription series dedicated primarily to new plays and our classes are designed to train students to perform in our main stage events.

St. Nicholas was started by a group of artists interested in doing theater. Originally, David Mamet was the guiding light of the theater. He was basically an educator. The group went around from space to space doing performances. The first year they were together they spent around $12,000 and they earned $12,000. Simple. At the same time they started classes. There was no clear program, they decided just to do everything at once. At this stage all decisions were collective ones. There was an inner group of from three to five who constituted the board, plus a company of thirty-five — all of them people involved in the theatrical productions. Every month they had a big meeting and made all of the decisions.

After this first year they decided that if they were going to do this seriously they needed a building. So they looked around, found a space, and with $6,000 they converted an old printing company building into a theater.

At this point in time they were doing *American Buffalo*, a David Mamet play. The next production which they did here was *A View from the Bridge*, which was Stephen Schacter's professional debut. Before it had finished its run they had already decided to do another play, and it was at this time that they decided that they needed some professional management. They didn't quite know how to go about finding someone, they didn't advertise in the right places, but by chance a friend of mine saw their advertisement in the Chicago *Reader*, and sent me the clipping in New York. I responded with a resumé, we got together and talked, I saw *A View from the Bridge* and decided that they knew what they were doing theatrically, I was offered the job, and accepted it. As I was hired David Mamet left for New York.

In that year, they brought in $100,000 and spent about $105,-000. Of course no books were kept, the checkbook wasn't balanced, if checks cleared fine, if not, well too bad. There was no paid staff. A little CETA money. Grants were written late. Classes were filled, performances were well attended. But there was no management. No one was committed to running the theater, though the group was committed to making theater. It was clear **to me** from the start that it was going to take at least a year to change things. It was my feeling that to make money, to make things run efficiently, we were going to have to spend money. We went in one year from a budget of $105,000 to a budget of $250,000. We went from an organization which was breaking even to one which had a $20,000 deficit. Now this was quite a shock to everyone. Here was a small organization held together by chewing gum and magic, which was suddenly hiring professional management, and this management was putting them into debt. It was very scary for everyone.

One of the first decisions that we made was to hire a full-time staff, and in this we were different from all of the other small theaters in the city. We made a conscious decision to be a full-blown theater that would attempt to run with or without government or foundation funding for positions or projects. To me it just didn't make any sense to always be just scraping by, not spending enough money on staff, having a few people supported for part of the year, and then on unemployment for the other half of the year. You can only live that way for so long. So far, the theater has been able to support us all working full-time.

Our next step was to contact FEDAPT, a theater management organization, but they wouldn't touch us without a managing director and an artistic director. We still had our committee of three making the artistic choices. I had felt that we needed one artistic head all along, and this came home to Patricia, one of the members of that committee, when we went to a FEDAPT conference where everyone kept asking her how come we hadn't gotten an artistic director. Suddenly she changed her mind, came back to Chicago, said, hold on guys, I want my staff job, but I don't want to be part of the artistic committee. At the same time Bill

Macy, the second director, decided to be an actor full-time, so this left Stephen Schacter as the Artistic Director.

At the same time I was pushing to expand the board of directors from the three to fifteen, eighteen, thirty — which is our current goal. The board is the long term policy making organ of the institution, and it was my feeling that the theater should be independent of the personnel who run it. The board must have ultimate control to hire and fire us, and to replace us if we leave. Now this involves giving up something for the people who started the theater, and it was not an easy change for us to make, though I felt an essential one. In the end the idea prevailed and we started looking for board members. We decided to look for people who actively supported us, not just socialites. We also wanted people who had expertise in areas that related to our needs. We started with contacts that we had, and decided to ask nineteen people to join our board. We wrote letters asking everyone to get together and to sit down and talk about it. No commitment was asked in advance. Of this group, twelve decided to be on the board. Most of them had never served on a board before.

So now we had our board. The next step was to begin to educate them. We went to them and asked them to ratify our decision to make Stephen the artistic head of the theater and to vote on his salary — which they did. There has been minor committee work on the board, since then, but over the past six months some members of the board have become frustrated. There was a feeling that something wasn't going quite right, even though no one could put their finger on it. Our meetings tended to focus on day-to-day management problems, money problems, but with little talk about long term planning. In analyzing our situation we felt we had a well organized theater, a board that was getting more sophisticated, but still groping with the problem of actually leading the theater. Though with less involvement in our immediate day-to-day problems and more concern for our future.

Our weakest area has been fund raising, and we just put a professional fund raiser on the board. I went to him and said, "Hey, treat us like a professional organization. Tell us what we

need. Tell us how to make this theater more business-like." He said that we needed a feasibility study done to see what the potential of this community is. This would cost $3,000. There was no way of getting it for free. So this led to our first major conflict within the board. I wanted to pay the $3,000 to find out what we are doing, even if it just amounts to having someone tell us that our house is in order. The board felt threatened by this, as though the fact that we needed it meant that they weren't doing their job. Part of my feeling was that the whole process would be educational for all of us, even if we don't find out one thing that we don't know, because we will be hearing what we and aren't doing from someone from the outside, and that is bound to effect us. Our board is just starting to realize that they run the St. Nicholas Theater. They haven't given the theater a lot of money yet. They don't think we're ready, or that we have a crisis big enough to warrant their help. But now, some of them say, "Hey, I haven't given you enough this year."

They are beginning to realize their role in the theater, and through them we are making corporate connection from whom we will get money. Let's face it, no one ever gets money from corporations without knowing someone. These are contacts which take time to develop, time for them to see who you are, and that you are ok.

Money is of course always a problem. We tend to spend next year's money this year. For example we got our subscription funds for next year this year. We didn't have $6,000 for air conditioning, even though we had gotten the air conditioning itself donated and just had to put in the venting and duct work. We thought, though, that we could take this $6,000 and make $18,000 with it over the summer. In the same way we go to our bank — Mid Town Bank — and borrow money, and make money with it, and repay it, and then double our loan next time. You need a banking record, and you need a bank that is willing to support you. We've spent a lot of time cultivating this relationship. Right from the start we went in to meet the president of the bank and to tell him who we were and what we were about. His is a new bank in a new community, and we are part of his community.

The relationship works both ways. We generate business for him. He loans us money when we need it, but he also sits on our subscription fund account and checking fund account. We are currently borrowing $5,000 from him, and this figure has been as high as $11,000. It's a good deal for them as long as we continue to repay our loans, and at some point we are going to need $50,000 or $100,000 and will have to be in a position to go into him and get that money. In many ways though he is loaning the money to me, because he trusts me. A lot of business relationships are one-to-one like that.

It is important that our record keeping is accurate and fast, so we know exactly where our money is going and how much things are costing. You have to be even more efficient if you are working without capital reserves. We got our accountant to set us up in such a way that we can get this information at the beginning of every month for the previous month. For $25 we get a computerized statement, each month, though it cost $1,000 to get on this service. We are a business and have to run like one. We don't want to always have deficits. We don't exist to make money, but we do exist to cover our costs. I have to know if a show is making or losing money, if a class is worth running, if we can afford to have something in our building.

I feel like a lot of arts organizations should just forget it, particularly the ones that have been floundering around for years, and haven't gotten themselves together. Some foundations seem to be operating on this principle too, giving more money to fewer groups, and giving money where they can see it generating more money, and hopefully self-sufficiency.

This has been the tack that we have taken in our fund raising; give us money for this position this year, and next year it will pay for itself, and the year after it will make us $20,000. That makes sense to people who are giving you money.

What its all about, in a way, is giving people the chance to work in one place with some kind of security. Then the work can either sink or swim, but on its own merits.

PETER SCHNEIDER

BARRY HOLDEN FROM N.A.M.E. GALLERY

N.A.M.E. Gallery is a not for profit, tax-exempt organization located in a loft-like space at the north end of the Loop in Chicago. We have been in existence since 1973. Our main function is to present the visual arts, though we do have a comprehensive performance schedule of music, dance, and theatre.

We are run by a group of from six to ten artist / members. This size tends to be ideal for running an organization like this — with more you lose a certain intimacy, and with fewer there simply aren't enough to staff the space. We have a president and secretary and treasurer only on paper — in reality we are equals. The members are all on the board of directors.

Things have changed in the past year. At first the board, the members, used to do everything. Now we have three people running the space, which means that we have the board, the director of the space and the assistant director. Hopefully the board will have more time to talk about art, to make policy decisions, and to be less and less involved in the day-to-day running of the place.

You see we started out as a group of five friends who wanted just to talk about art — all of us were visual artists, and most of us were from the Art Institute of Chicago. Within the first couple of months we got the notion to start a gallery. There was no place for so called non-imagist art — abstract for lack of a better word — in Chicago. It wasn't sour grapes on our part, we wanted a place where we could control our shows, rather than just giving our work to a gallery. Usually artists have banded together in this fashion because they need a place to show and don't have access to one. This was not our motivation; we wanted to run a space, a space that was a loft space, more like an artist's studio, to distinguish it from your white, pristine gallery space. At that point for example I was doing these neon chairs, very messy and weird, and not for your conventional gallery.

Having decided to find a space we got incorporated, we found a lawyer through the Lawyers for the Creative Arts. It turned out that our lawyer was extremely good, a man who has worked

185

with us over the years, and who has learned an enormous amount about setting up a not-for-profit space like this.

It's a little hard to explain exactly what kind of place we have set up. Last December we went to a meeting of the National Endowment for the Arts on alternative spaces. I thought that we would find spaces like ours scattered around the country, but there really wasn't anything exactly like us. It is an important part of our identity to be an "alternative" space — an alternative to museums and to commercial galleries, and also somewhere off from a community arts center. We, for example, don't take a commission on work sold, we let the transaction take place between the artist and his buyer. We don't have a stable of artists and we don't have a permanent collection like a museum. Nor do we have benefactors and patrons like a museum, though it is true that we do have some contributors. We don't have an auxiliary board. We control the space ourselves, and this is important to us. We are a group that supports art, that is here for the community of artists of the world, not just of this area.

N.A.M.E.'s aesthetics are those of the group that is running the space at any one time. We will show an artist if two thirds of the group support that artist. At first we were set up in such a way that it was necessary for an artist to have approval of the whole board, which led to some incredible fights, with people screaming at one another and running out of meetings hysterical. That wasn't too workable. For anyone to please ten other artists is quite a task. So we decided on two thirds. Anyone can apply for a show here, but with the gallery run by us we can ask people to submit slides. We get about thirty-five sets of slides a quarter, and you figure we have twelve shows a year. We have now six two- to three-person shows, four special shows like a book exhibit. Two shows this year will be done by outside curators; we will give them complete autonomy to do whatever they want. We have had a show of local New York Artists and another one which will be an exchange show with a Toronto gallery. The members of N.A.M.E. can show every year and a half. Most of the shows are from outside people — maybe 70% — and this distinguishes us from a cooperative gallery.

The ideas about what the space is going to be, come from the inside, and that's why the size of the group is so important. If the core group is too large you can be pulled in too many directions at the same time, and all of the ideas can be good ones, you just can't do everything. Another thing we learned was that it was not so great for everyone to be responsible for everything. Now individuals are responsible for specific projects. In this way it is their work and they get the praise or the blame. From an almost-commune we have become much more project-oriented and individualistic.

Things have worked out well for us. We don't have many enemies. Of course you always hurt someone's feelings when you turn them down for a show. We have tried not to ally ourselves with any causes, or any political groups inside the community of artists in the city. We have always tried to fill in the gaps, rather than to compete. We for example have been showcasing avant garde jazz for a few years because we felt it should be presented and no one else was willing to do it. We did it. If there are enough clubs around to do it, which there may be soon, then there is no need for us to do it. We're heavily into performance art. Four years ago we were the only ones showing it, now it's hot, and though we have three weeks of performance in our schedule this year, it is conceivable there might not be any reason for us to do it in the future.

We made the choice at N.A.M.E. right from the start to be the board of directors. We never wanted a conventional board filled with "people of influence". Another thing, we are mainly friends on the board. We have mixed business and pleasure, and the results have reflected this. We have, for the most part, remained friends through all of our trials. We haven't perhaps been as hard on one another as we would have been had we not been friends. On the other hand we communicate well, the way you can with someone with whom you have been engaged in dialogue for years. So there is a real basis for working together. On the whole our weekly Monday night meetings have kept things clear enough — though there are some ex-members who won't talk to us, and we have had a lot of members. To give you some idea, in the past

four years twenty-eight members have passed through this group, though four of the original members are still here.

This seems ok. Stability and change, and we tend to read the numbers passing through the organization as a sign of health. It has given us lots of new ideas and new energy.

We have stuck to our belief that an alternative space can survive, that artists can control the exhibition of their own work, and don't have to be subject to the whims and schemes of dealers and critics. There is also a purpose in showing art that is going on now, which can be shown in spaces like ours at relatively low costs, unlike the museums which need $50,000 just to open their doors. On the other hand it's great that a big museum can mount a Monet retrospective. We can't do that, nor do we want to. On the other hand we can present work that is not as accessible to the general public, but which is important work.

Our funding came initially from each of us putting in $15 a month. We still do that. At first our rent was fifty dollars a month. We got most of the materials donated that we needed to renovate the space. You could do that five or six years ago, before everybody started asking for the same supplies. Our first grant came from the student body of The Art Institute. It was an amazing political coup. We were short $500 and we couldn't have opened without it. We went to them and they said yes. Our second year we got $1600 from the Illinois Arts Council for a speakers program which we altered to pay some of the costs of the shows. In our third year we got a grant from the Workshop Program of the National Endowment for the Arts. We got them to change their guidelines so that, along with five or six other places around the country, we were eligible. From the NEA we got $15,000 for the first year, a little more the second, and exactly $15,000 this year. In addition, for the past two years we have had CETA money.

Foundation grants have been the hardest to get. We wrote fifty grants our first year, and we got fifty rejections. This year we tried again and got one grant for $1500 to support fund raising of all things. We went to the IBM Foundation, after all the IBM building is right around the corner from us. We're neighbors, right. Where is Hubbard Street they said. What do they

care about a neighborhood. The world is their neighborhood. Foundations have a hard time with alternatives like ours. They're afraid to give money to us, for fear that they are giving it to the wrong people. It's easier to give it to the cultural giants.

From our constituents and friends we tried to get money this year. We did a big fund raising campaign, and after the dust had settled we did a little more than break even. Times have changed. It's hard to get money through the mails, through foundations, to get materials donated. There are more and more people trying to get money from the same pie.

What is needed is a secondary level of support, we need liasons between the artists and the foundations, between the artists and big business. Critics and art lovers can do this. The world of the visual arts is so fragmented, though. There are a lot of individuals and few organizations.

It is interesting to me that there are more and more artists who are also administrators. It isn't so threatening anymore to do both. There are problems of course. I feel like a lot of my time over the past couple of years has gone into administration which could have gone into my work. I have made less art, but I think that what I have learned doing this will go into my art. You need the same skills and commitment to do both. I have to think clearly, to be organized to do my own work. It is important to know that you need the same passion to do both things. In order to promote N.A.M.E. or to talk about my own work I have to believe in them. Without that belief you can't get anywhere because you are dealing with things that can't be quantified or looked at objectively very easily. How effectively a hospital works can be determined more easily than how good the work shown at N.A.M.E. Gallery is.

We picked the name N.A.M.E. deliberately. We wanted a neutral name, an empty vehicle, one which didn't have strong connotations. We have tried to keep things open here, and I think that we have. We have a lot of new projects and the gallery seems to have its own momentum now.

BARRY HOLDEN

MoMing: The History of a Dance/Theatre Center

In this book I wanted to include the history of one functioning arts organization to illustrate how all of the pieces that I have talked about fit together. While I was prepared to write an administrative history of MoMing, the guts of the experience are the separate tales of each of the founders, all of whom were involved in the questions of management, as well as in performing, producing, choreographing, teaching, and an endless series of less glorious-sounding tasks.

If the tale evolves Rashomon-like with contradictions, discrepancies, and a lack of resolution, that is perhaps not a fault, but a more honest expression of the nature of intensely-lived experience. I didn't want to trade that quality for a series of pat answers or glib explanations.

MoMing is not being presented as a paradigm, and there is no suggestion that you should try to model your arts organization after it. It did work though, and perhaps the greatest tribute that can be paid the institution is that it was flexible enough so

that it could be shaped by its founders to conform to their chang-
ing needs and desires. It weathered many crises, which in no
small part is a reflection of the care that went into its creation.
It was not without flaws. It should be taken for what it was. For
those of us most intimately involved it was an intense learning
experience; and sometimes we learn as much from what fails
and does not nourish us, as from what endures.

AN ADMINISTRATOR'S BIOGRAPHY OF MOMING

I was ambivalent about getting involved. I still had a bad taste
in my mouth from my previous experience of setting up a per-
formance center, where I had to work with a . . . very difficult
dancer / director. But there I was listening to the tales of woe
of five others who had helped make that Dance Center work,
and who were now in the process of being rather ungraciously
offed. So what could I do. I certainly knew the mechanics of put-
ting together a performance center; it did hold the attraction of
another puzzle to be put together; and sitting down and work-
ing out the figures as carefully as I could it seemed likely that
it would work. So I said yes, I would help.

All of this was happening in the middle of the Spring of 1974
in Chicago.

The first step was to see who of the previous group wanted
to embark on this new venture. Of the old group of dancers, five
out of the seven decided that they were in, after hearing from
me that it was feasible — at least on paper. This was fine. The
first problem to be resolved was to exit from The Dance Center
with some grace. It was clear that there was going to be some
trouble. The director did not let anybody leave gracefully. There
were always recriminations of one sort or another. It was a tight
rope act, avoiding on the one side a confrontation and on the
other side avoiding exploitation. But there is nothing worse than
starting something new with lingering evil feelings about what
you just left. We consulted the *I Ching*, The Chinese Book of

Changes. It advised us to move cautiously and to avoid strife. The group did so, and with the exception of a few skirmishes managed to exit with some dignity. Succeeding castings of the *I Ching* confirmed that it was a time of REVOLUTION, and that the moment had come to overthrow the old, repressive regime. Success was promised.

We were deliberate and cautious in setting up the organization, trying to account for all contingencies. Every moment spent in the interminable process of planning and talking and rethinking was worth it. The demands of setting up an arts organization with little money, a small market, high start-up costs, and inflammable personalities had always struck me as being more demanding than establishing your normal business. Many problems that get glossed over in for-profit businesses, with the lure of wealth and job security, become impossible obstacles in a small foundering arts organization.

We were blessed with having a talented lawyer — a room mate of two of us involved — who was willing to spend hours and hours working with us in setting up our corporation and applying for our tax exemption. Unlike most organizations which simply modify a stock set of by-laws, we made ours up in large measure from scratch. In this way they conformed to the realities of what we were trying to do and who we were. To do this you need a lawyer who is willing to put in the time to see you through this process. We decided that we — the group of seven — would be the board of directors of the corporation. Now this is a choice which most conservative lawyers advise against, and a choice which the IRS has been critical of in recent years. But since there was not going to be much money flowing through our hands, and since it was essential to us to control the corporation, we decided to take the chance. We wanted to control what we were about to make; once burned, twice cautious.

With a large dose of cynicism/realism we constructed our by-laws, ever mindful of the kinds of irreconcilable conflicts that could develop. How many people could freeze-out the corporation? We decided that two fewer than the total number of the board members could. How many votes did new board members

193

need? Once again we decided on the same figure. All of these
calculations taking into account at what point the corporation
would cease to be functional any way because of internal dis-
sension. In any event, filling out the 1023 form for the IRS, regis-
tering as a corporation in the state of Illinois, working up our
by-laws was not just a formality for us, but an active, engaging
process. It was impressive to see people who had never had to
think this way suddenly grappling with these legal and financial
complexities. Facing the fiscal responsibilities and understanding
the legal questions in setting up your corporation is to my mind
an essential part of the process of creating an organization, and one
in which all of the principal figures should be involved.

We had one meeting at which we each read statements that
we had written about what we wanted from the organization.
Some things emerged clearly; we wanted a place where we could
work as equals, a place that didn't exploit students or workers,
an open, alive institution. At that point in time there was clarity
to our desires and our needs. It was a very exciting time. Our
astrologer assured us the stars, particularly Jupiter, were in the
right places in the heavens, the times were auspicious.

Even the choosing of a name was an inspired process. We
tried out name after name and came up with nothing. We even
attempted to find a name the way one of the group remembered
the Dadaists to have done it, by selecting a name at random from
the dictionary. We tried this approach but kept coming up with
words like "carrot" and "drivel" and "pencil". Those wouldn't
do. Finally, our Tai Chi teacher suggested that there was a lake
in China so beautiful that it couldn't be named — MoMing. "Name-
less", that which couldn't be named, also an ancient Taoist philo-
sophical concept. Perfect. Open ended and suitably obscure.

Our next step was to look for a building. Having looked be-
fore for a building of this sort I knew how to go about doing it:
contacting realtors, asking friends, driving up and down streets
in likely neighborhoods, reading the newspapers. It was Eric,
though, who found an old church building that was being va-
cated in a changing, slightly funky neighborhood. We contacted
the church that owned the building and began negotiating. It

was ideal for our purposes. Four floors. On the first floor a big office, lobby, class-room space, lounge, huge kitchen, bathrooms. On the second and third floors, what had been the old gymnasium / auditorium, a big open space with a balcony, proscenium stage, forty foot ceilings, huge gothic windows, and an open floor space that could include a 1,500 square foot dance floor and seating for about 150. On the fourth floor a beautiful ballet room and what became the "Jupiter Bozo Room" — the costume, dressing, day-time hanging out in room, and residence for whoever happened to be between apartments. The rent was $750 per month, and the church agreed to paint the interior, fix broken windows, plumbing, etc. The church was to prove to be an incredible ally, an ideal landlord. They were flexible, responsible, and supportive of what we did. Of course this relationship worked both ways. I prompty paid the rent on the first of the month, gave them comps to all of our events, and we were willing to provide entertainment for their children's program, etc. It is a blessing to be at peace with your landlord.

We made the decision to be — in one member's words — "good children" and to try to do everything legally. Consequently, we applied for a license as a "Community Theatrical Center", to use the language of the city. We talked to the Mayor's Committe on Economic and Cultural Development — an agency whose function it was to help groups like ourselves. They looked up our building and discovered that the zoning was not right for the use to which we wanted to put the building, and they told us to forget it, to look for another building. Ever confident, I decided to go ahead and file a zoning appeal with the Zoning Board of Chicago.

Now this turned out to be a big deal. First we had to get the approval of the local Zoning Board, because we were in a ward that was run by an independent alderman with a highly active local political organization. It was also desirable to let them know what we were up to, since we intended to be an active part of the community. We had a hearing with them, and they decided that we were kosher, and would be a desirable addition to the community. We then had to file an appeal with the Zoning Board.

I chose to do this myself, rather than hiring a lawyer to do it. The appeal itself was not difficult. I wrote it clearly, throwing in what sounded to me like legal language, stating clearly why and for what purposes we wanted to use the building. The clerk at the zoning office befriended me — admiring my hubris — and told me what arguments would be the most effective in substantiating our case, and I'm sure that she was better informed than all but the most sophisticated lawyers who deal regularly with these problems. She guided our appeal through the administrative maze, and made one further suggestion which was to prove invaluable. This was to ask to be exempted from the off-street parking requirement for community theatres on the grounds that the two previous occupants had been exempt — in reality had used the building for similar functions without applying for a license and had not been challenged on this issue — and that to require us to comply with this regulation would be to discriminate against us This proved fortunate for us, because there was no off-street parking available, and it would have been impossible for us to comply with this requirement

We were required to notify by certified mail all of the owners of the property within a 250 foot radius of the building of our intention to file for a zoning change This entailed several hundred title searches, at a cost of about $5 each Fortunately, I met a clerk in the department of buildings who was willing to do the work for a flat fee that worked out to be about $1 per title, with him working, of course, on city time. Another lesson to me though: much power and knowledge rests with those "lowly" clerks who actually do the work, and who know the ropes. When you have a problem with city government, go to them.

Much to our distress, our hearing was rescheduled so that it was to be on the Thursday before the Monday of our opening in September. We made the choice to open anyway, and to hope for the best. At the hearing I testified, as well as a crowd from the local zoning board, our alderman, and our landlord. We had taken the further precaution of pulling the few political strings that we could. The week after our opening we got the formal approval of the zoning commission. This was an instance in which I did the

work that normally a lawyer would have undertaken. At times it is desirable to take things into your own hands and to avoid what can become a complicated and expensive legal solution to a political or administrative problem.

Fortunately, we were experienced in publicity and promotion and knew how to produce posters, where to put them up, how and to whom to mail them — we had a mailing list of some 2,500 names and borrowed a not-for-profit-mailing permit until we could get our own — we knew where to advertise, and how to generate press. All of this went off without a hitch. The city knew that we were opening that fall.

In terms of preparing our building we had a few large jobs to do, one of which was laying our 1,500 square foot wooden floor. I was the most experienced carpenter, and that was saying very little. Yet, we figured out how to lay our $2,000 floor, and the results were impressive. It required a lot of labor and patience, but it was satisfying to work together with our own hands to make *our* floor. There is nothing like the feeling of self-sufficiency, and the knowledge that if something goes wrong or breaks down, or if you don't have enough money, you can do it yourself.

We needed roughly $20,000 in start-up money to get our performance center off the ground. Of this one parent donated $5,000, another $3,000, another $300 per month, and one of the members put up $5,000 of his own money. This proved adequate. It was in retrospect inauspicious that two of the others who had promised to try to come up with funds, did not do so.

The decision to start on this scale — which is to say full-blown — was largely the decision of the three men. It seemed better to us to try it, so that if it succeeded it would be something.

We were prepared to do it full-time, and we were also prepared to fall flat on our faces. And I remember the feeling of the first day of classes as we waited in our newly prepared building, all of our money spent, waiting to see if there were going to be any students. We were all on edge, maybe spaced out would be more accurate. But the response was good, we had done our work right, and we had plenty of eager, excited students for the school. We were off and running.

We made the decision to invest money in bringing prominent, "avant-garde" performers to MoMing that first year, people whose work had not been seen here. We asked Trisha Brown to perform at our opening, and while she warmed up for her performance, with the audience waiting downstairs, we banged the last nails into our seating. The performance was a public success, if controversial. Audiences for other imported dancers like Laura Dean, Barbara Dilley, Doug Dunn, and Kenneth King tended to be small compared to theatre audiences, but to us fifty to a hundred and fifty people at a performance was fine. These dancers were moreover willing to have the chance to perform to receptive audiences in Chicago even though we could only pay them peanuts. It was a desire — to some of us a mission — to educate the Chicago dance audience. Four years later many of those performance ideas and styles which appeared at MoMing have found their way into the repertoires of Chicago dance groups, though at the time much of the dance community seemed resistant to what we were presenting.

We were marketing a commodity which was not familiar to even the dance audience here, and which lacked the "Good Dancing Stamp of Approval"—except maybe in the *Village Voice*. So it was no easy task. Members of the Chicago dance establishment were ambivalent, some would pass through those performances and remark to me that we should find a building in a better neighborhood, that we should make our lobby fancier, that our dancers should get more technical training. In light of the monumental task of getting our space set up, and presenting work by MoMingers and others which was far more exciting than anything else going on in the city, these responses were sheer venom. But it was a good lesson to discover first-hand the conservatism and snootiness of the arts establishment, which probably more than anything was just threatened by this new work.

On a more calculated level, we were marketing ourselves and trying to create a distinctive identity. The work may have been obscure to many, but it clearly had integrity and it was distinctive. We got considerable press coverage, and though there were pressures from within MoMing to get more, I felt the dan-

gers of over-exposure were as great as those of being unrecognized. At a certain point people say what's all the excitement about, they aren't so special. You want to attract audiences to your events, but you don't want to set them up to be disappointed. Our performance audience grew slowly through that whole year.

MoMing was pulsing with excitement those first months with the newness of the space and the classes, the performance opportunities that were suddenly available, as well as the sheer sexuality that seemed so much a part of everything. There were many personal conflicts in those first few months. Jealousies, anxieties, sexual tensions, and organizational problems to be hashed out. The ties that bound us together and made MoMing possible, at times strangled us. Outsiders could be attracted or repelled, supportive or critical, but few who looked at the situation had anything like a balanced picture, nor could they understand the complicated relationships that both sustained and restrained MoMing. We were nourished by our passion for what we were doing, and that passion was not always under control. One of us was always ready to quit while someone else was soaring. The rest were somewhere in the middle of the see-saw. Work was sustaining, and the group was productive through all of the crises.

I chose in that first year to rationalize MoMing as a business and to set up good business routines. I felt that it was more important for us to earn money and be reasonably self-sufficient, than to put my energies into fund-raising. Our school and performance income was five percent higher than my original estimates and in addition there were small contributions, some money from benefits and concessions. We were, for the most part, truly committed to what we were doing, and though we decided that we would pay ourselves and work full time, most of us would have continued with or without money. In the first three years we missed only one paycheck. Our decision to be the full time staff was vindicated.

In our second year we got small grants from the Illinois Arts Council, five CETA positions paying over $700 per month, and more sizable grants from the National Endowment for the Arts.

Our earned income was up. We were in very good financial shape. People did what they wanted, and nothing was not done because of lack of funds. We invested in people and activities and kept our material purchases to a minimum.

I chose not to put too much emphasis on getting money from private foundations and from businesses largely because the process is so time-consuming. Also because we were new, and institutions are not anxious to give away their money to groups which may not be here tomorrow. We also did not have any strong connections in either of these communities, and when everything is said and done, these connections can often pave the way for initial grants. We did approach half a dozen foundations during our first two years, but all of our applications were rejected. Everyone was hitting-on the foundations in the city, and our activities were too obscure for them. Nevertheless, we did do our homework and all of the foundations active in supporting the performing arts — nationwide — were put on our mailing list to get our dozen or so announcements each year. At some point they could be approached. But, by temperament I have always preferred self-supporting organizations or at least those that minimize their dependence on grants. That dependency is too much like acquiring another set of parents, and from my limited experience in that area, one set of parents is more than enough.

The idea of working as a collective proved to be difficult. There were only three of us who had any real interest in collectives. There was a limit to how far discussions could go before some members of the group lost interest, felt threatened, or were put off by what they felt was "political" talk.

Collective responsibilities like cleaning our building, office-sitting, and administrative tasks were thought by some to be "shit work". Not a healthy point of view. And though everyone wanted the power as an equal member of the collective, there was no shared will to work collectively. The collective was consequently a terminal arrangement.

Arts administrators are frequently resented because of the influence that they have in "artistic" decisions. The reality is that artistic decisions are frequently business decisions too, and un-

less there is a happy marriage of both elements, the future of the work is jeopardized. It is all too easy to blame artistic failures or problems on the "insensitive", mundane bureaucrat who handles the business of art. Two signs seem promising: it is no longer so suspect for artists to be business-like and even financially successful (some of the myths of the Romantic Artists are hopefully being laid to rest). And, more and more arts administrators are involved in the art which they administrate, which has the tendency of reducing the tension between the two spheres.

At MoMing, though we had no intentions of relinquishing any of our control of the corporation, at the end of the second year we did change the board of directors to include three new people who had nothing to do with MoMing. In fact they were selected because they were at some remove from us, with no stake and little active interest in us. They would stay out of our way, but for legal purposes, and to satisfy the IRS, they were part of our board. It was clear that we wanted to run MoMing, and our yearly board meeting consisted of the board granting the collective the right to make decisions for the maintenance of the corporation.

An entertaining side-light is that we continued to struggle to get our Community Theatre License for three years. We had dutifully made all of the repairs to the building that each of the innumerable building inspectors had requested. We had even had to satisfy the demands of one inspector who was out to get us because he hadn't gotten paid off, as he had expected. He continued to cheerfully find new violations until he got bored with the whole process. I thought we were down to the wire after all of the inspectors were done. We found ourselves in the peculiar position of paying for our license each year, even though we couldn't get the license itself. At that point we got caught in an endless shuttle between two departments in the city who would each demand that the other approve a set of seating plans before they would look at them. On several occasions, after shuttling between their offices for half a day, I was almost reduced to tears. The problem was resolved though, in true bureaucratic fashion, by a friend from another city agency whose function it

was to smooth the way for arts organizations in dealings of this sort. He personally took *all* of the sets of plans, which we had labored over, to a meeting with both department heads. The plans were promptly lost — or misplaced or destroyed. And though MoMing continues to operate as a theatre and to pay its yearly fees, there is now no way to get the "required" license. It was not an unseccessful resolution of a problematic question for all parties involved.

To conclude the saga. At the end of the first year Jim Self left to set up his own studio and to do his own work. Working with a group did not suit his temperament, and he felt, perhaps rightly so, that his work was better than everyone else's. Jim is now a member of Merce Cunningham's Company, and still doing his own work. At the end of the second year Kasia Mintch left the collective but continued to teach and to perform at MoMing. Administration was not to her taste. During the middle of the third year, Denne Babbin, the business manager, left to travel in Europe. Towards the end of the year Susan Kimmelman left, worn down from the battles and from not getting enough of her own work done. Susan finished a novel she had been working on, and is currently enrolled in the first year of law school. Eric Trules left at the end of the third year and moved to the Big Apple where he is clowning and acting, and hoping to satisfy larger ambitions. I left at the end of the third year, leaving MoMing in sound financial shape with $10,000 in the bank, to set up Cloud Hands, a space for Tai Chi with limited performance activity. Cloud Hands is a simple, and to my mind elegant, not-for-profit corporation run by Susan and myself. Jackie Radis, the only remaining founder, continues to work as a non-specific director of the un-collective MoMing.

MOMING BY ERIC TRULES — A DANCER

I remember when MoMing began: Spring 1974. Five dancer /
performer/fledgling artists decided to leave a deteriorating situ-
ation to set up a new one which would have greater potential for
growth, fulfillment, and individuality. Some of us said we knew
what we wanted; others couldn't say or didn't really know. In
time, some who knew changed their minds. Others who didn't
know, came to know.

For the three years I worked at MoMing, it was an ever-chang-
ing institution of growth, one that dealt constantly with self-defi-
nition, group dynamics, and the collective process. The experi-
ence was always challenging, provocative — never satisfying. Ul-
timately MoMing was and is a proving ground.

In opting for group improvisational dance / theatre work and
the opportunity to present their own choreography, the five dan-
cers, along with Tem Horwitz, an artist / administrator who for-
merly managed The Dance Troupe, and Sally Banes, a writer,
founded MoMing and opened for business in September 1974.

In this new organization defining itself as a collective, there
was suddenly a new and significantly different relationship set
up among the members. Whereas before, we were all, working
for one person, a single artistic director with ultimate authority,
we were now all equal directors and all equally responsible.
Before, we were all colleagues and friends suffering the injusti-
ces of the tyrannical director. Now we became solo artists, solo
directors, individualists and unfortunately, *competitors.* This com-
petition was for me the crux of the collective experience.

Externally, MoMing was always together. Internally it was
always at war. While MoMing had a successful performance sea-
son, hosted exciting talent from out-of-town (Meredith Monk,
Laura Dean, Kenneth King, Grand Union, Doug Dunn, Trisha
Brown, Barbara Dilley, The S. F. Mime Troupe, etc.), won NEA,
CETA, and Illinois Arts Council grants, developed and educated
a Chicago audience, operated a school, and earned itself a na-
tional reputation, its members were at each other's throats a good
deal of the time. Weekly meetings came to be dreaded by all,

responsibilities were overwhelming (especially responsibility "to the group"), competition and jealousy ran rampant, and gradually one member at a time decided to leave.

Had we been a different group of people, perhaps MoMing would have been enough for us. But we had ambitions as individuals — or the fact that some of us did, practically forced the others to have them. We were not content with the success of MoMing, the place; we wanted personal recognition — as artists, as choreographers, as performers, as directors. Of course, the press encourages this kind of response in any group, by singling out virtuosos and particular performers. Yet despite this, it was the larger institutions that achieved recognition, not the individuals. People knew MoMing, not its individual members. And at least three of us left for this reason alone; we wanted personal success and MoMing had not brought it to us.

I always perceived MoMing as an institution set up to serve its members, a vehicle. I always thought that "colle*ction*" was a better word for us — a group of individuals joined together in a not-for-profit arts organization designed to secure the means to pursue our individual interests. Yet we did operate like a "collec*tive*." It was always ambiguous. Can a collective be dedicated only to the individual interests of its members, or does it have to be dedicated to a principle, a belief, something larger than the sum of its parts.

The San Francisco Mime Troupe is a working collective that has survived. They started off under the direction of Ronnie Davis but have operated for the last eight years or so as an artistic collective (though no longer a living collective). One of its members told me that their survival is based upon their political commitment. That is, their politics come before their egos. They subordinate individuality to common principles.

MoMing had no shared aesthetic, only the goal of survival. We began with the idea of working together artistically. Soon we found out that this was not easy going, and in fact, was unpalatable to several of the members. We began working alone, and soon the only collective work we collaborated on were unrehearsed, spontaneous, improvisational performances.

What we did do as a group was to run the institution. We got through this process (detrimentally I think in the long run) by deferring to the expertise and advice of our business administrator and financial advisor. In a way we were not a collective, administratively. We went through the motions (much discussion and argument) but usually followed the lead of one member.

Our decision-making process was often laughable — though none of us appreciated the humor in the actual doing of it. There were usually two options to chose from after perhaps several others had been eliminated. Two members would disagree strongly over a particular issue, whether it be spending money or inviting a guest artist. They would be adament and the others in the group would have to choose between. We would finally decide a question (much to at least one member's displeasure), set a precedent, and then deciding the same kind of issue months later, not follow the precedent at all, but recreate the argument and come to the opposite decision! Our first and best decision was the one in which we chose a name. After about a month of discussion and disagreement, we were given the name MoMing ("nameless" in Chinese) by a Tai Chi teacher / sage at a dinner. Everyone had to agree on the name — it having come from an external soothsayer. If only all our decisions could have been arrived at so easily.

We were like a family, one that quarrels among itself, but stands united against the world. There was so much love / hate going on within this small group that as time went on things got more complicated rather than more clearly defined. Our institution and organization was growing, but our individual and collective maturity was deteriorating. At times things went more smoothly than others, and sometimes we would think that adding a new member or two would alter the course of things and change the group dynamics. But our method and our madness were basically unalterable. As long as there were four original members, the nature of things (business, art, relationships) would not change.

Part of the problem too was the actual size of the undertaking. There was so much pressure and responsibility in merely

running the institution; operating a school, managing a full-time theatre, applying for grants, maintaining a four-story building — that often what came last on the list was our art. The saddest and most frustrating thing of all for me was that often having finally taken care of all the business production and promotional details, and having put together a show, (poster, or any successful project), there was not time, space, or support enough to enjoy the fruits of my labor.

Things were continually convoluted by jealousy and our complicated incestuous relationships did not make things any easier. Let it be said simply that work and sex within a group should not be mixed. The best advice I ever received in this area was from a lover who advised me that if MoMing was to straighten out, its members had better get out of each other's beds and back pockets. I agreed and a year later, found this ex-lover a collective member.

A visitor from Denmark, upon seeing our building, remarked that our undertaking was truly extraordinary. He "felt" we were moving towards "sainthood" and that we should *never* lose our faith. I always tried to keep his observations in mind, especially in our difficult moments. Then again, I imagine that all dedication and sacrifice in the artistic disciplines is "saintly", and requires all the steely faith, and belief we can muster — in the face of great odds and little reinforcement to continue.

I am saddened by my loss of faith in MoMing and in the collective artistic experience. I have just recently left. But as I said at the outset, I feel the time spent in the process and at MoMing was one of growth, and that it served as a proving ground for those of us who passed through.

© ERIC TRULES
June, 1977

MOMING BY ELLEN MAZER — A STUDENT

In 1974 when I graduated from college MoMing was there to catch me. Moving from stuffy academic Hyde Park and the University of Chicago to the "hip" Northside (a symbol, I thought, of my transformation to the artistic life), I was drawn to this coagulation of personalities, ideas, crises, as an inevitable next step.

My education in many ways prepared me for a role in MoMing: an interaction between 60s turmoil and old rigorous life-of-the-mind style, it was pass / fail, do-your-own-thing, as well as minutely analytical. By my third year dance had become a chief extracurricular activity and an important adjunct to my studies. Merce Cunningham, Yvonne Rainer, Susan Sontag, Meredith Monk, Suzanne Langer and all of the "event" artists were my idols as I meditated in philosophy classes on the relationship between expression, symbolism, and meaning.

I took modern dance classes downtown (drawing on childhood ballet training), but felt both defeated and confined by the traditional techniques. A joyous quirky self was yearning to be expressed in movement and choreography if I could only find the means to unleash it.

By the time I started at MoMing as a full-time scholarship student, part-time dance critic and choreographer (eking out an income by grading papers for a correspondence high school), I was spunky, inquisitive, sure of a new way of dancing, and ready to divide the world neatly into dance traditionalists (them) and the new wave (us).

MoMing was a confusing, delirious, melodramatic, sexual, inspired place then. EVERYONE CAN DANCE! EVERYONE CAN BELONG! — this was the magic MoMing seemed to breathe. Finally here was a community center where people could realize their own abilities — whether through dancing, teaching, working in the kitchen, office chores, tech, or carpentry — a socio-artistic dream come true!

The invitation to improvise and a de-emphasis of technical vitruosity both in MoMing performances and technique classes,

magnified the aura of freedom — as though all you had to do to be a good performer was be authentically, intelligently yourself. In this atmosphere I blossomed; I danced, wrote, talked, created. The fertile, welcoming expansiveness of MoMing was its most positive quality.

At the same time an insidious cult of the personality was evolving alongside and threatened to overtake MoMing's democratic principles. People began to say that an artist could have all the right ideas about performance and his/her work still didn't "make it". What was the difference between a true and a failed performance? We called it the "presence" of the performer, but what it came down to, really, was how magnetic a person the artist was. Within MoMing sharp differences developed as to who "had it" and didn't. Was it dark, mystical Susan? Jim Self, with his long blond locks and polymorphous sexual appeal? Cruel/beautiful Jackie? Voluptuous Kasia? Or Eric's tough, Jewish sensitivity? Early MoMing performances were wrenchingly personal, almost a contest to see who could reveal more "presence", more soul.

I was too involved at the time to see this contradiction (which is tatamount to the Orwellian, "everyone is equal [a good performer] but some are more equal [better performers] than others"), but it was the downfall of MoMing as far as I can see. (Are interpersonal conflicts always the downfall of good ideas?)

The infighting, which began even before the formal inception of MoMing, escalated into major battles. Husbands, lovers, wives, people in other media, other dance troupes, visiting New York artists, and the Chicago *Reader*, became embroiled in a fantastic, unbreatheable morass. I was in the thick of it, fighting, intriguing, gossiping along with everyone else.

The particulars of these schisms and alliances are unimportant, and anyway, they're much too detailed to relate here. The important thing is, they made me miserable and dancing impossible. I say this fully acknowledging my own role; I was no innocent lamb being victimized by MoMing wolves.

After about two years, bored and stifled, I finally quit being involved in MoMing. Having had an inside glimpse of the "avant

garde" scene, I didn't think it so wonderful anymore; it seemed intellectually, artistically, interpersonally barren, played out, with nowhere to go. MoMing lost its kick not just for me but for most of the original cast of characters, most of whom moved to New York or turned their attention elsewhere. What's left of MoMing strikes me as remarkably similar to other mediocre Chicago dance endeavors.

For the time being I have pushed away thoughts of Art and Meaning to concentrate on more practical matters, like earning a living and graduate school. The original creative impulse that attracted me to MoMing in the first place is still inside me, though, to be actualized in saner, more mature, and very possibly more individualistic form sometime in the future.

ELLEN MAZER

MOMING AS MAX SEES IT

The Last Word,
Autopsy of a Collective,
MoMing as Max sees it, or
Why I chose to leave the glamorous and charmingly egotistical
world of moderately successful young artists . . .

Looking back at MoMing, and myself, I am struck again and again by the persistence of our confusion. Those endless meetings, and hours of talking, before decisions were made. And half an hour later, we had forgotten what decision we *had* made, finally, and all we remembered was the confusion. In retrospect, confusion persists. The experience resists reduction to linear explanation, psychological, economic, or otherwise, which is not to say that I won't try to make one. Is confusion just a natural tendency of the animal called group? How did such an aggregation of good intentions come to such a painful impasse? However it happened, there came a time when the institution could

209

not go on until half of us had packed our shopping bags full of old leg-warmers and said our good-byes. It's more unpleasant in retrospect, remember, without the glitter of intensity and inevitability that the life had in the living. For all these reasons, the remarks I have to offer are incomplete and piecemeal, like the memory of the time itself.

In the beginning, there was the sweeping energy of our initial united decision to begin our own place, and to assert ourselves, together, against what we saw as the oppression of our situation. A very short time later, that united group had dissolved into individuals struggling to define themselves and to assert themselves against each other. What might have bound us together and carried us through?

Devotion to our art, that's the obvious answer, isn't it? But perhaps that art itself was part of the problem. A premise of the kind of dance-theatre we did is a kind of totalitarianism of the self as the source of the art. Hardly the stuff of which collectives are made.

Well, after our first feverish excitement and love for one another had begun to fade, we tried an economic equation, which went something like this, theoretically: "I'll support MoMing", each member says, "because the existence of the institution will make it possible for me to do my own work." But that was not adequate either. Too literal, perhaps, or too mechanical.

At the same time that I railed against the supposed "apolitical" nature of our group, I secretly congratulated myself. It was clear that many more politically sophisticated collectives were ravaged finally by a kind of senseless, endless, internal argument. I imagined that we would last all the longer for not having much extra baggage in the way of theoretical underpinnings. In fact, I thought to myself hopefully, our group (the original one) was a kind of auspicious accident. Before we danced together we had not been friends, most of us, and so I thought that it was our love for our work which had brought us together and would preserve us. Mistaken, again. The passionate ambivalence we developed towards one another, the repressed competition, the violence or pettiness of our own feelings, were soon hopelessly entangled.

Surely it would have taken more than some progressive political ideals to get us through that.

You see what a problem explanations are. They shift and fade. If, If, If, If we hadn't, if we had. If we had examined our premise more closely, perhaps, or thoughtfully. Because we didn't define our enterprise very clearly or intelligently as an alternative to the existing conventions, we had not a chance really to escape those conventions. So although our project was humble when weighed on some scales, the whole system was right there with us. The vanity and bitterness bred in the hierarchy were no less divisive just because we made a few dutiful remarks about collective theatrical activity. It was a collective only by the broadest interpretation of the word. More accurate, I think, to call it a many-levelled, rigid structure in a constant state of great and disorderly change.

So who's to say? If we hadn't been the way we were, other things would have torn us apart, as likely as not. There was one theory Kasia used to like, about how MoMing should have a life of its own, ideally, and then each of us could come and go. MoMing goes on, certainly, so perhaps that goal has been attained, for some. I know I won't go back, nor Eric, nor Jim.

Then there was another theory, about how we would have been much better off if none of us had ever been lovers. Now you won't have heard too much about that in these respectable essays, but that's certainly the last thing I would have wanted to miss. As much pain as there may have been, those memories are more sweet than bitter.

So I can't say exactly why, or how, it ended for me. Perhaps none of the particular arguments had anything to do with it. Perhaps there just came a day when somebody said, silently, "I'll take it. Give it to me." And another said, "Oh no you won't." And when the dust cleared, some of us were far away living in other worlds.

For myself, art has become a different kind of pursuit. Private in some ways. Public in other ways. I imagine it will be said that I never really loved dancing, or I would never have been able to give it up for something as prosaic as the law. But I will

tell you something. When my teachers said to me, you must dance for yourself, and your own joy in it, I took them very seriously. And now that is what I do.

MAX

Appendix 1

VOLUNTEER LAWYERS FOR THE ARTS

California

Bay Area Lawyers for the Arts. Apt. 3, 2206 Durant Av., Berkeley, California 94704. (415) 841-1369. Hamish Sanderson, Dir.

Advocates for the Arts. Law School — Room 2467 C, University of California, Los Angeles, California 90024. (213) 825-3309 or 825-4841. Audrey Greenberg.

Georgia

Georgia Volunteer Lawyers for the Arts, Inc. c/o Alston, Miller & Gaines, 1200 C & S National Bank Bldg., Atlanta, Ga. 30303. (404) 588-0300. Robert C. Lower, Esq.

Illinois

Lawyers for the Creative Arts. 111 North Wabash Av., Chicago, Illinois 60602. (312) 263-6989. Thomas R. Leavens, Dir.

Massachusetts
> LAWYERS FOR THE ARTS
> Massachusetts Arts and Humanities Foundation, Inc.
> 14 Beacon Street, Boston, Mass. 02108.

Minnesota
> *The Upper Midwest Regional Arts Council.* Butler Square
> No. 349, 100 North 6th Street, Minneapolis, Minn. 55403.
> (612) 338-1158. Michael Skindrud.

New Jersey
> *Cultural Law Committee.* New Jersey State Bar Association,
> 172 W. State Street, Trenton, N.J. 08608. (201) 232-2323.
> Harry Devlin, Esq.

New York
> *Volunteer Lawyers for the Arts.* 36 West 44th Street, New
> York, N.Y. 10036. (212) 575-1150. (See also numerous re-
> gional New York state council offices.)

Ohio
> *Arts Council of the Ohio River Valley.* Room 703, Mercan-
> tile Bank Building, Cincinnati, Ohio 45202. (513) 621-1818.
> Mitchell Kaufman, Director.

> *Volunteer Lawyers for the Arts.* c/o Cleveland Area Arts
> Council, 140 The Arcade, Cleveland, Ohio 44114. (216)
> 781-0045.

> *Greater Columbus Arts Council.* Attention: Dan Dorman,
> 50 W. Broad Street, Columbus, Ohio 43215. (614) 221-1321
> (ask for the Arts Council office).

Oregon
> *Oregon Volunteer Lawyers for the Arts.* c/o Leonard DuBoff,
> Assistant Professor of Law, Lewis & Clark College, North-
> western School of Law, Portland, Oregon 97219. (503) 244-
> 1181.

Pennsylvania
> *Lawyers for the Arts Committee.* Young Lawyers Section, Philadelphia Bar Association, 423 City Hall Annex, Philadelphia 19107. (215) 686-5685.

Texas
> c/o Jay M. Vogelson, Esq. Steinberg, Generes, Luerssen & Vogelson, 2200 Fidelity Union Tower, Dallas, Texas 75201. (214) 748-9312.

Washington, D.C.
> c/o Charles B. Rutenberg, Esq. Arent, Fox, Kintner, Plotkin & Kahn, Federal Bar Building, 1815 H Street, N.W., Washington, D.C. 20006. (202) 347-8600.

Washington
> *Washington Volunteer Lawyers for the Arts.* University of Puget Sound, School of Law, 8811 South Tacoma Way, Tacoma, Washington 98499.

Also, groups tentatively being formed by Michigan Council for the Arts, Indiana Arts Commission, and Kentucky Art Commission. Check with your local municipal or state arts council to find out whether such service is offered or is planned to be offered.

Appendix 2

LAW AND THE ARTS

Application for Recognition of Exemption

Under Section 501(c)(3) of the Internal Revenue Code

To be filed in the Key District for the area in which the organization has its principal office or place of business.

This application, when properly completed, shall constitute the notice required under section 508(a) of the Internal Revenue Code in order that an applicant may be treated as described in section 501(c)(3) of the Code, and the notice under section 508(b) appropriate to an organization claiming not to be a private foundation within the meaning of section 509(a). **(Read the instructions for each part carefully before making any entries.)** The organization must have an organizing instrument (See Part II) before this application may be filed.

Part I—Identification

1 Full name of organization	2 Employer identification number (If none, attach Form SS-4)
CLOUD HANDS, INC.	36-2919806

3(a) Address (number and street)	Check here if applying under section:
9 West Hubbard	☐ 501(e) ☐ 501(f)

3(b) City or town, State and ZIP code	4 Name and phone number of person to be contacted
Chicago, Illinois 60610	Thomas R. Leavens, 263-6020

5 Month the annual accounting period ends	6 Date incorporated or formed	7 Activity Codes		
April	May 13, 1977	030	088	093

8(a) Has the organization filed Federal income tax returns? ☐ Yes ☒ No

If "Yes," state the form number(s), year(s) filed, and Internal Revenue Office where filed ▶................................

8(b) Has the organization filed exempt organization information returns? ☐ Yes ☒ No

If "Yes," state the form number(s), year(s) filed, and Internal Revenue Office where filed ▶................................

Part II.—Type of Entity and Organizational Documents (See instructions)

Check the applicable entity box below and attach a conformed copy of the organization's organizing and operational documents as indicated for each entity.

☐ Corporation—Articles of incorporation, bylaws. ☐ Trust—Trust indenture. ☐ Other—Constitution or articles, bylaws.

Part III.—Activities and Operational Information

1 What are or will be the organization's sources of financial support? List in order of magnitude. If a portion of the receipts is or will be derived from the earnings of patents, copyrights, or other assets (excluding stock, bonds, etc.), identify such item as a separate source of receipt. Attach representative copies of solicitations for financial support.

1. Tuition revenues
2. Grants, gifts & contributions from foundations, corporations, and individuals
3. Benefit receipts

A projected budget breakdown is attached as Exhibit "B"

2 Describe the organization's fund-raising program, both actual and planned, and explain to what extent it has been put into effect. (Include details of fund-raising activities such as selective mailings, formation of fund-raising committees, use of professional fund raisers, etc.)

The Corporation intends to seek broad support from the sources listed under Part III, Item 1, for which purpose its fund-raising program contemplates applications for funds from various federal, state and local cultural and educational institutions, including the National Endowment for the Arts and the Illinois Arts Council. In addition, the directors will seek contributions from private foundations by personal contacts. Tuition revenues have been received from the first series of classes. Benefit events have been contemplated but have not been definitely planned.

I declare under the penalties of perjury that I am authorized to sign this application on behalf of the above organization and I have examined this application, including the accompanying statements, and to the best of my knowledge it is true, correct and complete.

(Signature)	PRESIDENT _(Title or authority of signer)_	5/1/77 _(Date)_

Part III.—Activities and Operational Information (Continued)

3 Give a narrative description of the activities presently carried on by the organization, and those that will be carried on. If the organization is not fully operational, explain what stage of development its activities have reached, what further steps remain for the organization to become fully operational, and when such further steps will take place. The narrative should specifically identify the services performed or to be performed by the organization. (Do not state the purposes of the organization in general terms or repeat the language of the organizational documents.) If the organization is a school, hospital, or medical research organization, include sufficient information in your description to clearly show that the organization meets the definition of that particular activity that is contained in the instructions for Part VII–A.

 See attached

4 The membership of the organization's governing body is:

(a) Names, addresses, and duties of officers, directors, trustees, etc.		(b) Specialized knowledge, training, expertise, or particular qualifications
Susan Kimmelman	3222 N. Clifton, Chicago	
Tom Horwitz	3222 N. Clifton, Chicago	See attached resumes
Thomas Behrens	3619 N. Magnolia, Chicago	

Part III.--Activities and Operational Information, part 3.

The Corporation has to date conducted three sets of classes in a singl.
series in Tai Chi, an announcement for which is attached. Tai Chi
consists of a very precise sequence of movements performed in slow
motion and accompanied by deep abdominal breathing. Tai Chi has won
considerable attention in the United States for its significant medical
value and the philosophy of peace and humanism that is a very impor:.1.
part of its tradition. Two of the corporation's founders are author: c
a definitive text on Tai Chi Chuan, a copy of which is attached.
Enrollment for these classes were: Part I-25; Part II-9; Part III-8
All classes were conducted at the Cloud Hands studio at 9 W. Hubbard
Chicago, Illinois.

The Corporation has also conducted free lecture/demonstrations at the
Lakeview Learning Fair, the Hammond Art Fair, the North Shore Music
Center, and the East/West Bookstore, all located in Chicago. It will
conduct its next free lecture/demonstration on Sept. 17, 1977, and plan.
to conduct at least three such events each year at its studio, in addi.on
to other outside lecture/demonstrations done upon request.

The Corporation has scheduled new classes for the fall, an announcement
for which is attached. In addition, it will conduct a workshop on
rapranathy, which is a massage-like body release technique, a work-
shop on shiatzu, which is an acupressure technique for the relief of
body stress and disorder, a basic movement, or dance, course, and a
workshop on Tai Chi for senior citizens. All classes will be taught.
by experienced practitioners, but the instructors will be employed
on a volunteer or minimum fee schedule which would not exceed -10.00
per class taught.

The educational and cultural activities in Tai Chi and other related
movement exercises which are offered by the Corporation are not avail-
able elsewhere to the public, nor would such activity as presented by
the Corporation be commercially viable, such as instruction in the
Martial Arts is, for example. Tai Chi represents an example of eastern
culture and life full of value as a teaching tool for introducing the
Orient and some of its philosophy and customs to the West and America
The Corporation is dedicated to Tai Chi and its ideals and to the genera
education and enculturation of Chicagoans to some of the day-to-day
practices of people living and working thousands of miles and an en-
tire world away.

Part III.—Activities and Operational Information (Continued)

4 **(c)** Do any of the above persons serve as members of the governing body by reason of being public officials or being appointed by public officials? . □ Yes ☒ No

If "Yes," please name such persons and explain the basis of their selection or appointment.

(d) Are any members of the organization's governing body "disqualified persons" with respect to the organization (other than by reason of being a member of the governing body) or do any of the members have either a business or family relationship with "disqualified persons"? (See specific instructions 4(d).) . . □ Yes ☒ No

If "Yes," please explain.

(e) Have any members of the organization's governing body assigned income or assets to the organization? . □ Yes □ No

If "Yes," attach a copy of assignment(s) and a list of items assigned.

(f) Is it anticipated that any current or future member of the organization's governing body will assign income or assets to the organization? . □ Yes □ No

If "Yes," explain fully on an attached sheet.

5 Does the organization control or is it controlled by any other organization? □ Yes ☒ No

Is the organization the outgrowth of another organization, or does it have a special relationship to another organization by reason of interlocking directorates or other factors? □ Yes ☒ No

If either of these questions is answered "Yes," please explain.

6 Is the organization financially accountable to any other organization? □ Yes ☒ No

If "Yes," please explain and identify the other organization. Include details concerning accountability or attach copies of reports if any have been rendered.

7 **(a)** What assets does the organization have that are used in the performance of its exempt function? (Do not include property producing investment income.) If any assets are not fully operational, explain what stage of completion has been reached, what additional steps remain to be completed, and when such final steps will be taken. The Corporation has a few individually-donated assets: a modest audio equipment system, office equipment and supplies, and some furniture.

(b) To what extent have you used, or do you plan to use contributions as an endowment fund, i.e., hold contributions to produce income for the support of your exempt activities?

8 **(a)** What benefits, services, or products will the organization provide with respect to its exempt function? The Corporation will serve as a community cultural resource open to the public and serving that public by providing education, instruction and information in and concerning Tai Chi Chuan, dance, body movement, exercise, and health. Public performances, classes in movement, dance, and Tai Chi, demonstrations of the disciplines and art forms will enhance community life.

Part III.—Activities and Operational Information (Continued)

8 (b) Have the recipients been required or will they be required to pay for the organization's benefits,
 services, or products? . ☒ **Yes** ☐ **No**
 If "Yes," please explain and show how the charges are determined.

Although the Corporation will operate strictly on a not-for-profit basis,
it will charge tuition and performance fees on a cost-recovery basis.
Scholarships will be available to persons unable to pay tuition, and free
public performances will be offered regularly.

9 Does or will the organization limit its benefits, services or products to specific classes of individuals? . . . ☐ **Yes** ☒ **No**
 If "Yes," please explain how the recipients or beneficiaries are or will be selected.

10 Is the organization a membership organization? . ☐ **Yes** ☒ **No**
 If "Yes," complete the following:
 (a) Please describe the organization's membership requirements and attach a schedule of membership
 fees and dues.

 (b) Describe your present and proposed efforts to attract members, and attach a copy of any descriptive
 literature or promotional material used for this purpose.

 (c) Are benefits, services, or products limited to members? ☐ **Yes** ☐ **No**
 If "No," please explain.

11 Does or will the organization engage in activities tending to influence legislation or intervene in any way in
 political campaigns? . ☐ **Yes** ☒ **No**
 If "Yes," please explain. (Note: You may wish to file Form 5768, Election/Revocation of Election by an Eligible Sec-
 tion 501(c)(3) Organization to Make Expenditures to Influence Legislation.)

12 Does the organization have a pension plan for employees? ☐ **Yes** ☒ **No**

13 Are you filing Form 1023 within 15 months from the end of the first month in which you were created or
 formed as required by section 508(a) and the Regulations thereunder? ☒ **Yes** ☐ **No**
 If "No," and you are claiming that section 508(a) does not apply to you, attach an explanation of your basis
 for this claim.

Part IV.—Statement as to Private Foundation Status

1 Is the organization a private foundation? . ☐ **Yes** ☒ **No**
2 If question 1 is answered "No," indicate the type of ruling being requested as to the organization's status
 under section 509 by checking the applicable box(es) below:
 Definite ruling under section 509(a)(1), (2), (3), or (4) check here ☐ and complete Part VII.
 Advance ruling under section ▶ ☐ 170(b)(1)(A)(vi) or ▶ ☐ 509(a)(2)—See instructions.
 Extended advance ruling under section ▶ ☐ 170(b)(1)(A)(vi) or ▶ ☒ 509(a)(2)—See instructions.
3 If question 1 is answered "Yes," and the organization claims to be a private operating foundation, check here ☐ and
 complete Part VIII.
 (Note: If an extended advance ruling is desired you **must check** the appropriate block for an advance ruling also.)

Statement of Receipts and Expenditures, for period ending June 30 **, 19** 77

Receipts		
1 Gross contributions, gifts, grants and similar amounts received		530.00
2 Gross dues and assessments of members		0
3 Gross amounts derived from activities related to organization's exempt purpose	4490.00	
Less cost of sales		4490.00
4 Gross amounts from unrelated business activities		
Less cost of sales		0
5 Gross amount received from sale of assets, excluding inventory items (attach schedule) . .		
Less cost or other basis and sales expenses of assets sold		0
6 Interest, dividends, rents and royalties		0
7 Total receipts .		5020.00

Expenditures		
8 Fund raising expenses .		
9 Contributions, gifts, grants, and similar amounts paid (attach schedule)		
10 Disbursements to or for benefit of members (attach schedule)		
11 Compensation of officers, directors, and trustees (attach schedule)		
12 Other salaries and wages .		
13 Interest .		
14 Rent .		900.00
15 Depreciation and depletion .		
16 Other (attach schedule) .		1340.00
17 Total expenditures .		2240.00
18 Excess of receipts over expenditures (line 7 less line 17)		2780.00

Balance Sheets	Enter dates ▶	Beginning date 5/77	Ending date 6/20/77
Assets		0	
19 Cash (a) Interest bearing accounts		0	1010.00
(b) Other		0	2780.00
20 Accounts receivable, net			
21 Inventories .			
22 Bonds and notes (attach schedule)			
23 Corporate stocks (attach schedule)			
24 Mortgage loans (attach schedule)			
25 Other investments (attach schedule)			
26 Depreciable and depletable assets (attach schedule)			530.00
27 Land .			
28 Other assets (attach schedule)			
29 Total assets			4320.00
Liabilities			
30 Accounts payable (rent)			450.00
31 Contributions, gifts, grants, etc., payable			
32 Mortgages and notes payable (attach schedule)			
33 Other liabilities (attach schedules)			
34 Total liabilities			450.00
Fund Balance or Net Worth			
35 Total fund balance or net worth			3870.00
36 Total liabilities and fund balance or net worth (line 34 plus line 35) . . .			4320.00

Has there been any substantial change in any aspect of your financial activities since the period ending date shown above? . ☐ Yes ☐ No
If "Yes," attach a detailed explanation.

Part VI.—Required Schedules for Special Activities	If "Yes," check here;	And, complete schedule—
1 Is the organization, or any part of it, a school?	X	A
2 Does the organization provide or administer any scholarship benefits, student aid, etc.?	X	B
3 Has the organization taken over, or will it take over, the facilities of a "for profit" institution? . . .		C
4 Is the organization, or any part of it, a hospital or a medical research organization?		D
5 Is the organization, or any part of it, a home for the aged?		E
6 Is the organization, or any part of it, a litigating organization (public interest law firm or similar organization)?		F
7 Is the organization, or any part of it, formed to promote amateur sports competition?		G

Part VII.—Non-Private Foundation Status (Definitive ruling only)

A.—Basis for Non-Private Foundation Status

The organization is not a private foundation because it qualifies as:

✔	Kind of organization	Within the meaning of	Complete
1	a church	Sections 509(a)(1) and 170(b)(1)(A)(i)	
2	a school	Sections 509(a)(1) and 170(b)(1)(A)(ii)	
3	a hospital	Sections 509(a)(1) and 170(b)(1)(A)(iii)	
4	a medical research organization operated in conjunction with a hospital	Sections 509(a)(1) and 170(b)(1)(A)(iii)	
5	being organized and operated exclusively for testing for public safety	Section 509(a)(4)	
6	being operated for the benefit of a college or university which is owned or operated by a governmental unit	Sections 509(a)(1) and 170(b)(1)(A)(iv)	Part VII.–B
7	normally receiving a substantial part of its support from a governmental unit or from the general public	Sections 509(a)(1) and 170(b)(1)(A)(vi)	Part VII.–B
8	normally receiving not more than one-third of its support from gross investment income and more than one-third of its support from contributions, membership fees, and gross receipts from activities related to its exempt functions (subject to certain exceptions)	Section 509(a)(2)	Part VII.–B
9	being operated solely for the benefit of or in connection with one or more of the organizations described in 1 through 4, or 6, 7, and 8 above	Section 509(a)(3)	Part VII.–C

B.—Analysis of Financial Support

		(a) Most recent taxable year 19........	(b) 19........	(c) 19........	(d) 19........	(e) Total
			(Years next preceding most recent taxable year)			
1	Gifts, grants, and contributions received					
2	Membership fees received .					
3	Gross receipts from admissions, sales of merchandise or services, or furnishing of facilities in any activity which is not an unrelated business within the meaning of section 513					
4	Gross income from interest, dividends, rents, royalties, and unrelated business taxable income (less section 511 tax) from businesses acquired by the organization after June 30, 1975					
5	Net income from organization's unrelated business activities not included on line 4					
6	Tax revenues levied for and either paid to or expended on behalf of the organization .					
7	Value of services or facilities furnished by a governmental unit to the organization without charge (not including the value of services or facilities generally furnished the public without charge)					
8	Other income (not including gain or loss from sale of capital assets)—attach schedule					
9	Total of lines 1 through 8 .					
10	Line 9 less line 3					
11	Enter 2% of line 10, column (e) only .					

12 If the organization has received any unusual grants during any of the above taxable years, attach a list for each year showing the name of the contributor, the date and amount of grant, and a brief description of the nature of such grant. Do not include such grants in line 1 above. (See instructions)

Part VII.—Non-Private Foundation Status (Definitive ruling only) (Continued)

B.—Analysis of Financial Support (Continued)

13 If the organization's non-private foundation status is based upon:

 (a) Sections 509(a)(1) and 170(b)(1)(A)(iv) or (vi).—Attach a list showing the name and amount contributed by each person (other than a governmental unit or "publicly supported" organization) whose total gifts for the entire period exceed the amount shown on line 11.

 (b) Section 509(a)(2).—With respect to the amounts included on lines 1, 2, and 3, attach a list for each of the above years showing the name of and amount received from each person who is a "disqualified person."

 With respect to the amount included in line 3, attach a list for each of the above years showing the name of and amount received from each payor (other than a "disqualified person") whose payments to the organization exceeded $5,000. For this purpose, "payor" includes but is not limited to any organization described in sections 170(b)(1)(A)(i) through (vi) and any government agency or bureau.

C.—Supplemental Information Concerning Organizations Claiming Non-Private Foundation Status Under Section 509(a)(3)

1 Organizations supported by applicant organization:

Name and address of supported organization	Has the supported organization received a ruling or determination letter that it is not a private foundation by reason of section 509(a)(1) or (2)?

2 To what extent are the members of your governing board elected or appointed by the supported organization(s)?

3 What is the extent of common supervision or control that you and the supported organization(s) share?

4 To what extent do(es) the supported organization(s) have a significant voice in your investment policies, the making and timing of grants, and in otherwise directing the use of your income or assets?

5 As a result of the supported organization(s) being mentioned in your governing instrument, are you a trust which the supported organization(s) can enforce under State law and with respect to which the supported organization(s) can compel an accounting? . ☐ Yes ☐ No
If "Yes," please explain.

6 What portion of your income do you pay to each supported organization and how significant is such support to each?

7 To what extent do you conduct activities which would otherwise be carried out by the supported organization(s)? For any such activities, please explain your reasoning as to why such activities would otherwise be carried on by the supported organization(s).

8 Is the applicant organization controlled directly or indirectly by one or more "disqualified persons" (other than one who is a disqualified person solely because he or she is a manager) or by an organization which is not described in section 509(a)(1) or (2)? . ☐ Yes ☐ No
If "Yes " please explain.

Part VIII.—Basis for Status as a Private Operating Foundation

If the organization—
 (a) bases its claim to private operating foundation status upon normal and regular operations over a period of years; or
 (b) is newly created, set up as a private operating foundation, and has at least one year's experience;

complete the schedule below answering the questions under the income test and one of the three supplemental tests (assets, endowment, or support). If the organization does not have at least one year's experience, complete line 21. If the organization's private operating foundation status depends upon its normal and regular operations as described in (a) above, submit, as an additional attachment, data in tabular form corresponding to the schedule below for the three years next preceding the most recent taxable year.

		Most recent taxable year
	Income Test	
1	Adjusted net income, as defined in section 4942(f)	
2	Qualifying distributions:	
	(a) Amounts (including administrative expenses) paid directly for the active conduct of the activities for which organized and operated under section 501(c)(3) (attach schedule)	
	(b) Amounts paid to acquire assets to be used (or held for use) directly in carrying out purposes described in sections 170(c)(1) or 170(c)(2)(B) (attach schedule)	
	(c) Amounts set aside for specific projects which are for purposes described in section 170(c)(1) or 170(c)(2)(B) (attach schedule)	
	(d) Total qualifying distributions (add lines 2(a), (b), and (c))	
3	Percentage of qualifying distributions to adjusted net income (divide line 1 into line 2(d)—percentage must be at least 85 percent) .	%
	Assets Test	
4	Value of organization's assets used in activities that directly carry out the exempt purposes. Do not include assets held merely for investment or production of income (attach schedule)	
5	Value of any corporate stock of corporation that is controlled by applicant organization and carries out its exempt purposes (attach statement describing such corporation)	
6	Value of all qualifying assets (add lines 4 and 5)	
7	Value of applicant organization's total assets	
8	Percentage of qualifying assets to total assets (divide line 7 into line 6—percentage must exceed 65 percent) .	%
	Endowment Test	
9	Value of assets not used (or held for use) directly in carrying out exempt purposes:	
	(a) Monthly average of investment securities at fair market value	
	(b) Monthly average of cash balances	
	(c) Fair market value of all other investment property (attach schedule)	
	(d) Total (add lines 9(a), (b), and (c))	
10	Subtract acquisition indebtedness with respect to line 9 items (attach schedule)	
11	Balance (line 9 less line 10) .	
12	For years beginning on or after January 1, 1976, multiply line 11 by a factor of 3⅓% (⅔ of the applicable percentage for the minimum investment return computation under section 4942(e)(3)). The factors to be used for years beginning prior to January 1, 1976, are as follows: for 1974 and 1975 use 4%, for 1973 use 3½%. Line 2(d) above must equal or exceed the result of this computation . . .	
	Support Test	
13	Applicant organization's support as defined in section 509(d)	
14	Less—amount of gross investment income as defined in section 509(e)	
15	Support for purposes of section 4942(j)(3)(B)(iii)	
16	Support received from the general public, five or more exempt organizations, or a combination thereof (attach schedule) .	
17	For persons (other than exempt organizations) contributing more than 1 percent of line 15, enter the total amounts in excess of 1 percent of line 15	
18	Subtract line 17 from line 16 .	
19	Percentage of total support (divide line 15 into line 18—must be at least 85 percent)	%
20	Does line 16 include support from an exempt organization which is in excess of 25 percent of the amount on line 15? . ☐ Yes ☐ No	

21 Newly created organizations with less than one year's experience: Attach a statement explaining how the organization is planning to satisfy the requirements of section 4942(j)(3) with respect to the income test and one of the supplemental tests during its first year's operation. Include a description of plans and arrangements, press clippings, public announcements, solicitations for funds, etc.

SCHEDULE A.—Schools, Colleges, and Universities

1 Does or will the organization (or any department or division within it) discriminate in any way on the basis of race with respect to:

(a) Admissions? . ☐ Yes ☒ No

(b) Use of facilities or exercise of student privileges? ☐ Yes ☒ No

(c) Faculty or administrative staff? . ☐ Yes ☒ No

(d) Scholarship or loan program? . ☐ Yes ☒ No

If "Yes," for any of the above, please explain.

2 Does the organization include a statement in its charter, bylaws, or other governing instrument, or in a resolution of its governing body, that it has a racially nondiscriminatory policy as to students? ☒ Yes ☐ No

Attach whatever corporate resolutions or other official statements the organization has made on this subject.

3 (a) Has the organization made its racially nondiscriminatory policies known in a manner that brings such policies to the attention of all segments of the general community which it serves? ☒ Yes ☐ No

If "Yes," please describe how these policies have been publicized and state the frequency with which relevant notices or announcements have been made. If no such newspaper or media notices have been used, please explain.

All Corporation functions are conducted without regard to race, color, creed, religion, sex, age, or national origin. Circulars announcing curricula, press releases, posters and handouts all make this policy immediately apparent.

(b) If applicable, attach clippings of any relevant newspaper notices or advertising, or copies of tapes or scripts used for media broadcasts. Also attach copies of brochures and catalogues dealing with student admissions, programs, and scholarships, as well as representative copies of all written advertising used as a means of informing prospective students of your programs.

4 Attach a numerical schedule showing the racial composition, as of the current academic year, and projected as far as may be feasible for the subsequent academic year, of: (a) Student body, (b) Faculty and administrative staff.

5 Attach a list showing the amount of scholarship and loan funds, if any, awarded to students enrolled and racial composition of the students who have received such awards.

6 (a) Attach a list of the organization's incorporators, founders, board members, and donors of land or buildings, whether individuals or organizations.

(b) State whether any of the foregoing organizations have as an objective the maintenance of segregated public or private school education, and, if so, whether any of the foregoing individuals are officers or active members of such organizations.

SCHEDULE B.—Organizations Providing Scholarship Benefits, Student Aid, etc. to Individuals

1 (a) Please describe the nature of the scholarship benefit, student aid, etc., including the terms and conditions governing its use, whether a gift or a loan, and the amount thereof. If the organization has established or will establish several categories of scholarship benefits, identify each kind of such benefit and explain how the organization determines the recipients for each category. Attach a sample copy of any application the organization requires or will require of individuals to be considered for scholarship grants, loans or similar benefits. (Private foundations which make grants for travel, study or other similar purposes are required to obtain advance approval of scholarship procedures. See sections 53.4945–4 (c) and (d) of the Private Foundation Regulations.)

Scholarships will be for the cost of tuition in an amount to be decided on a case-by-case basis according to need. They will be for the term of one class and will be of no special category.

(b) If you desire us to consider this application as a request for approval of grant procedures in the event we determine that you are a private foundation, please check here . ☐

SCHEDULE B.—Organizations Providing Scholarship Benefits, Student Aid, etc. to Individuals (Continued)

2　What limitations or restrictions are there on the class of individuals who are eligible recipients? Specifically explain whether there are, or will be, any restrictions or limitations in the selection procedures based upon race and whether there are, or will be, restrictions or limitations in selection procedures based upon the employment status of the prospective recipient or any relative of the prospective recipient. Also indicate the approximate number of eligible individuals

Recipients will be selected on the basis of need, without regard to race, creed, religion, national origin, sex or age. Special talent and ability will be recognized in appropriate situations, but will not be a determining factor. Scholarship decisions will be made by the managing members of the Corporation or the Board of Directors,

3　Indicate the number of grants you anticipate making annually|　　none

4　List the names, addresses, duties and relevant background of the members of your selection committee. If you base your selections in any way on the employment status of the applicant or any relative of the applicant, indicate whether there is or has been any direct or indirect relationship between the members of the selection committee and the employer. Also indicate whether relatives of the members of the selection committee are possible recipients or have been recipients.

5　Describe any procedures you have for supervising grants, such as obtaining reports or transcripts, which you award and any procedures you have for taking action in the event you discover a failure to live up to the terms of the grant.

SCHEDULE C.—Successors to "For Profit" Institutions

1　What was the name of the predecessor organization and the nature of its activities?

2　Who were the owners or principal stockholders of the predecessor organization? (If more space is needed, attach schedule.)

Name and address	Share or interest

3　Describe the business or family relationship between the owners or principal stockholders and principal employees of the predecessor organization and the officers, directors, and principal employees of the applicant organization.

4　(a) Attach a copy of the agreement of sale or other contract that sets forth the terms and conditions of sale of the predecessor organization or of its assets to the applicant organization.
　　(b) Attach an appraisal by an independent qualified expert of the facilities or property interest sold showing fair market value at time of sale.

INCOME:

Donations:

 foundation, private sector support......2500.00

 state and local arts councils..........1500.00
 $4000.00

Performance receipts (gross)..................... 2000.00

Tuition payments, receipts(based upon
 30-35 students per 3 1/2 month
 terms (3 terms) @ $90.00/term................ 9000.00
 $15000.00

TOTAL INCOME: 15000.00

EXPENSES:

Rent..................................... 5400.00
Rental deposit........................... 950.00
Promotion................................ 1500.00
Space Renovation, improvements........... 1200.00
Office supplies.......................... 200.00
Janitorial supplies, maintenance......... 300.00
telephone................................ 450.00
electricity.............................. 600.00
insurance................................ 400.00
instruction.............................. 4000.00

TOTAL EXPENSES: 15000.00

SCHEDULE 1: #15 OTHER EXPENDITURES

Deposit on rental property................$900.00

Deposit on electricity, utilities......... 110.00

publicity................................. 50.00

maintenance............................... 15.00

telephone................................. 90.00

electricity............................... 25.00

miscellaneous supplies, equipment......... 150.00

1340.00

SCHEDULE 2: #25 DEPRECIABLE AND DEPLETABLE ASSETS

miscellaneoouse office furniture, etc......100.00

audio system and related equipment........300.00

telephone equipment, answering...........130.00

530.00

Appendix 3

EXAMPLE OF PURPOSE CLAUSE IN ARTICLES OF INCORPORATION

The purpose or purposes for which the corporation is organized are: exclusively charitable, educational, and civic, including, but not limited to, the following: (a) to establish and maintain a theatre company to perform and present theatrical plays, dramas, musicals, revues, and other productions of all kinds, with a particular focus on theatre for children; (b) to offer seminars, workshops, and other classes in theatre related skills; (c) to establish and maintain such theatre programs or series as will further the educational goals of the institution; (d) to promote appreciation of, interest in, and understanding of the theatre arts; and (e) to perform all other acts necessary or incidental to the above. Notwithstanding any other provisions of these Articles, the purposes of the corporation are exclusively charitable, and the organization shall not engage in any activities expressly prohibited by section 501 (c) (3) of the Internal Revenue Code of 1954, as amended.

Any other provision contained in these Articles notwithstanding, no part of the net earnings of the corporation shall inure to the benefit of any private shareholder or individual and no sub-

stantial part of its activities shall be the carrying on of propaganda or otherwise attempting to influence legislation, nor shall it participate in or intervene in any political campaign on behalf of any candidate for public office. No solicitation of contributions to the corporation shall be made and no gifts, bequests or devise to the corporation shall be accepted upon any condition or limitation which, in the opinion of the corporation, may cause the corporation to lose any exempt status which it may obtain from the payment of Federal Income Taxes.

Nothwithstanding any other provisions of these Articles, if at any time or times the corporation shall be a "private foundation" as defined in Section 509 of the Internal Revenue Code of 1954, as amended, then during such time or times the corporation shall distribute its income for each taxable year at such time and in such manner as not to become subject to attacks on undistributed income imposed by Section 4942 of the Internal Revenue Code of 1954 as amended; shall not engage in any act of self-dealing as defined in Section 4941 (d) of said Code; retain any excess business holdings as defined in Section 4943 (c) of said Code; make any investments in such manner as to incur tax liability under Section 4944 of said Code, or make any taxable expenditures as defined in Section 4945 (d) of said Code.

Nothwithstanding any other provisions of these Articles, during such time or times that the corporation shall elect to have the provisions of Section 501 (h) of the Internal Revenue Code of 1954, as amended, in effect, the corporation shall not make any lobbying expenditures in such manner as to incur tax liability under Section 4911 of said Code.

In the event of dissolution, the corporation shall, after payment of all liabilities, distribute any remaining assets to an organization or organizations which, at the time, are exempt from taxation under Section 501 (c) (3) of the Internal Revenue Code of 1954, as amended.

Any reference herein to any provision of the Internal Revenue Code of 1954 shall be deemed to mean such provisions as now or hereafter existing, amended, supplemented, or superseded, as the case may be.

Appendix 4

ARTICLE I

PURPOSES

The purposes of the corporation are exclusively charitable, educational and civic, and will be accomplished by (example: insert appropriate services and purposes) providing volunteer legal services and information to people and organizations involved in the creative arts who meet the criteria established by the corporation, by coordinating diversified legal services for such persons and organizations, and through such related activities as are desirable and proper within the limitations of section 501 (c) (3) of the Internal Revenue Code of 1954, as amended, and related provisions thereof.

ARTICLE II

MEMBERS

The corporation shall have no members. (Check with local counsel whether members are required for not-for-profit corporations in your own state.)

ARTICLE III

BOARD OF DIRECTORS

Section 1. *General Powers.* The affairs of the corporation shall be managed by its Board of Directors.

Section 2. *Number, Qualifications, Election and Term of Office.* The initial Directors shall be the four persons named in the Ar-

ticles of Incorporation dated_____, 197__. At the first meeting of the initial Board of Directors, the Directors shall elect a regular Board of Directors, to consist of the number of Directors elected at such meeting (but in no event shall such number be more than sixteen (16), to serve until the first annual meeting of the Directors. Thereafter, such number of Directors shall be elected each year at the annual meeting by a majority of the Directors then in office, and each Director so elected shall continue in office until a successor shall have been elected and qualified. Any Director may be removed, with or without cause, at a special meeting of the Directors called for that purpose, by a majority of all Directors.

Section 3. *Annual Meeting.* Beginning with the year 197__, an annual meeting of the Directors shall be held in the month of _____ at such date, time and place as the Board of Directors shall determine.

Section 4. *Special Meetings.* Special meetings of the Board of Directors may be called by or at the request of the Chairman or any two Directors. The person or persons authorized to call special meetings of the Board may fix any place within the State of _____ as the place for holding any special meeting of the Board called by them.

Section 5. *Notice.* Notice of any special meeting of the Board shall be given at least two days previous thereto by written notice delivered personally or sent by mail or telegram to each Director at his address as shown on the records of the corporation. If mailed, such notice shall be deemed to be delivered when deposited in the United States mail in a sealed envelope so addressed, with postage thereon prepaid. Any Director may waive notice of any meeting. The attendance of a Director at any meeting shall constitute a waiver of notice of such meeting, except where a Director attends a meeting for the express purpose of objecting to the transaction of any business because the meeting is not lawfully called or convened. Neither the business to be transacted at, nor the purpose of, any regular or special meet-

ing of the Board need be specified in the notice or waiver of notice of such meeting, unless specifically required by law or by some provision in these bylaws.

Section 6. *Quorum.* A majority of the Directors then in office shall constitute a quorum for the transaction of business at any meeting of the Board, provided that, if less than a majority of the Directors are present at said meeting, a majority of the Directors present may adjourn the meeting from time to time without further notice.

Section 7. *Vacancies.* Any vacancy occuring in the Board of Directors or any directorship to be filled by reason of an increase in the number of Directors shall be filled by the Board of Directors. A Director elected to fill a vacancy shall be elected for the unexpired term of his predecessor in office.

Section 8. *Compensation.* No Director or officer of the corporation, except in the case of the Executive Director, shall receive, directly or indirectly, any salary, compensation or emolument therefrom either in his capacity as an officer or Director or in any other capacity.

ARTICLE IV

BOARD OF SPONSORS

Section 1. *Appointment.* The Board of Directors may appoint such persons as it reasonably deems necessary or desirable to act as the Board of Sponsors of the corporation. To the extent possible, persons appointed to the Board of Sponsors should be involved in the arts, or have an ongoing relationship to the arts or to arts-related activities. The number of persons appointed to constitute the Board of Sponsors shall be determined in the sole discretion of the Board of Directors.

Section 2. *Purpose.* It shall be the function and purpose of the Board of Sponsors to advise the Board of Directors on matters relating to the arts, and to suggest or be available for consulta-

tion with regard to projects or activities which the corporation may undertake, consistent with its exempt purpose, in furtherance of its goals and objectives.

ARTICLE V

OFFICERS

Section 1. *Number and Qualifications.* The officers of the corporation shall consist of a President, a Secretary, a Treasurer, and such other officers, if any, including one or more Vice Presidents, one or more Assistant Secretaries, one or more Assistant Treasurers, and an Executive Director, as the Board of Directors may from time to time appoint. Any two or more offices may be held by the same person, except for the offices of President and Secretary.

Section 2. *Election and Term of Office.* The officers of the corporation shall be elected annually by the Board of Directors at the regular annual meeting immediately following the election of Directors. If the election of officers shall not be held at such meeting, such election shall be held as soon thereafter as may be convenient. The vacancies may be filled or new offices created and filled at any meeting of the Board of Directors. Each officer shall hold office until his successor shall have been duly elected and qualified.

Section 3. *Removal.* Any officer of the corporation may be removed by a vote of the majority of the Board of Directors then in office.

Section 4. *President.* The President shall be the principal executive officer of the corporation and shall, in general, supervise and conduct the activities and operations of the corporation. He shall have general supervision of the affairs of the corporation, and shall keep the Board of Directors fully informed and shall freely consult with them concerning the activities of the corporation. He may sign, with the Secretary or any other proper officer of the corporation authorized by the Board of Directors, in the name

of the corporation all contracts and documents authorized either generally or specifically by the Board. He shall preside at all meetings of the Board of Directors. He shall perform such other duties as shall from time to time be assigned to him by the Board of Directors.

Section 5. *Vice President.* The Vice President(s) shall have such powers and duties as may be assigned to them by the President or the Board of Directors. In the absence of the President, the Vice President(s) shall, in general, perform the duties of the President, unless an Executive Director shall have been appointed and charged with the obligation of performing such duties.

Section 6. *Secretary.* The Secretary shall act as Secretary of all meetings of the Board of Directors, and shall keep the minutes of all such meetings in books proper for that purpose. He shall attend to the giving and serving of all notices of the corporation. He shall be custodian of the corporate records and of the seal of the corporation, and shall see that the seal of the corporation is affixed to all documents the execution of which on behalf of the corporation under its seal is duly authorized in accordance with the provisions of these bylaws. He shall perform all other duties customarily incident to the office of Secretary, subject to control of the Board of Directors, and shall perform such additional duties as shall from time to time be assigned to him by the Board of Directors.

Section 7. *Treasurer.* The Treasurer shall have custody of all funds of the corporation which may come into his hands. He shall keep or cause to be kept full and accurate accounts of receipts and disbursements of the corporation, and shall deposit all moneys and other valuable effects of the corporation in the name and to the credit of the corporation in such banks or depositories as the Board of Directors may designate. Whenever required by the Board of Directors, he shall render a statement of his accounts. He shall at all reasonable times exhibit his books and accounts to any officer or Director of the corporation and shall perform all duties customarily incident to the position of Trea-

surer, subject to the control of the Board of Directors, and shall, when required, give security for the faithful performance of his duties as the Board of Directors may determine.

Section 8. *Assistant Secretaries and Assistant Treasurers.* The Assistant Secretaries and Assistant Treasurers shall perform such duties as shall be assigned to them by the Secretary or Treasurer, respectively, or by the President or Board of Directors, including any of the duties customarily performed by the secretary or treasurer of a corporation.

Section 9. *Executive Director.* The Board of Directors may appoint an Executive Director to handle and carry out the day to day operations of the corporation customarily handled and carried out by the President, subject to the control and supervision of the Board of Directors. He shall have all the powers of and shall be subject to all the restrictions upon the President. The Executive Director shall perform such other duties as may from time to time be assigned to him by the President or the Board of Directors.

ARTICLE VI
COMMITTEES

Section 1. *Committees of Directors.* The Board of Directors, by resolution adopted by a majority of the Directors in office, may designate one or more committees, each of which shall consist of two or more directors, which committees, to the extent provided in said resolution, shall have and exercise the authority of the Board of Directors in the management of the corporation; but the designation of such committees and the delegation thereto of authority shall not operate to relieve the Board of Directors, or any individual director, of any responsibility imposed upon it or him by law.

Section 2. *Other Committees.* Other committees not having exercised the authority of the Board of Directors in the management of the corporation may be designated by a resolution

adopted by a majority of the Directors present at a meeting at which a quorum is present. Except as otherwise provided in such resolution, members of each such committee shall be appointed by the President of the corporation. Any member of any committee may be removed by the person or persons authorized to appoint such member whenever in their judgment the best interests of the corporation shall be served by such removal.

Section 3. *Term of Office.* Each member of a committee shall continue as such until the next annual meeting of the Board of Directors and until his successor is appointed, unless the committee shall be sooner terminated, or unless such member be removed from such committee, or unless such member shall cease to qualify as a member thereof.

Section 4. *Chairman.* One member of each committee shall be appointed chairman thereof.

Section 5. *Vacancies.* Vacancies in the membership of any committee may be filled by appointments made in the same manner as provided in the case of the original appointments.

Section 6. *Quorum.* Unless otherwise provided in the resolution of the Board of Directors designating a committee, a majority of the whole committee shall constitute a quorum and the act of a majority of the members present at a meeting at which a quorum is present shall be the act of the committee.

Section 7. *Rules.* Each committee may adopt rules for its own government, so long as such rules are not inconsistent with these bylaws or with rules adopted by the Board of Directors.

ARTICLE VII

CONTRACTS, CHECKS, DEPOSITS AND FUNDS

Section 1. *Contracts.* The Board of Directors may authorize any officer or officers, agent or agents of the corporation, in addition to the officers so authorized by these bylaws, to enter into any contract or execute and deliver any instrument in the name of

and on behalf of the corporation, and such authority may be general or confined to specific instances.

Section 2. *Checks, Drafts, Etc.* All checks, drafts or other orders for the payment of money, notes or other evidences of indebtedness issued in the name of the corporation shall be signed by such officer or officers, or agent or agents, of the corporation and in such manner as shall from time to time be determined by resolution of the Board of Directors. In the absence of such determination by the Board of Directors, such instruments shall be signed by the Treasurer or an Assistant Treasurer and countersigned by the Chairman of the Board of Directors or the President of the corporation.

Section 3. *Deposits.* All funds of the corporation shall be deposited from time to time to the credit of the corporation in such banks, trust companies or other depositories as the Board of Directors may select.

Section 4. *Gifts.* The Board of Directors may accept on behalf of the corporation any contribution, gift, bequest or devise for the general purposes or for any special purpose of the corporation.

ARTICLE VIII
OFFICE AND BOOKS

Section 1. *Office.* The office of the corporation shall be located at such place as the Board of Directors may from time to time determine.

Section 2. *Books.* There shall be kept at the office of the corporation correct books of account of the activities and transactions of the corporation, including a minute book which shall contain a copy of the Articles of Incorporation, a copy of these bylaws, and all minutes of the Board of Directors.

ARTICLE IX

CORPORATE SEAL

The seal of the corporation shall be circular in form and shall bear the name of the corporation and words and figures showing that it was incorporated in the State of Illinois in the year 1972.

ARTICLE X

FISCAL YEAR

The fiscal year of the corporation shall coincide with the calendar year.

ARTICLE XI

INDEMNIFICATION

The corporation shall, to the fullest extent now or hereafter permitted by law, indemnify any person made, or threatened to be made, a party to any action or preceeding by reason of the fact that he, his testator or intestate was an associate, Director, officer or other agent of the corporation, or of any other organization served by him in any capacity at the request of the corporation, against judgments, fines, amounts paid in settlement and reasonable expenses, including attorneys' fees.

ARTICLE XII

AMENDMENTS

These bylaws may be amended by the affirmative vote of a majority of the Directors in office at any meeting of the Board of Directors.

Bibliography

ARTS ADMINISTRATION GENERAL

Adams, Howard, *The Politics of Art*, ACA, New York, 1966.

Baker, Hendrik, *Stage Management and Theatrecraft*, Theatre Arts Books, New York, 1968.

Baumol & Bowen, William, *Performing Arts: The Economic Dilemma*, Twentieth Century Fund, New York, 1966.

Bing, Rudolph, *5000 Nights at the Opera*, Doubleday, New York, 1972.

Cavanaugh, Jim, *Organization and Management of Non-Professional Theatre*, Rosen, New York, 1972.

Crawford, Ted, *Legal Guide for the Visual Artist*, Hawthorn Books, New York, 1977.

Dorian, Frederick, *Commitment to Culture: Art Patronage in Europe. Its Significance for America*, University of Pittsburgh, Pittsburg, 1964.

Farber, Donald, *From Option to Opening*, Drama Book Specialists, New York, 1968.

————, *Producing on Broadway: A Comprehensive Guide*, Drama Book Specialsits, New York, 1969.

Georgi, Charlotte, *The Arts and the World of Business*, Scarecrow Press, Metuchen, New Jersey, 1973.

Gingrich, Arnold, *Business and the Arts*, Erickson, New York, 1969.

Langley, Stephens, *Producers on Producing*, DBS, New York, 1976.

————, *Theatre Management in America*, DBS, New York, 1974.

Management and the Arts: A Selected Bibliography, UCLA, 1976.

The Performing Arts: Problems and Prospects, Rockefeller Panel Report, McGraw Hill, New York, 1965.

Prieve, Arthur, *Administration in the Arts: An Annotated Bibliography*, University of Wisconsin, Madison, 1973.

Reiss, Alvin, *The Arts Management Handbook*, Law Arts Publishers, New York, 1970.

————, *Culture and Company: A Critical Study of an Improbable Alliance*, Thwayne, New York, 1974.

Schoolcraft, R., *Performing Arts*, Books in Print, DBS, New York, 1973.

Wolf, Thomas, *Presenting Performances: A Handbook for Sponsors*, New England Foundation for the Arts, 1977.

BUILDINGS AND SPACES

The Arts in Found Places, EFL, New York, 1976.

Beranek, Leo, *Acoustics*, McGraw Hill, New York, 1954.

Bricks, Mortar and the Performing Arts: Report of the Twentieth Century Fund Task Force on Performing Arts Centers, Twentieth Century Fund, New York, 1970.

New Places for the Arts, EFL, New York, 1976.

MARKETING

FEDAPT, "Audience Survey Guidelines & Samples", New York.

Hardy, James, *Corporate Planning for Nonprofit Organizations*, Association Press, New York, 1972.

Kotler, Philip, *Marketing for Nonprofit Organizations*, Prentice Hall, Englewood Cliffs, 1975.

Shapiro, Benson, *Marketing in Nonprofit Organizations*, Marketing Science, Institute, Cambridge, 1972.

GRANTS, GRANT WRITING AND FUND RAISING

American Association of Fund-Raising Counsel Inc., 500 Fifth Avenue, Suite 1015, New York, New York 10036.

Andrews, F. Emerson, "Applications for Grants", Russell Sage Foundation, New York, 1956.

Annual Register of Grant Support, Marquis Academic Media, Chicago, 1975–76.

The Bread Game: The Realities of Foundation Fundraising, Regional Young Adult Project and Pacific Change, Glide Publications, San Francisco, 1973. Send $2.95 to Glide Publications, 330 Ellis Street, San Francisco, Ca 94102.

Broadsky, Jean, *The Proposal Writer's Swipe File*, Taft Products, 1000 Vermont Ave., Washington, D.C. 20005, 1973.

Church, David, *Seeking Foundation Funds*, National Public Relations Council of Health and Welfare Services, New York.

Commission on Private Philanthrophy and Public Needs, 1776 K Street, N.W., Washington, D.C. 20036.

Creamer, Robert, *Fundraising and Local Community Organiza-*

tions, Midwest Academy, 600 W. Fullerton St., Chicago, IL 60614, $.40.

Dermer, Joseph, *How to Get Your Fair Share of Foundation Grants,* Public Service Materials Center, New York, 1973.

————, *How to Raise Funds from Foundations,* Public Service Materials Center, New York, 1972.

————, *How to Write Successful Foundation Presentations,* Public Service Materials Center, New York, 1972.

Encyclopedia of Associations, Gale Research Company, Detroit, 1975. (Information on organizations which make grants, though are not classified as private foundations.)

Exempt Organizations Handbook, IRS, Washington, D.C., 1976.

Flanagan, Joan, *The Grass Roots Fundraising Book,* Swallow, Chicago, 1977.

The Foundation Center, 888 Seventh Avenue, New York 10019.

About Foundations: How to Find the Facts You Need to Get a Grant, Judith Margolin, $3, prepaid.

Foundation Annual Reports: What They Are and How to Use Them. $2, from The Foundation Center.

The Foundation Grants Index. (Bimonthly) Included in *Foundation News.* $20 per year for *Foundation News.* The Council on Foundations, Box 783, Old Chelsea Station, New York 10011.

The Foundation Grants Index (annual volume), from Columbia University Press, 136 South Broadway, Irvington, New York 10535. $15.

The Foundation Grants Index: Subjects on Microfiche (annual). $3 per card, from The Foundation Center.

"What Makes a Good Proposal?" and "What Will a Foundation Look for When You Submit a Grant Proposal?". $50. each from The Foundation Center.

Giving in America; Toward a Stronger Voluntary Sector. 1975. 240 p. $1.50.

Giving USA Annual Report; A Compilation of Facts and Trends on American Philantrophy (annual). $5.50.

The Grantsmanship Center News, $15 per year, from them at 1015 West Olympic Boulevard, Los Angeles, California 90015.

Hill, William, *A Comprehensive Guide to Successful Grantsmanship.* Grant Development Institute, Littleton, Colorado, 1972.

Hillman, Howard and Abarbanel, Karin, *The Art of Winning Foundation Grants,* Vanguard, New York, 1975.

Hodson, H. V., *International Foundation Directory,* Gale Research, Detroit, 1975.

Mirkin, Howard, *The Complete Fund Raising Guide,* Public Service Materials, New York, 1972.

The Nonprofit Money Game, Junior League of Washington, D.C., 3039 M Street, NW, Washington, D.C. 20007. $1.

Urgo, Louis, *A Manual for Obtaining Foundation Grants,* Robert J. Corcoran Co., Boston, 1971.

White, Virginia, *Grants: How to Find Out About Them and What to Do Next,* Plenum Press, New York.

FINANCIAL MANAGEMENT

AICPA (American Institute of Certified Public Accountants) *Audits of Voluntary and Welfare Organizations / Audits of Colleges,* c/o AICPA, 1211 Avenue of the Americas, New York, NY 10036.

Anthony, Robert, *Management Accounting,* R. D. Irwin, 1970.

_____, *Operations Cost Control,* R. D. Irwin, 1967.

Bookkeeping Handbook for Low-Income Citizen Groups, National Council on Welfare, Brooke Claxton Building, Ottawa, Ontario K1A 0K9 Canada, 1973. Free.

Bibliography

Finney, Harry, and Miller, *Principles of Accounting* (Elementary, Intermediate, Advanced), Prentice Hall, 1965.

Gross, Malvern, *Financial and Accounting Guide for Nonprofit Organizations*, Ronald Press, New York, 1974.

Hodgson, Richard, *Direct Mail and Mail Order Handbook*, Dartnell Press, Chicago, 1974.

Kerrigan, Harry D., *Fund Accounting*, McGraw Hill, 1969.

Lee, James, *Do or Die: Survival for Nonprofits*, Taft Products, Washington, 1974.

Nelson, Charles and Turk, Frederick, *Financial Management for the Arts*, ACA, New York, 1975. $4.50 (includes postage) from ACA Publications, 1564 Broadway, New York, NY 10036.

United Way, *Accounting and Financial Reporting*, 1974, United Way, Systems Division, 801 N. Fairfax, Alexandria, VA 22314.

Wehle, Mary, *Financial Management for Arts Organizations*, AARI, Cambridge, 1975.

_____ _____, *Financial Practice for Performing Arts Companies*, AART, Cambridge, 1977. Arts Administration Research Institute, 75 Sparks St., Cambridge, Mass 02138.

BOARDS OF DIRECTORS

Adizes, Ichak, "Boards of Directors in the Performing Arts: A Managerial Analysis", *California Management Review*, 1972, vol. XV, no. 2.

Conrad, William R., Jr. and Glenn, William E., *The Effective Voluntary Board of Directors: What It Is and How It Works*, Swallow Press, Chicago, 1976.

Houle, Cyril, *The Effective Board*, Association Press, New York, 1972.

How to Be an Effective Board Member, SEDFRE, One Penn

Plaza, New York 10001, 1973. $1.

On Being Bored, Or, How Not to Be Dead Wood, Rocky Mountain Planned Parenthood, 2030 East 20th Ave., Denver, CO 80205, 1973. $.50.

Reiss, Alvin, *The Arts Management Handbook*, pp. 211-223, Law-Arts Publishers, New York, 1974.

Sorenson, Ray, *How to Be a Board or Committee Member*, Association Press, New York, 1962.

ARTS ORGANIZATIONS AND PUBLISHERS

THE FOUNDATION CENTER
888 Seventh Avenue, New York, N.Y. 10019

About Foundations: How to Find the Facts You Need to Get a Grant
Judith B. Margolin. $2 prepaid.

The Foundation Grants Index (Annual Volume).
Lee Noe, Grants Editor. $15. Order from: Columbia University Press, 136 South Broadway, Irvington, New York 10533.

The Foundation Grants Index (Bimonthly).
Included as a separate section in FOUNDATION NEWS. $20 annual subscription rate for FOUNDATION NEWS. Order from: The Council on Foundations, Inc., Box 783, Old Chelsea Station, New York 10011.

The Foundation Grants Index: Subjects on Microfiche
Annual. $3 with card.

Foundation Annual Reports on Microfiche
Quarterly. $2 with card.

Bibliography

Guide to Foundation Annual Reports
Annual. $2.

What Makes a Good Proposal?
F. Lee Jacquette and Barbara L. Jacquette. 8 pages. $.50.

What Will a Foundation Look for When You Submit a Grant Proposal?
Robert A. Mayer. 8 pages. $.50.

Philanthrophy in the United States: History and Structure
F. Emerson Andrews. 48 pages with bibliography. $.50.

The Foundation Directory, Edition 5
Marianna O. Lewis, editor.
540 pages, 15 tables, 4 semiannual supplements. Introduction by Thomas R. Buckman. $30.

The Foundation Center Source Book
Terry-Diane Beck and Alexis Teitz Gersumky, editors.
Volumes 1 and 2, 1975/1976, 1034, 1316 pages. $65 per volume.

·

AARI: Arts Administration Research Institute, 75 Sparks Street, Cambridge, Mass 02138. A good collection of books. Mary Wehle's books on financial management are particularly good.

Cases in Arts Administration, 1975, Raymond, Greyser, and Schwalbe, $19.50.

Financial Management for Arts Organizations, Wehle, $9.75.

Financial Practice for Performing Arts Companies — A Manual, 1976, Wehle, $9.75.

Bibliography

Conflict in the Arts: The Relocation of Authority, 1976 and 1977, Schwalbe, Baker-Carr.
The Arts Council, $5.95.
The Orchestra, $5.95.
The Museum, $5.95.

Cultural Policy and Arts Administration, Greyser, 1973, $5.95.

FEDAPT

FEDAPT: Foundation for the Extension and Development of the American Professional Theatre, 1500 Broadway, New York, NY 10036, (212) 869-9690. Direct inquires to Lila Aumuller, Program Coordinator. An *excellent* collection of pamphlets and booklets on the theatre.

Title/Subject	Price	Postage
1. Investigation Guidelines for Setting Up a Theatre, 1975	$3.00	.24
2. Pre-Production Budget Form	.40	.13
3. Audience Survey Guidelines and Samples	.80	.13
4. FEDAPT Selected Reference Books (List)	.40	.13
5. Safe and Sanitary Code (Actor's Equity Association)	.25	.13
6. 8 Newspaper Articles on Dinner Theatre	1.00	.13

 1. *Variety*
 2. *Minnesota Progress*
 3. *New York Times*
 4. *Wall Street Journal*
 5. *Durham Morning Herald*

7. *YPO Enterprise*, "Dinner Theatre: New Business for Show Business", 1975 (Reprint)	.40	.13

Bibliography

Title/Subject	Price	Postage
8. Chart of Accounts / Payroll Analysis (Dinner Theatre)	1.00	.13
9. Outline for Dinner Theatre Prospectus	.40	.13
10. "Dinner Theatre Now Big Business", 1974, State of Massachusetts Blue Sky Laws Intra State Offering Circular	.25	.13
11. Sample Limited Partnership Agreement (Dinner Theatre)	1.50	.24
12. Group Sales Brochure / Chanhassen, Dinner Theatre	.25	.13
13. Dinner Theatre Marketing Survey	2.50	.24
14. "The Business of Dinner Theatre Business", Chanassen Booklet	1.50	.24
15. New York Times, 1974, "Culture Means Money, City Told Report" New York Times, 1974, "Shrinking Giants" (2 articles)	.25	.13
16. "Board of Directors in the Performing Arts: A Managerial Analysis" by Ichak Adizes, plus "Purpose of Hartford Stage Company and the Role of the Board of Directors"	1.00	.24
17. Performing Arts Company in Residence / A Feasibility Study (Maryland Arts Council)	.80	.13
18. "Some Guidelines to the Preparation of an Effective Foundation Proposal"	.40	.13
19. "Artistic and Administrative Policy at the Long Wharf Theatre" (Booklet)	1.50	.24
20. Reliable Direct Mail Data	.40	.13
21. Dinner Theatre List (Actors' Equity Assoc.)	.25	.13
22. LORT List (Actors' Equity Assoc.)	.25	.13
23. Children's Theatre List (Actors' Equity Assoc.)	.25	.13
24. Summer Stock List (Actors' Equity Assoc.)	.25	.13

Bibliography

Title/Subject	Price	Postage
25. Winter Stock List (Actors' Equity Assoc.)25	.13
26. *Box Office Guidelines*	5.00	.25
	Book Rate	
27. *Subscription Guidelines*	7.50	.35
	Book Rate	
28. Hartford Stage Company (35-Page Monograph)	3.00	.24
29. Indiana Repertory Theatre (15-Page Monograph)	1.75	.13
30. The Grand Opera House of Wilmington, Delaware (9-Page Monograph)	1.25	.13
31. Monographs, No. 28, No. 29, No. 30 (above) together	5.00	.50

ACUCAA

ASSOCIATION OF COLLEGE, UNIVERSITY
AND COMMUNITY ARTS ADMINISTRATION, INC.
P.O. Box 2137 / Madison, WI 53701

Programming, *Taylor & Goldberg*, $1.50

A Residency Handbook (46 p., ill.) *Dawson*, $6

Guide to Agency / Management Exhibitors,
ACUCAA 20th Annual Conference, $1

Negotiating & Contracting . . ., *Taylor*, $3.75

Supplement No. 48, "Divergent Views on Promoting the
Performing Arts", *Michaelis*, $1

Supplement No. 58, "Building a Marketing Plan for the
Performing Arts", *Weinberg*, $1

Bibliography

Publicity & Promotion, *Taylor & Goldberg*, $1

No Cost PR, *Salzman & Runyon*, $1

Third Class Mail, Rules & Regulations, *Willis & Nakamoto*, $1

Mailing Lists, *Peterson*, $1

Supplement No. 59, "Pricing the Product", *DeKorte*, $1

Box Office & Ticket Procedures, *Stewart*, $2

Ticket Office As a Public Relations . . . Asset, *Willis*, $1

Fundraising & Grantsmanship, *Glazer & Baird*, $1.75

Facilities Management & Theatre Technology, *Weedman*, $1

Operating the Auditorium, *Wockenfuss*, $4

Planning the New Facility, *Wockenfuss*, $1.25

Guide to Arts Administration Publications & Organizations, *Willis & Nakamoto*, $1

ACUCCA Handbook: Presenting the Performing Arts (complete), $25

ACUCCA Handbook: Presenting the Performing Arts (binder only), $5

PERIODICALS

ACA REPORTS

Associated Councils of the Arts, 570 Seventh Avenue, New York, NY 10018. Six issues per year. Free to members.

Bibliography

ACUCAA BULLETIN

Association of College, University and Community Arts Adminis-
trators, Box 2137, Madison, Wi 73701. Monthly. Free to members.

ARTS MANAGEMENT

Arts Management, 408 W. 57th St., New York, NY 10036.
Monthly. $15 per year.

CULTURAL POST

NEA, Office of Program Information, Washington, D.C. 20506.
Bi-monthly. Free.

FOUNDATION NEWS

Council on Foundations, Subscription Department, Box 468,
West Haven, Ct 06416. $10 per year.

FUND RAISING MANAGEMENT

Hoke Communications, 224 Seventh Avenue, Garden City, NY
11530. $8 per year.

GRANTSMANSHIP CENTER NEWS

The Grantsmanship Center, 7815 S. Vermont Ave., Los Angeles,
CA 90044, $10 per year.

ISPAA BULLETIN

International Society of Performing Arts Administrators,
Columbia Music Festival Association, 1527 Senate St., Columbia,
SC 29201. Nine issues annually. $10 per year.

Performing Arts Review: The Journal of Management and Law,
Law Arts Publishers, New York.

THEATRE CRAFTS

Theatre Crafts, 33 E. Minor St., Emmaus, PA 18048. Six issues at $8 per year.

USITT NEWSLETTER

United States Institute for Theatre Technology, 1501 Broadway, Room 1408, New York, NY 10036. Five issues per year. Free to members.

WASHINGTON INTERNATIONAL ARTS LETTER

Box 9005, Washington, D.C. 20003. Ten issues per year. $16 individual, $26.50 nonprofit, $32 institutional.

LAW AND THE ARTS

Abouaf, Jeffrey. *Tax and the Individual Artist.* Arts Law Guide Number 5. San Francisco: Bay Area Lawyers for the Arts, 1976.

Alexander, James, ed. *Law and the Arts.* 3rd ed. Chicago: Lawyers for the Creative Arts, 1975.

ALI-ABA Course of Study, *Legal Problems of Museum Administration*, Joint Committee on Continuing Professional Education, Philadelphia, 1974.

ASMP — The Society of Photographers in Communications, Inc. *ASMP Guide: Business Practices in Photography: 1973.* New York: ASMP — The Society of Photographers in Communications, Inc., 1973.

Associated Councils of the Arts, The Association of the Bar of the City of New York, and Volunteer Lawyers for the Arts. *The Visual Artist and the Law.* 1st rev. ed. New York: Praeger Publishers, 1974.

Bibliography

Baumgarten, Paul A., and Farber, Donald C. *Producing, Financing and Distributing Film.* New York: Drama Book Specialists, 1973.

Cartoonists Guild. *Syndicate Survival Kit.* New York: Cartoonists Guild, 1975.

Cavallo, Robert M., and Kahan, Stuart. *Photography, What's the Law?* New York: Crown Publishers, Inc., 1976.

Chernoff, George, and Sarbin, Hershel. *Photography and the Law.* 4th ed. Garden City, New York: Amphoto, 1973.

Crawford, Tad, *Legal Guide for the Visual Artist*, Hawthorn Books, New York, 1977.

Derenberg, Walter J., and Goldberg, Morton David. *Current Developments in Copyright Law.* 2 vols. New York: Practicing Law Institute, 1975.

DuBoff, Leonard D. *Art Law: Domestic and International.* South Hackensack, New Jersey: Fred B. Rothman & Co., 1973.

Feldman, Franklin, and Weil, Stephen E. *Art Works: Law, Policy, Practice.* New York: Practicing Law Institute, 1974.

Freedman, Robert. *Basic Law for Artists.* Legal Rights Guide Number 1. San Francisco: Bay Area Lawyers for the Arts, 1975.

Graphic Artists Guild. *Pricing and Ethical Guidelines.* 2nd ed. New York: Graphic Artists Guild, 1975.

Hodes, Scott. *What Every Artist and Collector Should Know About the Law.* New York: E. P. Dutton & Co., 1974.

Holcomb, Bill, and Striggles, Ted. *Fear of Filing.* New York: Volunteer Lawyers for the Arts, 1976.

Bibliography

Hollander, Barnett. *The International Law of Art*. London: Bowes & Bowes, 1959.

Knoll, Alfred P. *Museums — A Gunslinger's Dream*. Legal Rights Guide Number 3. San Francisco: Bay Area Lawyers for the Arts, 1975.

Lindey, Alexander. *Entertainment, Publishing and the Arts*. 2 vols. New York: Clark Boardman Co., Ltd., 1963, Supp. 1975.

Moegeli, Thomas. *Handbook for Tour Management*. University of Wisconsin, Center for Arts Administration, Madison, 1975.

Nimmer, Melville. *Legal Rights of the Artist*, National Foundation on the Arts and Humanities, Washington, 1971.

————. *Nimmer on Copyright*. 2 vols. New York: Matthew Bender, 1963, Supp. 1975.

Planning and Probating the Collector's Estate. 2d. ed. New York: Practicing Law Institute, 1975.

Redfield, Emanuel. *Artists' Estates and Taxes*. New York: Artists Equity Association, 1971.

Sandison, Hamish, ed. *The Performing Artist and the Law Handbook*. Bay Lawyers for the Arts, 2446 Durant, Berkeley, Ca. 94704, 1975.

————, ed. *The Visual Artist and the Law*. San Francisco: Bay Area Lawyers for the Arts, 1975.

————, ed. *A Guide to the New California Artist-Dealer Relations Law*. San Francisco: Bay Area Lawyers for the Arts, 1975.

Volunteer Lawyers for the Arts. *Housing for Artists: the New York Experience*. New York: Volunteer Lawyers for the Arts, 1976.